LIVING TRIBES

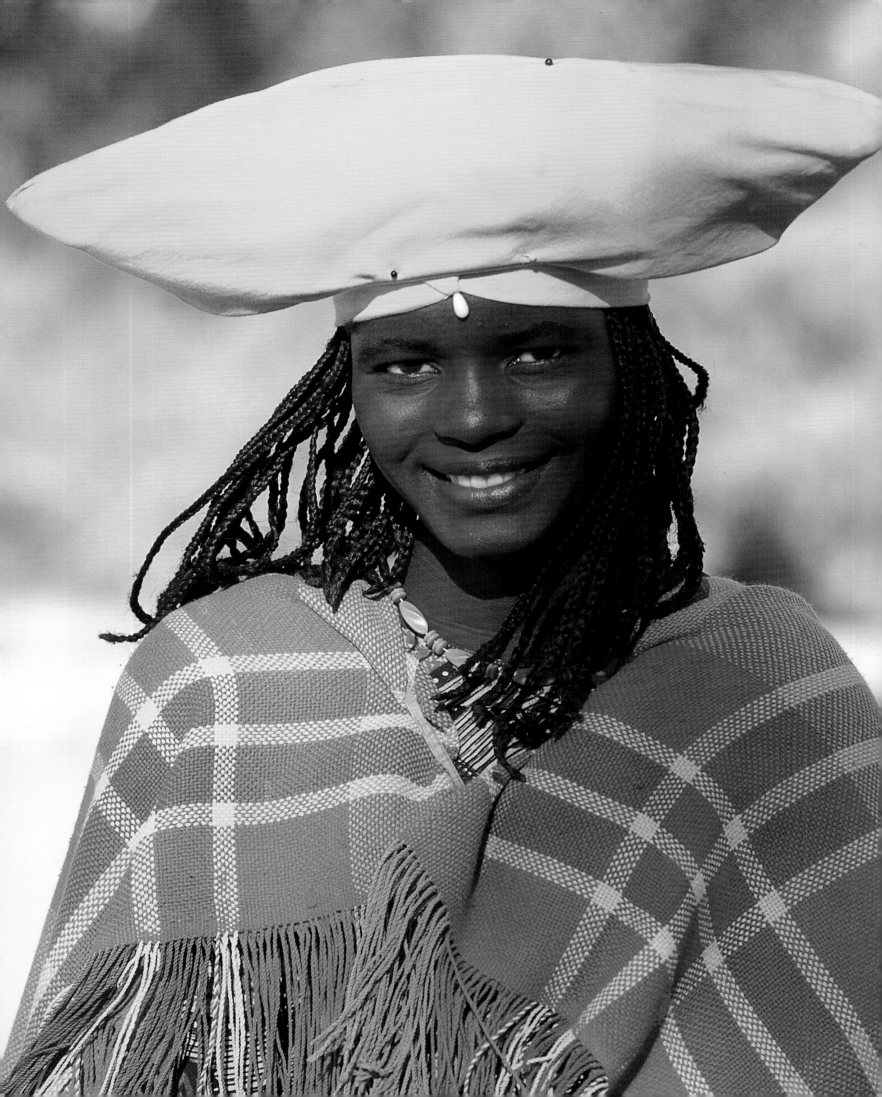

LIVING TRIBES

COLIN PRIOR

Introductions by Carolyn Fry

CONSTABLE • LONDON

For Alexandra and Laurence

Constable & Robinson Ltd
3 The Lanchesters
162 Fulham Palace Road
London W6 9ER
www.constablerobinson.com

First published in the UK in 2003 by Constable,
an imprint of Constable & Robinson Ltd

A copy of the British Library Cataloguing in Publication Data is
available from the British Library.

ISBN 1-84119-545-6

Design by Becky Willis at Design Revolution
Printed and bound in the EU

HERERO GIRL (PAGE 2)
Sesfontein, Namibia

MANGATI GIRL (OPPOSITE)
Mingingu, Tanzania

SAMBURU WARRIOR (PAGES 6-7)
Wamba, Kenya

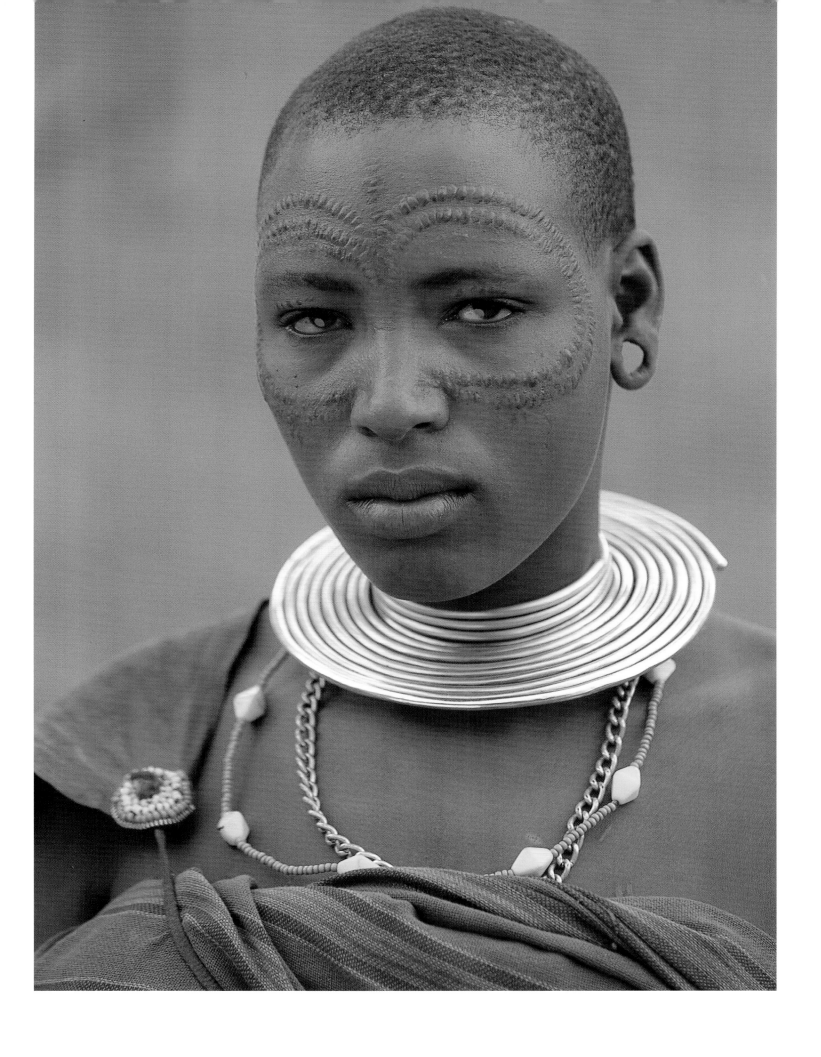

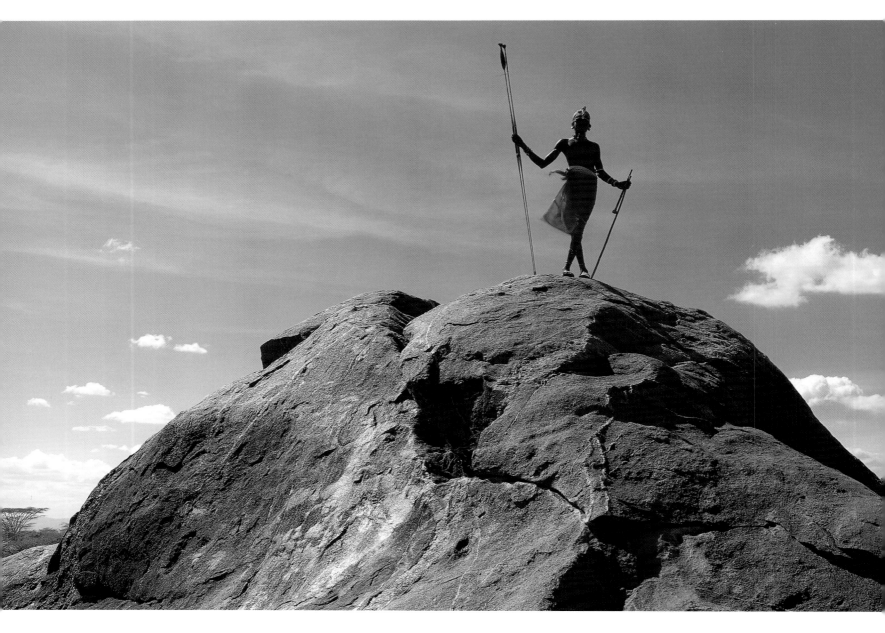

Contents

Introduction

What does the imagination conjure up when you hear the word tribe? Maybe it's the red-skinned, adorned warriors of East Africa's savannah, or serene ring-necked women from Myanmar's Padaung people. Or perhaps it's the flushed, fur-rimmed faces of Inuit children from the Arctic. These days tribal images are used to sell anything from holidays to clothing and beauty products. Television documentaries showing far-off communities enacting centuries-old rituals and traditions have helped cement a somewhat clichéd view of tribes as being preserved relics of ancient times. But in this age of cheap travel and globalization, tribal distinctions are blurring. Inuit families are just as likely to wear the latest Gore-Tex waterproofs as they are more traditional fur garments to protect them from the worst of the Arctic weather. More and more tribal communities are settling in towns, swapping traditional regalia for cheap western clothing, sending their children to school and becoming wage earners. Is there really such a thing as a living tribe – or have most tribal populations simply now become minority elements within increasingly homogenized societies?

The charity Survival, which campaigns on behalf of indigenous peoples around the world, defines tribes as people who have lived in tribal societies for many generations. They tend to be minorities and are usually the original inhabitants of the places they live in – or have at least lived there for hundreds or thousands of years. But even in centuries-old communities, changes have continually taken place. The Samburu of Kenya in Africa are today known for keeping camels as well as cattle – a practice adopted relatively recently in response to the repeated demise of their cattle herds through drought. And Namibia's Herero people, for whom semi-nakedness was once the norm as it remains today for their Himba cousins, now sport Tyrolean jackets and voluminous full-length dresses. The change was prompted by German missionaries in the 19th century prudishly offended by the sight of the tribe's bare bodies.

Given that such changes have subsequently become embroiled in the fabric of societies it is hard to identify an original "untouched" state in the history of any tribe. The further back in time you look, the more obvious it is that tribal boundaries have been continually moulded by change. Ultimately we may all even derive from a single ancient "tribe". Despite the diversity of peoples in the world the favoured theory among today's anthropologists is that modern humans are all descended from African stock. They believe these early Africans went on to travel the world, spawning as they went all the "races" that exist today.

The theory goes that modern humans evolved in Africa 200,000 years ago and began migrating away from it around 80,000 years ago. Anthropologists have identified two potential routes they could have taken from sub-Saharan Africa to Asia: one up the Nile corridor through Egypt and the Suez to the Levant and the other south across the mouth of the Red Sea and along the Arabian coast to Yemen and Oman. Geo-climatic evidence suggests the latter is more likely. The emigrant band is likely to have hugged the Indian Ocean coast, crossing land-bridges to cross Indonesia towards Bali. From here they made their way to Timor and then into Australia. En route, they encountered – and ultimately displaced – earlier *Homo erectus* species, who had made a similar migration out of Africa one million years ago. Though their expansion may seem rapid, given that they moved on foot through unknown desert and mountain terrain and had to cross water, experts have calculated that a modest 20-mile-per-generation "migration" could carry a population the equivalent distance from sub-Saharan Africa to western Europe in a mere 10,000 years.

Advances in genetic technology in the late 1980s brought new evidence to support a single origin human source. The genes we carry in our cells define each of us as individuals and are inherited from both our parents. Two tiny elements of our DNA pass intact from generation to generation without mixing: the Y chromosome through the male line and the mitochondrial DNA through female descent. A team of biochemists reported that using DNA from human mitochondria, they had traced back the genetic evolution of modern humans to one woman – labelled "Eve" in media reports – who had lived in Africa some 200,000 years ago.

If we all derive from such a unique source, the diversity on the planet seems all the more surprising. A glance at some of the varying peoples on our planet reveals dark and light skin, the absence of the epicanthic fold on the upper eyelid of Asian people, a variety of body builds, differently shaped lips and noses and many different ways of speaking. Anthropologists now believe the evolution of characteristic traits is a result of adaptation to specific prevailing conditions. Skin colour is thought to be an adaptation linked to the intensity of sunlight – with dark skin providing protection against high intensities of ultraviolet and pale skin producing more vitamin D to counteract low ultraviolet intensity. Build has also been linked to environmental conditions, namely through Bergmann's and Allen's rules. The former states that individuals in colder regions of a species range have a bulkier body build. The latter suggests that in colder regions of a specific range, body extremities such as limbs, fingers and ears will be shorter. It is clear

that people such as the Turkana, Maasai, Samburu and Himba, who have lived for many generations in hot, arid conditions are slightly built with elongated limbs, while Inuit who live in the Arctic are shorter and more solidly built.

Multiple languages are thought to have arisen as people migrated and intermingled. There are currently believed to be around 5,000 languages spoken throughout the world, although this number is diminishing. In some cases, a single language or dialect is only spoken across a very localized area such as in a single valley. Before white settlers arrived in Australia in the 18th century, there were 300,000 Aborigines in around 250 tribal groups – each of which had their own language. Today, among the neighbouring hilltribes straddling the Thai-Myanmar border, the Lisu speak a language with Chinese-Tibetan origins while the Padaung's tongue reveals their Mongolian roots. Interestingly, while the number of languages and dialects may seem to illuminate the variety in the human species, research into the linguistics of the world's diverse peoples suggests that language can also be used to link humans back to a specific source in a similar way to genetics.

If you take the Maasai people as an example, they derive from a Nilotic people and speak Maa which comes from a Nilo-Saharan linguistic family; they display immediate African characteristics genetically and linguistically. If, however, you take an Inuit tribe such as the Chukchi, their language derives from the Chukchi-Kamchatkan linguistic family, which is grouped with various other families – Sino-Tibetan, Indo-European, Afro-Asiatic, for example – under the Nostratic and Eurasiatic superfamilies. Looking at the Chukchi's genetic roots, they can be traced back to an Arctic grouping of peoples, who were descended from Northeast Asian peoples, who in turn came from North Eurasian stock. The North Eurasians were in turn descended from a wider Asian group. Thus, the genetic make-up of the Chukchi is reflected in the evolution of their language. While the roots of language go back a long way, individual tongues remain fluid, open to change. As recently as 1957, a new alphabetic script was created for the Lisu people.

So the elements that define particular groups of people have certainly evolved continually through time. The current languages, customs, religions and ways of life reflect the routes their ancestors took to reach their current locations and the subsequent influences of climate, environment and contact with different groups of people. Genetic data suggests that there are today seven main ethnic branches from which all the world's varying peoples derive. They are African, Caucasian, Northeast Asian, Amerindian; and Southeast Asian in the Pacific Islands, in Australia and in New Guinea. Aboriginal tribes

that exist in Australia today are likely to be direct descendants of those on the original migration out of Africa, while people such as the Inuit are descended from later migrations such as that via Beringia years ago. In this book, we use the term "tribe" in the loosest sense of the word, to mean communities that remain linked by common practices, clothing, language, religion and customs. Thus we include some traditional African groups such as the Himba, who live only in one part of Namibia and have maintained many of their traditional ways – as well as broader communities such as the Bhutanese who encompass varying groups but maintain certain customs and beliefs across those clusterings.

Religion has played a major role in shaping tribal identities. Communities such as the Ladakhi and Bhutanese, situated at the western and eastern extents of the Himalaya mountains respectively, have based their societies on Buddhism. The Mahayana form of Buddhism followed by the Ladakhi was derived partly from Indian Buddhism and partly from the Bon-Chos faith which early people in the region followed. The Kagyupa strand of the religion was adopted by Bhutan as Buddhism swept east from India into Tibet and then Bhutan in the 11th century. In both cases, the adoption of Buddhist beliefs hundreds of years ago has continued to drive their communities. In both places, Buddhist monasteries, some dating back centuries, dominate the landscape, while ancient religious hierarchies and customs continue to permeate everyday life.

West of Ladakh, families living deep in the Karakoram mountains of northern Pakistan initially adopted Buddhism like their neighbours. However, in AD 1379 a man named Amir Kabir Syed Ali Hamadani brought the Shiah faith to the region. It is this Islamic faith that today's Balti people now follow. Thus changes wrought in the distant past have clearly shaped the discrete evolution of tribal groups. In some locations, such as among the hilltribes of northern Thailand and Myanmar, groups living in very close proximity have evolved very different characteristics. While some hilltribes came under the influence of the easterly spread of Buddhism, others, such as the Lisu, maintained beliefs in spirit and ancestor worship. The Toraja of Indonesia, believed to have their roots in southeast Asia, and Australia's indigenous Aborigines also originally adopted forms of ancestor worship.

Although tribes have been exposed to outside influences which have shaped their destiny, the remoteness of many has meant they lived relatively settled lives for periods of hundreds or even thousands of years. African tribes such as the Maasai, Samburu and Turkana early on adopted nomadic lifestyles, moving with their herds across the vast African plains as nature dictated. When one area of grazing became exhausted they

simply moved on to another. Cattle raiding often took place between tribes, but battles were fought on a relatively even scale. Some tribes arranged their communities around age-sets – with young, strong men of the communities defending their people and the older ones offering wisdom and guidance. Complex rituals strengthened society bonds and marked the passing of one era into another.

In the harsh climate and terrain of the Himalaya and Karakoram mountains, societies based their lives around the water life lines provided by the glaciers of the highlands. They adopted semi-nomadic habits, moving their herds to the high pastures in summer when the snows melted, and heading back to the lowlands in winter. They also grew crops to supplement their diet – and communities shared the seasonal chores of sowing and harvesting crops. Communal patterns for agricultural work also emerged thousands of miles away in the High Atlas mountains of Morocco. Berber farmers pooled resources to generate sufficient food for the community and constructed shared granaries in which to store grain. They ruled their society using a method now known as the "segmentary lineage model". Famous anthropologists such as Edward Evans-Pritchard devoted years to studying how such tribes managed to run successful moral societies without the kind of settled leadership that dominates political governance today.

So, over hundreds of years, around the world, diverse groups of people evolved, following separate religions and beliefs, honing their own traditions and arranging their lives to suit the climate, environment and size of their own communities. The rise of colonialism, however, and the explorative journeys by Europeans in the 19th century had a very widespread impact on today's minority people. As the countries of Europe sought to conquer the world and gain the lion's share of power, they spread out across the world, slowly discovering and unearthing isolated and unique communities. In many cases, they aimed to exploit the resources that these people knew of, and to control them in a way that would give the newcomers powerful trading opportunities and advantages. Their arrival heralded the start of a period of negative change which tribal groups are still struggling to deal with today.

The "discovery" of the Inuit of Baffin Island is a good example. The Arctic was the last habitable place on Earth to be occupied by people. Even so, research suggests that Nunavut has been occupied continuously for 4,000 years and small pockets of the Kivalliq Region were occupied sporadically by Indian groups beginning 8,000 years ago. It is likely that the Inuit had some contact with Norse people but for generations life continued in much the same way, the main concern being to hunt and fish and provide sufficient food for their communities. European explorers visited from the 16th century

onwards after Martin Frobisher "discovered" Baffin Island while searching for a northwest passage. British whalers reached northern Baffin Island by 1817, hunting for the bowhead whale which they used to make corset stays, buggy whips and other such goods. Their discovery of a rich source of bowheads in Cumberland Sound escalated change. Following the arrival of Scottish and American whalers in the 1860s, life would never be the same again. The setting up of whaling stations changed Inuit settlement patterns and brought them into contact with metal, tools, guns and whaleboats.

Similar scenes were being played out in other parts. As Europeans fought to extend their empires, tribes in Africa bore the brunt of their power-crazed desires. Tribes such as the Nama and Herero in what is now Namibia but what was then Southwest Africa resented Germans taking land on which they had grazed their herds for generations. They rebelled but were no match for the armed invader. Their attempt to defend their land and culture prompted the German commander General von Trotha to issue the proclamation: "I the great general of the German troops send this letter to the Herero people … All Hereros must leave this land … Any Herero found with or without cattle, will be shot. I shall no longer receive women or children, I shall drive them back to their people. I will shoot them. This is my decision for the Herero people."

Such blatant disregard for minority peoples ways and customs was a familiar tale for much of the colonial period. Many anthropologists sought out undiscovered tribes at this time and often their works propagated the generally accepted racism of their home countries. In 1870, Reverend J. G. Woods wrote of the Aborigines in *The Natural History of Man*. His view was that they deserved no future as they had "performed barely half their duties as men". They had inherited the Earth but had not subdued it and did not replenish it. They left it in exactly the condition in which they found it. Woods believed the coming of the white man was not a curse, but a benefit for the Aborigines; it offered them a means of infinitely bettering their social condition. Their imminent disappearance from the face of the Earth was, to him, a case of: "following the order of the world, the lower race preparing a home for the higher". Such racist views prevailed into the 20th century. In 1926, Henry Fairfield of the American Museum of Natural History wrote: "The evolution of man is arrested or retrogressive … in tropical or sub-tropical regions." Roy Chapman Andrews, also of the American Museum, concluded in 1948: "The progress [through evolution] of the different races was unequal … Some developed into masters of the world at an incredible speed."

With the widespread view in the 19th and early 20th centuries that the white Christian lifestyle was the correct one and that minority peoples of the world needed to be

educated as to the ways of this superior white existence, the missionaries set out to convert the world. Just as the sweep of Buddhism in the 11th century provided the basis on which several mountain tribes built their identities, and the wave of Islam that crossed north Africa after AD 622 put in place the Berber's religious following, so too the missionary movement sought to replace earlier beliefs. Its widespread impact is clearly visible in the number of entirely Christian tribal communities around the world today and in the number of religions which have combined early animist, megalithic or spirit worshipping practices with Christian elements. The staunchly Christian churchgoing communities of the South Pacific Islands such as Tonga are an example of the former, while the Torajan funeral rituals of Sulawesi reflect a converted community which has maintained some distinctly non-Christian elements. Buffalo are still sacrificed at funerals, for example.

So where have the turbulent and destructive changes of the colonial era left the world's tribal peoples? For all their cultural differences, today's minority groups remain connected primarily by their need for food and land. Governments' favour for large-scale agriculture has particularly taken its toll on communities with traditionally nomadic lifestyles. African tribes such as the Maasai who once roamed with their herds across the empty plains are now struggling to make pastoralism work within confined land areas. Having initially had land taken from them in a series of colonial treaties, they also now find themselves in conflict with wildlife parks, who say that the herdsmen's cattle infringe on the activities of the wild animals. And when the parks bring in thousands of fee-paying people each year, the authorities tend to put conservation above the needs of the minority Maasai. However, the Maasai remain defiant despite the dwindling odds. "The warriors are still a Maasai standing army ready to defend their land and cattle from enemy attack," says one-time Maasai warrior Tepilit Ole Saitoti. "Tall, handsome and fearless they will fight to the end."

In another part of Africa, on the border between Namibia and Angola, the Himba face the destruction of their land from a different threat. The governments of the two countries plan to build a hydroelectric dam on the Kunene river, which at present provides essential dry-season grazing and vegetable gardens for Himba families. If the scheme goes ahead, the dam is likely to flood ancestral burial grounds which the people consider to be of great spiritual significance. The withdrawal of land, influx of foreign labourers and increased levels of waterborne diseases are likely to be disastrous for the Himba. While a few younger estranged tribe members seeking work favour the project, the majority oppose it. Himba headman Hikuminue Kapika has made his feelings clear: "They will have to shoot all the Himba before they build the dam."

Other tribes have faced struggles in trying to gain legal rights to land despite having inhabited it for generations. The battle for land by Australia's Aborigines has been prolonged and continues today. The original inhabitants of Australia probably reached the landmass at least 70,000 years ago. Aborigines believe that land, people and animals are spiritually connected; that animal spirits exist in human form, and landforms represent the places where spirits once lived. Their relationship with their land is thus central to their very existence. However, for many years the Australian Government declared the continent "Terra nullus" (i.e. inhabited by no-one) prior to 1778. This thwarted attempts by indigenous people to make court claims on land they felt was historically theirs. Various Land Rights Acts have, however, since been granted land to Aboriginal communities, gestures which amount to a small step in the right direction.

The Inuit have faced similar struggles and have achieved some success since the 1970s. The 1971 Alaska Native Claims Settlement Act amounted to U.S.$925 million; and was followed by the James Bay Treaty in Quebec and the 1979 Home Rule in Greenland. Eventually, in 1999, the Canadian government inaugurated Nunavut, a 770,000-sq-mile (two-million-sq-km) slice of northern Canada. Although not an ethnic Inuit state, it went some way to addressing land claims and harvesting rights, and gave the Inuit a greater degree of self-autonomy. Other tribal communities are now actively involved in court action to try and redress the balance of years of oppression and inequality. The Herero went to court in 2002 to get compensation for how the German government treated their people during the colonial period. The Maasai are similarly seeking to protect their remaining lands and are trying to gain legal control of sites they consider to be sacred at Endoinyo Ormoruwak and Entim e Naimina Enkiyio, to protect them from commercial exploitation. Maasai who live in Ngorongoro Conservation Area are also trying to secure their rights to the land they have inhabited for centuries and to ensure they get a fair share of money raised at this highly popular tourist attraction.

For many tribal peoples, the rise of tourism is the latest change that is impacting on their societies. The earliest explorers who bravely went to unknown corners of the planet brought back fantastical stories of alien people and places that amazed and excited those back home. After the camera was invented, explorers such as Sir Wilfred Thesiger, Herbert Ponting, Frank Hurley and others brought back beautiful and intriguing black-and-white images of extraordinary landscapes and unusual peoples, the latter regaled in unfamiliar costumes and practising never-before seen ceremonies. These further whetted people's appetites for travel but, initially, long-haul journeys remained the preserve of the very rich. Slowly, though, the situation changed. With the development of better transport links – including air transport – travel became

something that anyone could do. These days short-notice package holidays to Thailand, Indonesia or Africa can be snapped up for a reasonable price. But is this a good or bad thing for the tribal peoples whose traditionally remote and secluded homelands can now be easily reached by the masses?

Different countries have responded in differing ways to the rise of tourism. In Nepal, the increasing stream, since the 1950s, of wealthy westerners wanting to climb Everest has helped drive rapid development of its tourism industry. Many of the local people were suddenly exposed to commercialization with the result that people relinquished their traditional farming practices to earn money from tourism. In recent years, there has been growing concern that porters especially are being subjected to dangerous climatic conditions, without proper protective clothing and for very low wages. The speed at which the industry developed meant it did so without any real regulation and exploitation of the local inhabitants was, sadly, a result of this. Environmental degradation from the sheer volume of visitors and lack of management has also become a major problem. Only now is the work of various groups and charities, coupled with increased coverage of the situation in the western press, beginning to make a difference.

The opening up of traditionally closed societies to commercialism has had negative impacts in many minority communities. Since Ladakh opened its doors to tourists in 1975, traditional feelings of pride and self-confidence have been replaced by inferiority and dissatisfaction as locals have compared their lives to the idealized views of western living that have filtered into the country. It didn't take long for outside economic pressures to start undermining the local economy, and men who traditionally worked the fields increasingly sought paid work in the towns. The result of this has been that family and community bonds have weakened and pollution, crime and rapid urbanization have all entered Ladakhi life. A similar situation has arisen among the Lisu people of Thailand, Myanmar and Laos, only they have directed their money-making desires into building up a lucrative opium industry. Some farmers have stopped producing their traditional crops altogether to concentrate their activities on harvesting and refining opium from poppies. The drug makes its way from here onto the streets of western countries – but if governments put a stop to it the tribespeople lose their income.

Another negative impact of tourism on minority peoples is that some have reverted to abandoned traditional ways purely to attract tourist money. One of the most insidious cases of exploitation has been among the Padaung women in Myanmar and Thailand who used to wear multiple brass rings on their necks, arms and ankles. The weight of the rings gave the appearance of lengthening the neck but in practice depressed the clavicle.

If rings are removed after several years, the woman's neck is no longer able to support her head. This tradition had been largely abandoned, but news reports have circulated that unscrupulous operators are paying women to put rings on their children's necks in order to attract tourists' dollars.

But not all countries and people have allowed tourism to drastically impact on their way of life. Bhutan has taken a very controlled approach to tourism and westernization. Although it opened up to westerners in 1952 (as neighbours of China, both Nepal and Bhutan were seeking to strengthen their ties with the west at this time) it has severely restricted the numbers of visitors. Even by the 1980s, only 2,000 visitors per year were allowed in, and initially they could only do so as part of organized tours rather than travelling independently. They were only allowed to see sights such as scenery, temples and *dzongs* (ancient palaces turned museums). The country has also strongly guarded its Buddhist identity, dictating that all Bhutanese wear national dress. Although its approach has been severe, the result is that the environment has not suffered the extent of degradation of some other mountain regions. The costs for travelling to Bhutan is kept high, which restricts the type of visitors who enter the kingdom.

Many tribal communities are learning rapidly that tourism needs to be carefully managed to benefit their people rather than foreign companies. Some Maasai, recognizing that tourism is inevitable, have become involved in ecotourism ventures, designed to bring in money to local inhabitants, educate visitors in an intelligent way about their past and heritage and protect the fragile environment. Elsewhere, sensitive tourism ventures are enabling tribal people to make a living from producing crafts, clothing, rugs and jewellery to sell to visitors. If managed well, this type of project can help maintain and promote traditional skills which could otherwise be lost forever.

There is no doubt that today's tribal peoples are having to cope with change that is happening faster than ever before. Many are struggling to gain rights to land that they have inhabited for prolonged periods and to have the majority population accept their chosen way of living. For the estimated 70 uncontacted tribes that remain in the world, the chances of keeping their unique lifestyles intact are fragile. However, while traditional ways are clearly under threat, many groups have formed structured community groups to fight government decisions in court, and have turned to the media such as TV, film, radio and the Internet to help tell the world their stories on their own terms. This book is a photographic celebration of the diversity of people who inhabit our planet today, many of whom are fighting to keep their unique customs, values and heritage alive for future generations.

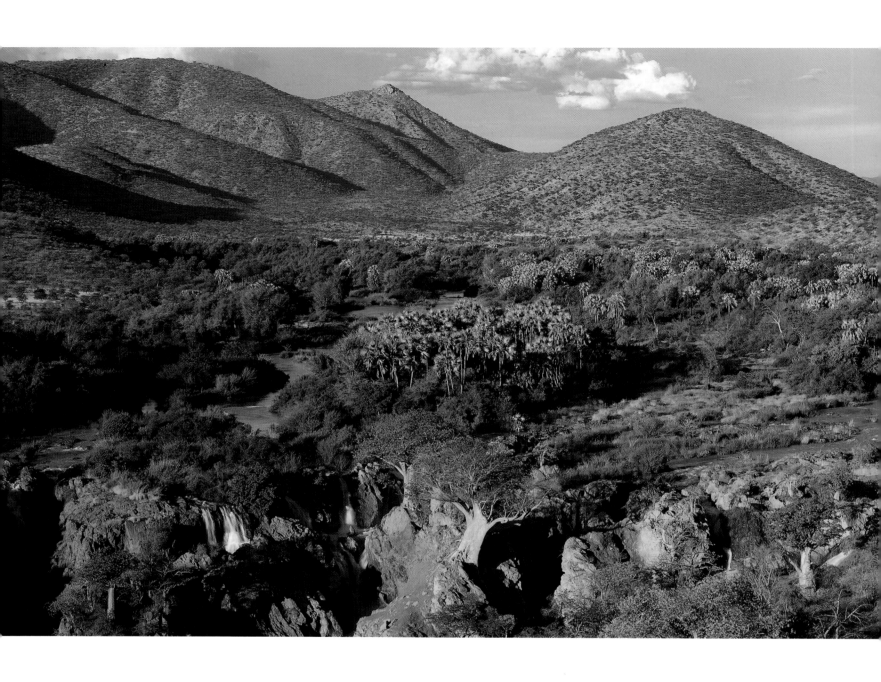

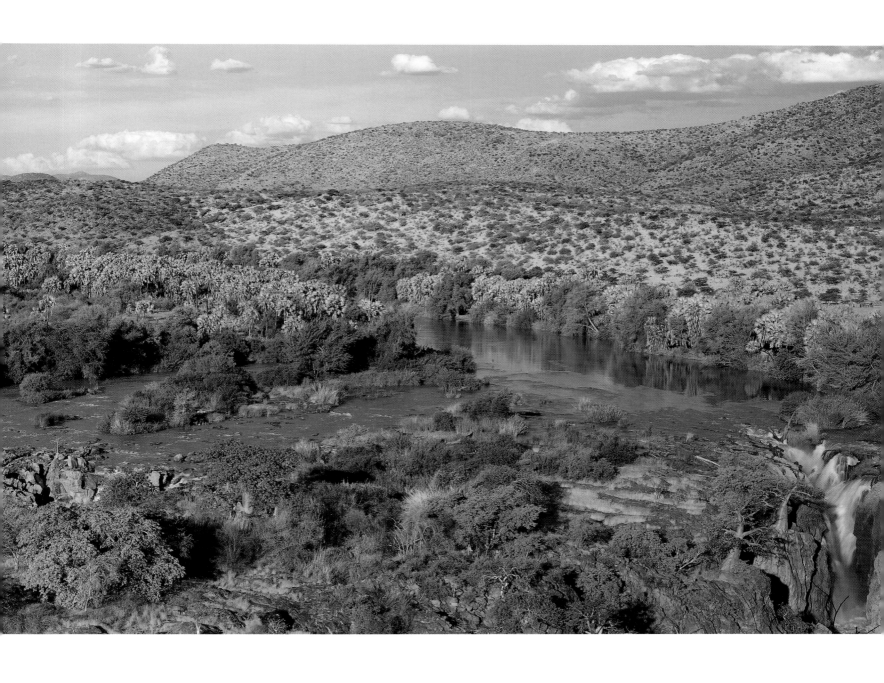

LAND OF OCHRE

Himba

Related directly to the Herero, the Himba are one of the last semi-nomadic pastoralist cultures of southern Africa. Skilled cattle herders, they live in central settlements, *onganda*, but establish mobile livestock camps, *ohambo*, during dry periods of the year. Many now also grow crops and barter goods to gain beads, alcohol, maize and other products. While recent years have brought closer contact with other modern living, the remoteness of the wilderness they inhabit beside the Kunene river in northern Namibia and southern Angola has helped them remain relatively self-sufficient. Although Himba men dress in increasingly westernized styles, the women still wear soft leather aprons and smear their bare upper bodies with butterfat and ochre (Jacobsohn, 1988).

The Namibian Himba live in Kaokoland, 19,000 sq miles (50,000 sq km) of the northwest corner of the country. The Herero arrived here around 400 years ago, part of early Bantu migrations from the Great Rift Valley. Impoverished by Oorlam cattle-raiders in the mid to late 1880s, some were forced into becoming hunter-gatherers. Many fled to Angola, where they were called "Ovahimba" (often now shortened to Himba), meaning beggars. However, after the First World War, with Kaokoland under South African rather than German rule, most returned.

Himba society is based around patrilineal and matrilineal kinship relations, the former controlling distribution and inheritance of religious symbols, the latter the distribution and inheritance of livestock (Crandall, 1991). An important custom is the keeping of the holy fire, or *okuruwo*. The fire is kept burning at night within the hut of the village headman, symbolizing a link with the family's ancestors. The fire is often just a smouldering mapone tree log, but each morning it is brought out to a fire pit. Most important events are carried out beside the *okuruwo*, and, as each new day dawns, the Himba gather around the fire for a ritual which precedes the first drink of milk of the morning.

During the 1980s, war between the South West Africa Peoples' Defence Organization (SWAPO) and the South African Defence Force (SADF) disrupted the Himba's peaceful existence. Not only were tribe members caught up in fighting along the border between Angola and South West Africa (now Namibia), but the war coincided with a three-year drought which decimated cattle stocks. Some experts considered the situation so grave that it threatened to end Himba society (Jacobsohn, 1990). However, by borrowing animals from those less affected, the Himba have rebuilt their stocks. With drought so prevalent throughout Himba history, the *omuyandje* – person giving food to others – is highly valued. Stories of great *omuyandje* live on for years after the person's death (Bollig, 1997).

KUNENE RIVER (PAGES 18-19)
A photograph by Kazuyoshi Nomachi initially inspired me to visit Epupa Falls. My first sighting was from the cockpit of a light aircraft after a three-and-a-half hour flight from Windhoek. The palm-fringed river, with deeply eroded fissures in which waterfalls flow, is punctuated by islands of giant, statuesque baobab trees. It was with horror, later that evening, that I learned of a proposal to build a hydroelectric dam on the Kunene River which would flood the entire area including 54 sq miles (140 sq km) of Himba settlements, grazing land and grave sites. A report by the World Commission on Dams declares that tribal peoples such as the Himba often get caught between a dam and a hard place.

OMAHONGA (OPPOSITE)
Himba women take several hours over beauty care every morning. The entire body is rubbed with a cream consisting of rancid butterfat and ochre powder. The aromatic resin of the omuzumba *bush is added as well. The cream lends the body an intense reddish shine: the region known as Kaokoland literally means "land of the ochre people".*

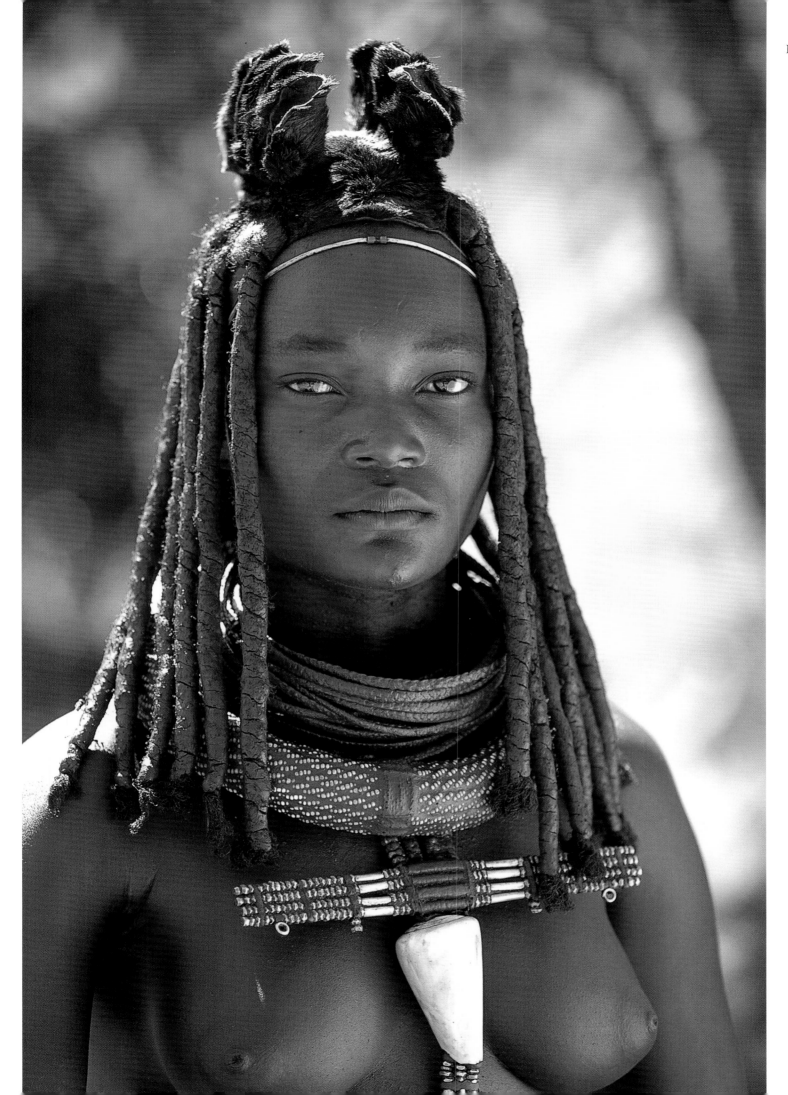

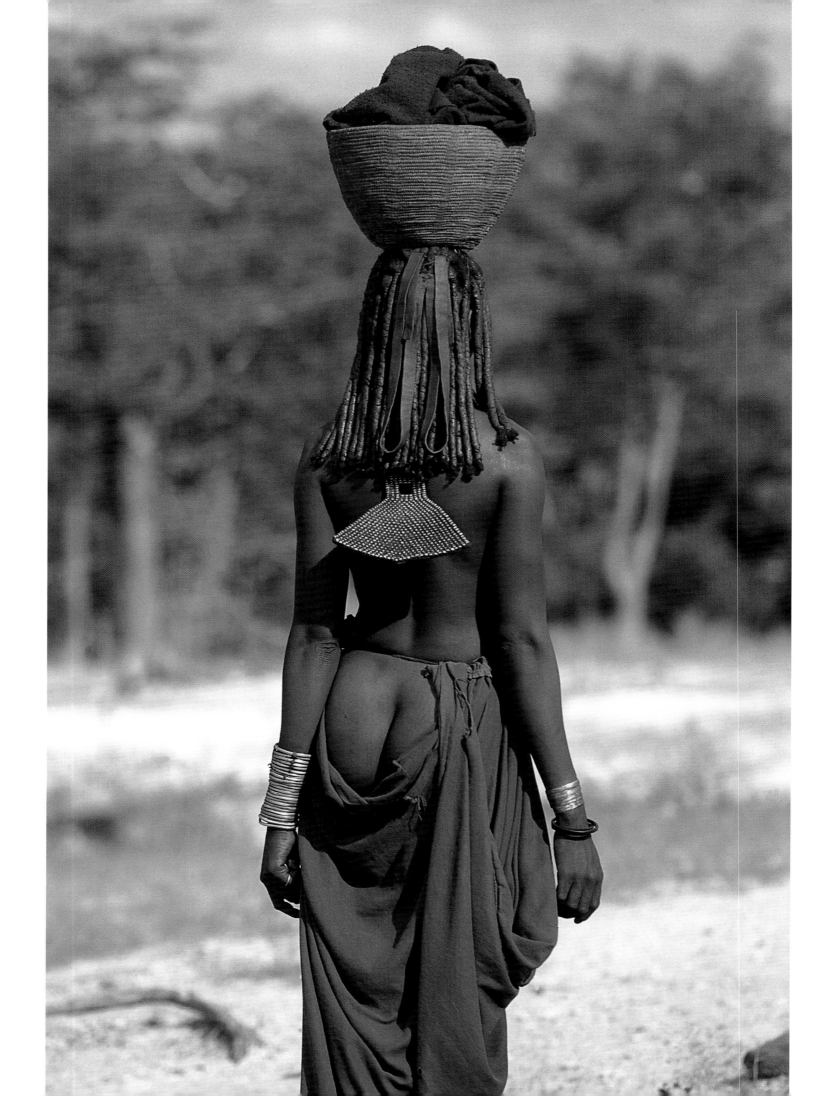

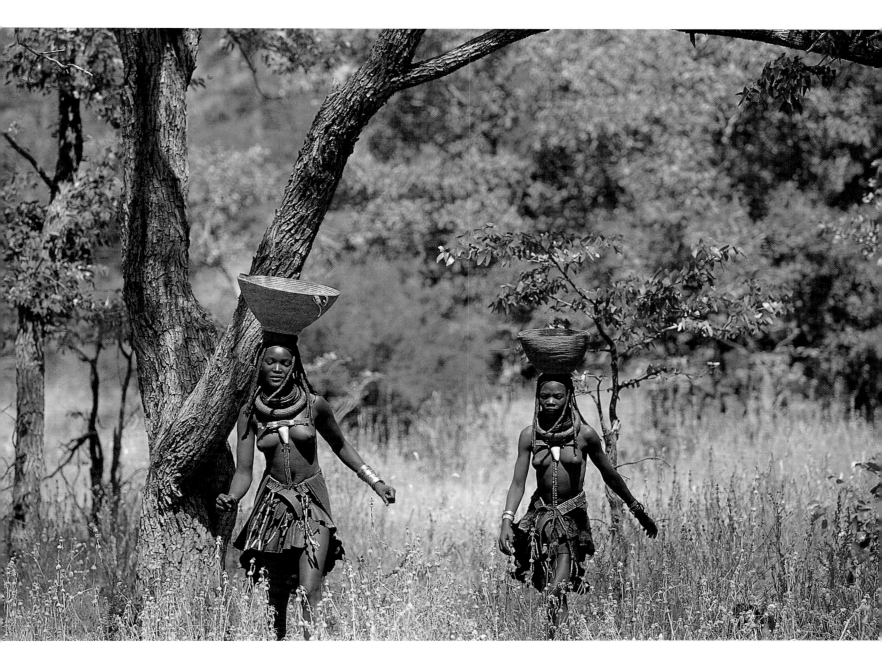

HIMBA BEAUTY (OPPOSITE)

It is a trait of the Himba to consider the body like a face. The body is essentially "neutral", or like the sheet of paper on which their culture is written. This is not nudity, just as it would be absurd to think of a face as nude. Such neutrality expresses a lifestyle in which the body is at one with the surrounding landscape and animals.

COLLECTING FRUIT (ABOVE)

Keen to join others collecting bird-plums, two girls push through the forest. Nearby I had been photographing two women, one about four months pregnant, and two younger girls, high up above in the branches of a tree. The bird-plums, yellow in colour, were the size of a seedless grape and were collected in empty tin cans attached to the women's belts. The Himba are one of the last groups of traditional people who are generally self-supporting.

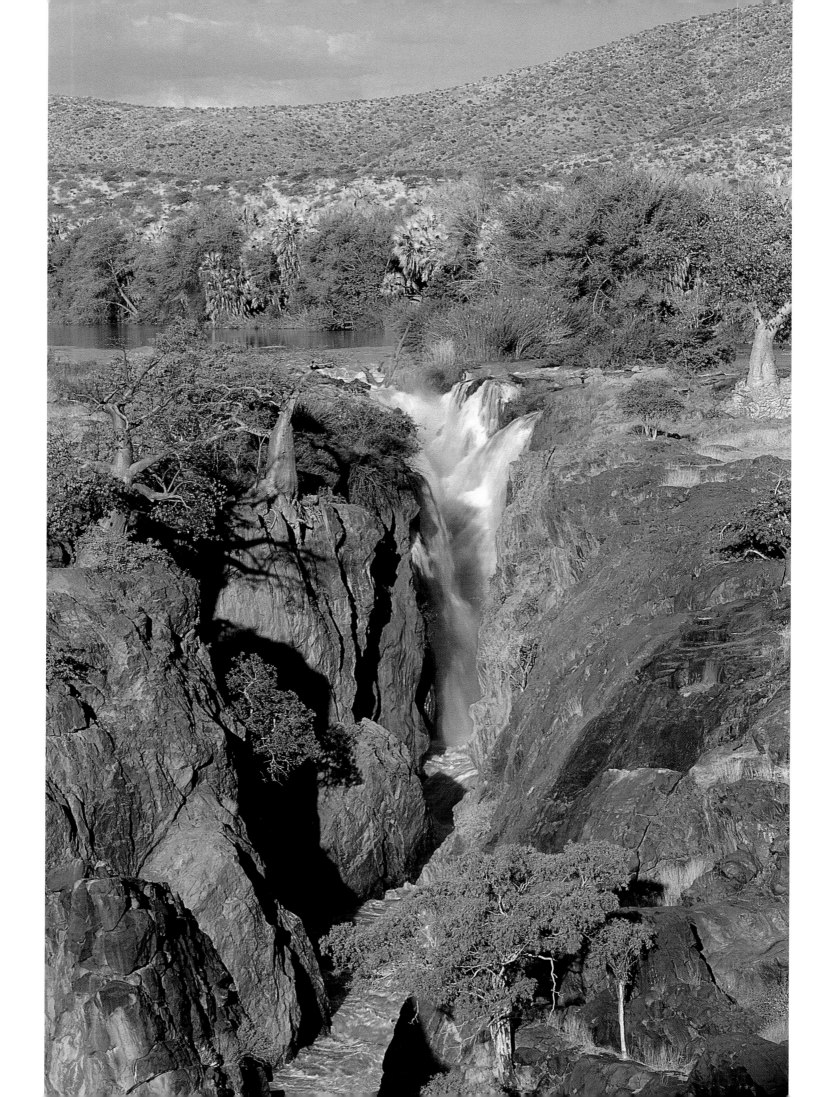

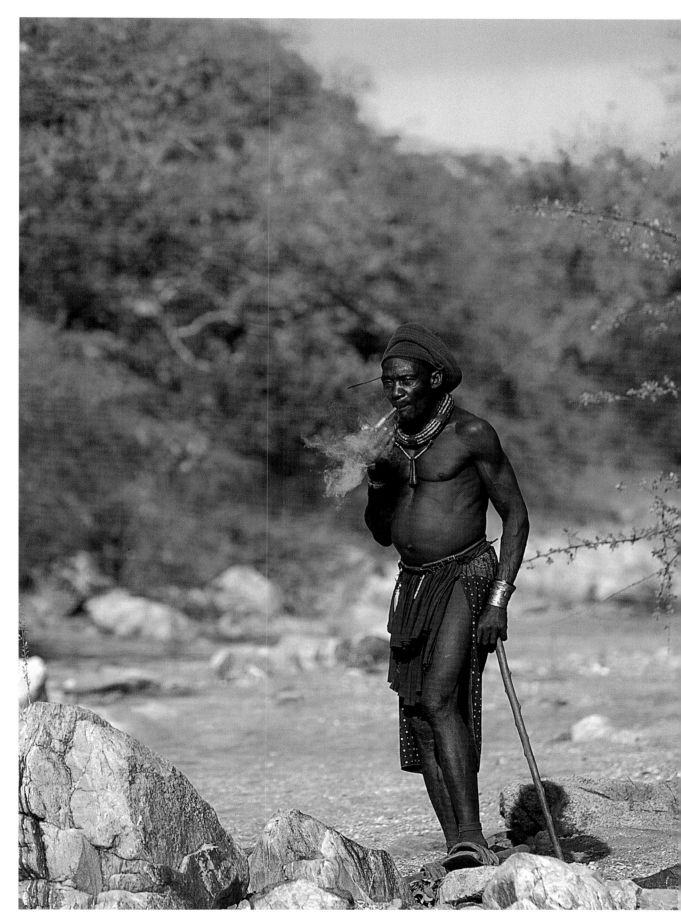

EPUPA FALLS (OPPOSITE)

"In our world a dam is a small thing that gives cattle water. What you are talking about is something else and will finish the Himba." Part of Chief Katjira Muniombara's alarm at the proposed dam on the Kunene River is that incomers will take valuable grazing land which the Himba are careful not to overuse. Himba leaders also object to the dam because it would flood hundreds of graves, which play a central role in the tribe's religious beliefs and social structure. But if the Namibian government has its way, in five years' time more than a thousand foreign workers will have settled in a temporary village just downstream from Epupa Falls.

HEADMAN (RIGHT)

Of all the fascinating Himba rituals, perhaps the most interesting is that of the holy fire, or okuruwo. *During daytime it burns in the area in front of the headman's hut, where he tends to it. On his death, both the hut and the fire are destroyed. His family dance in mourning throughout the night, and before his ritual burial everyone bids him "*karepo nawa*" meaning "stay well". Later, a fresh mapone tree stump is lit from the embers of the old fire and spiritual peace returns to the people.*

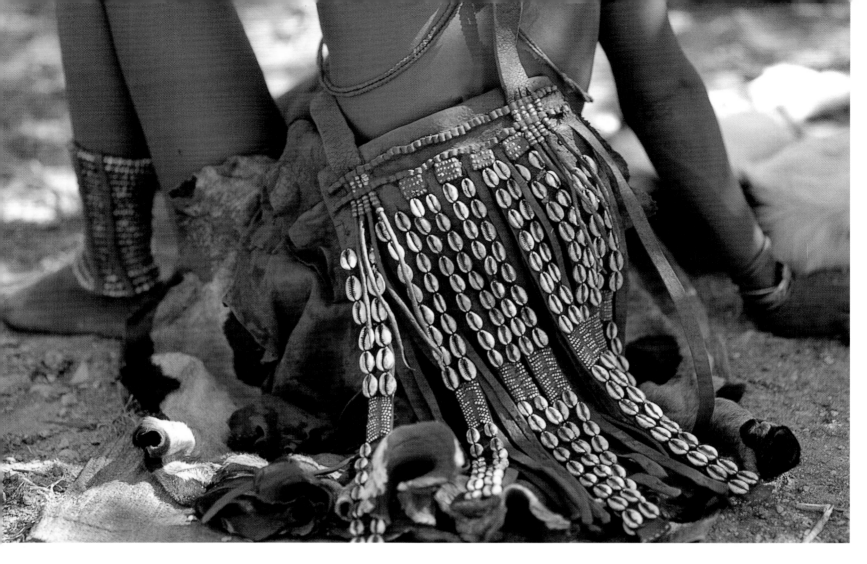

CALFSKIN SKIRT (ABOVE)
*Decorated with tiny cowry shells
and metal beads, the ochred
calfskin skirt is transformed into a
fashion garment. By preserving their
ochre-covered bodies, braids and
calfskin skirts, Himba women are
engaged in what anthropological
theory calls "change through
continuity", or "active conservatism".
Remaining apparently traditional
can be a strategic – and rational –
response to modern events.*

ANKLETS (RIGHT)
*Anklets and belts worn by women
are made from hexagonal nuts,
which are distressed and tightly
bound together by wire. Jewellery
is of particular significance to the
Himba and a key part of their
culture. Even newborn babies are
adorned with pearl necklaces.
When the children are a little older,
they are given bangles made of
beaten copper and shells.*

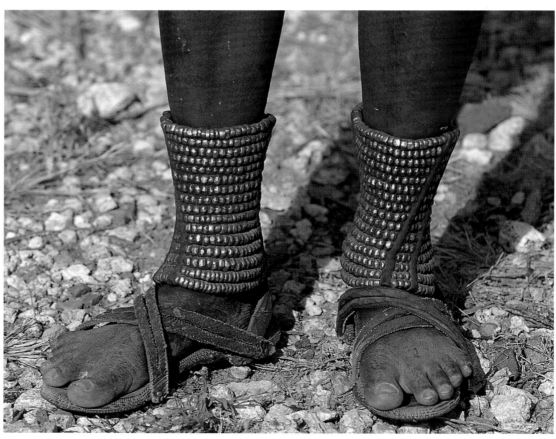

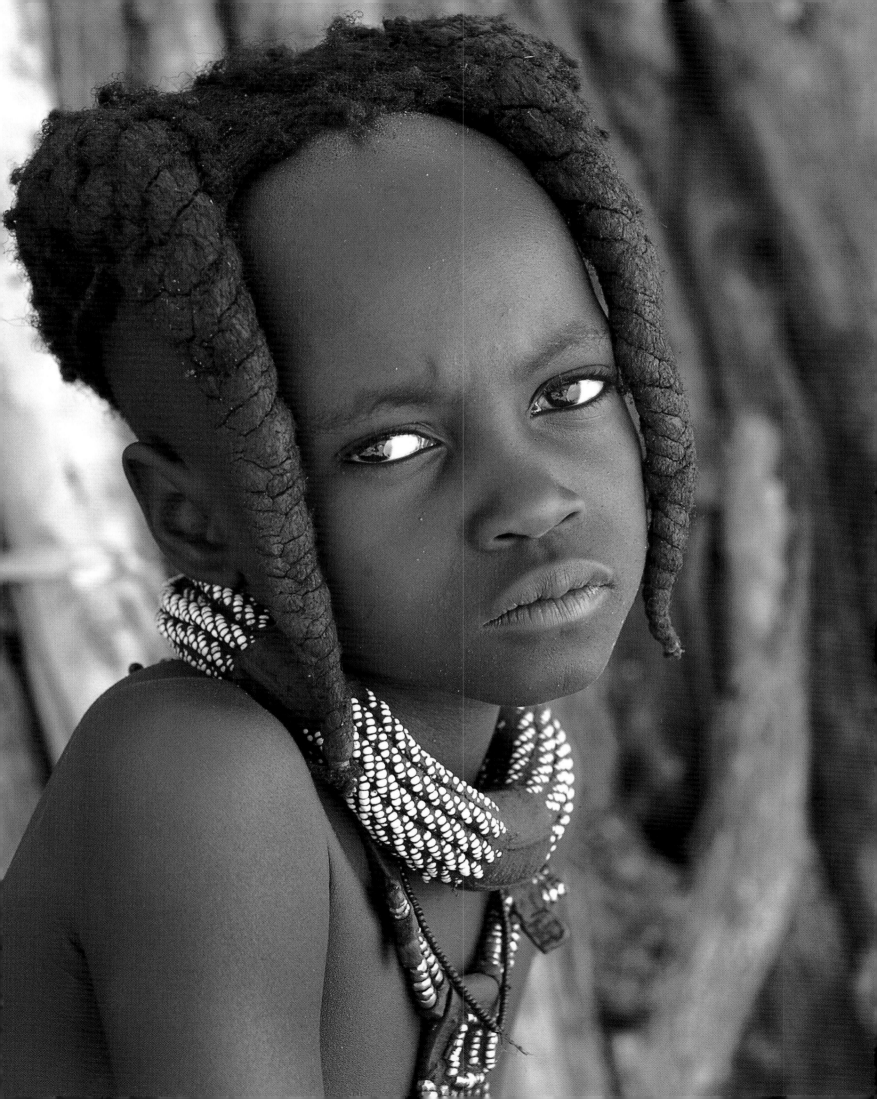

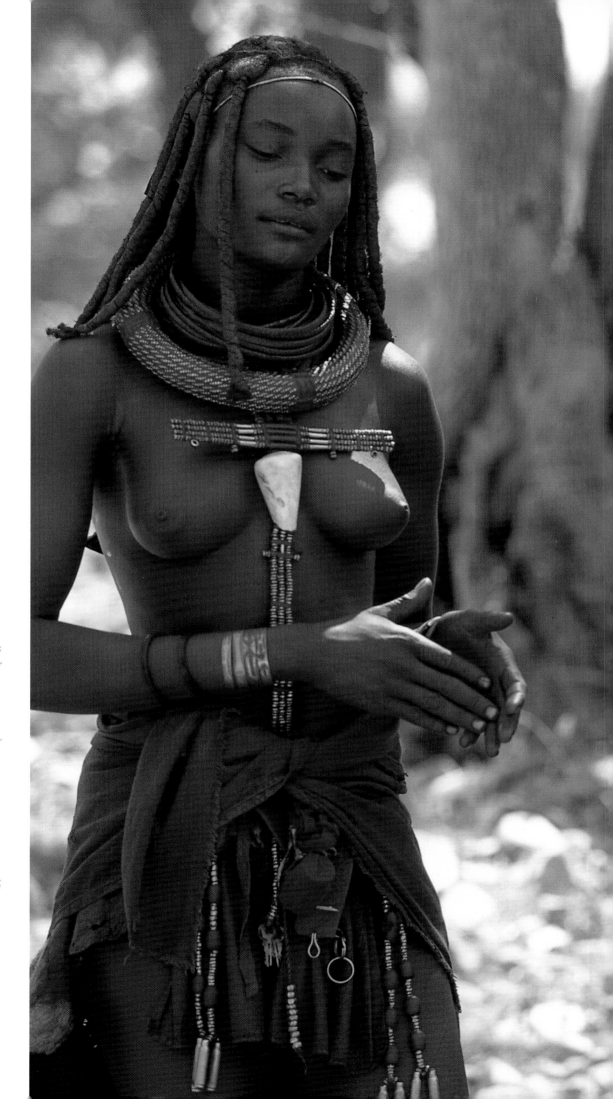

HIMBA GIRL (PAGE 27)

Within the corral, in the shadow of a hut, I photographed the headman's four-year-old daughter. Her hair was neatly plaited into the customary four braids for girls her age. Two of the thick braids hung forward over her face. When she reaches puberty, her mother will loosen her hair and plait it into dozens of braids that will cover her whole face. She will peep shyly from behind the braids until she attains womanhood. Then she will tie her hair to the back of her head, leaving her face open for the first time.

OTJUNDA (RIGHT)

In the otjunda *or "calf enclosure" dance, women form a large clapping circle. Young men and women get the chance to enter the circle and impress others with their dancing skills. The air at the homestead becomes a vibrant chaos of cheerful flirting and teasing which continues until after dark.*

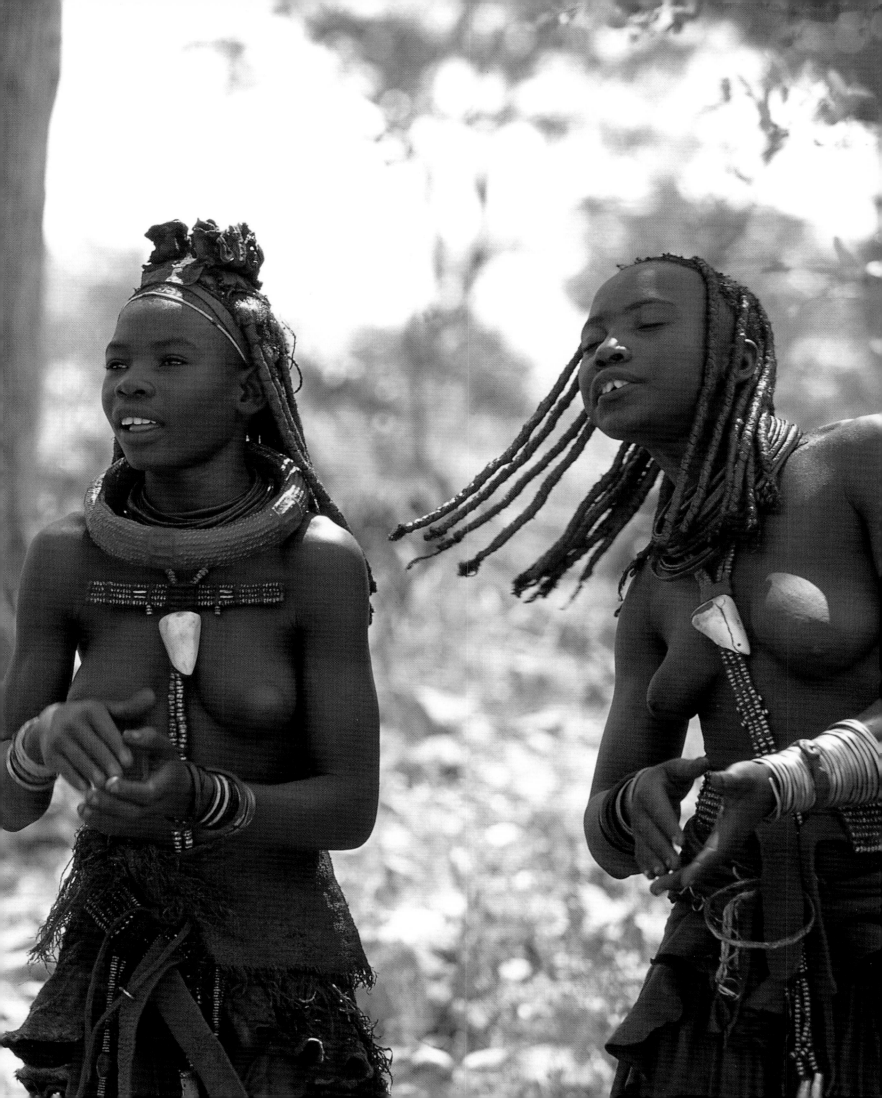

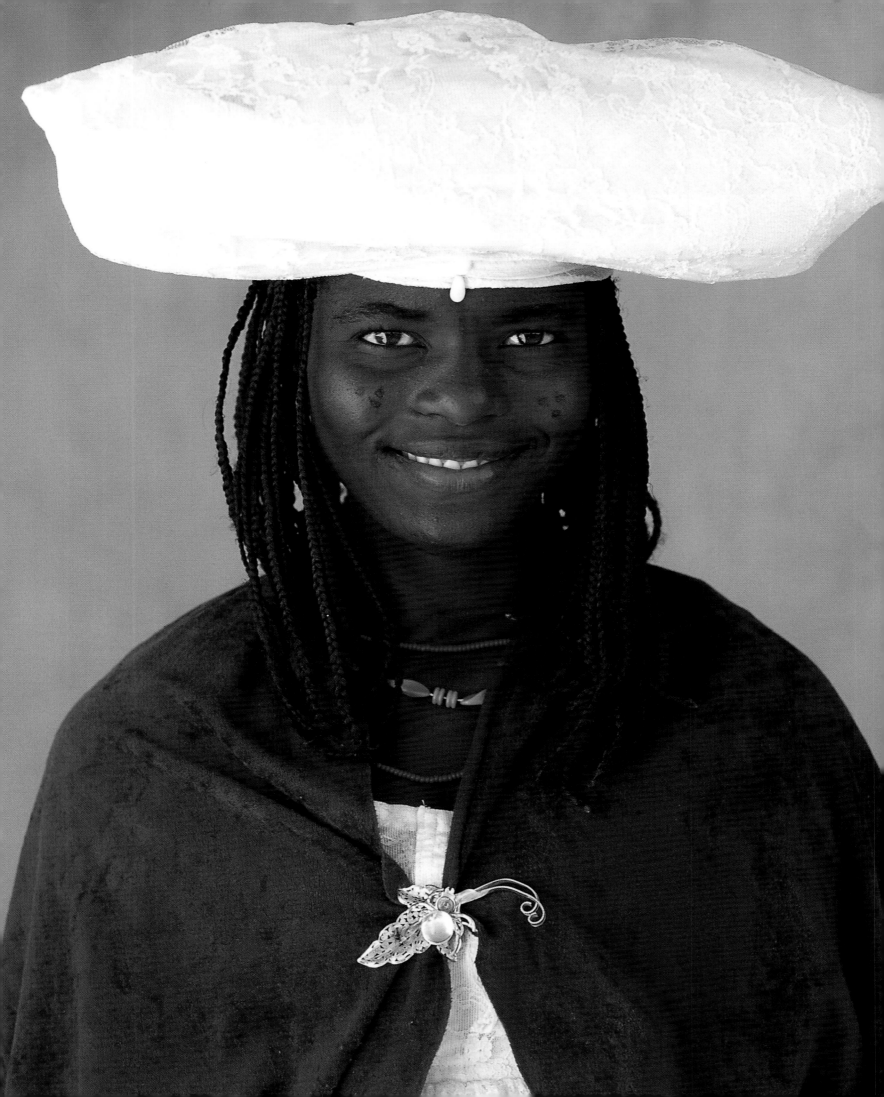

Herero

Herero-speaking peoples inhabit southern Angola, Namibia and Botswana. They comprise various sub-groups including the Tjimba and Ndamuranda groups who live in Kaokoland, the Mahereo who are found around Okahandja and the Zeraua who live around Omaruru. Ancestors of Namibia's Herero people entered the country from the north around 400 years ago. Some chose to stay in the northern region of Kaokoland – this group gave rise to the Himba. Those that moved farther south are known as the Herero.

Today's Herero and Himba share kinship, language, lifestyle, economy, land and resources. However, their different experiences in the recent past are expressed in the way they dress and in the types of houses they inhabit. The Herero are the more westernized of the two. The women wear colourful, high-necked, full-length dresses and brightly coloured horn-shaped head wraps, while the men sport Tyrolean-style jackets. These outfits derive from the arrival of German missionaries in the 19th century: offended by nudity, they encouraged the Herero to cover up.

While the initial arrival of the Germans had little impact on the pastoralist Herero, this changed after 1894 when German troops, the Schutztruppe, arrived to enforce rule. In the Herero–German war of 1904–08 this tribal society was almost completely destroyed; more than 50,000 of its people were killed in battle, lynched, shot or beaten to death. Some historians put the cause of the war down to the indigenous people rebelling against the German takeover of their land (Bley, 1971). However, more recent work studying oral histories of the Herero people suggests the export of men as labour to South African mines was a deliberate act by the Germans to weaken Herero strength before instigating the war (Gewald, 1999). In 2002, the Herero people went to court to try to gain compensation from the German government.

Today's Namibian Herero remain semi-nomadic, sometimes living in settlement communities with Himba families. Herero dwellings are square, in contrast to the Himba's round ones. Traditionally, women built them from saplings and plastered them with cattle dung and river sand. These days other materials include rubber from car tyres, plastic, cardboard and scrap metal. The term "house", or *ondjuwo*, is used when all or some of a shelter has been plastered, indicating a degree of permanence (Jacobsohn, 1988). Houses are grouped together in a camp called an *onganda*. As Herero and Himba need to move their livestock, different families make use of *onganda* at different times. However, the lifestyle of the Herero is changing. As more children attend school, there are fewer family members learning the traditional roles associated with cattle herding.

HERERO GIRL (OPPOSITE)
The Herero recognize their descent from both the mother's and father's families. Residence, religion and authority are taken from the father's line, while the economy and inheritance of wealth is passed on via the mother's clan. The Herero believe in a Supreme Being, called omukuru, *the Great One, or Njambi Karunga. Like the Himba they also have a holy ritual fire which symbolizes life, prosperity and fertility. However, the majority have converted to Christianity – the Herero church, the* oruuano, *combines Christian dogma with ancestor worship and magical practices.*

SHAWL (PAGES 32-33)
On the outskirts of Sesfontein on a barren, dusty plain, I caught a glimpse of a vibrant yellow hat and tartan shawl through the window of the Land Rover. We drove over and found this striking girl and her baby. After some conversations via a third party, she agreed to be photographed. Whilst a little embarrassed at first, she seemed to enjoy the experience – even her baby made an appearance to see what all the fuss was about. I am continually amazed by how such beauty can flourish in the face of such adversity.

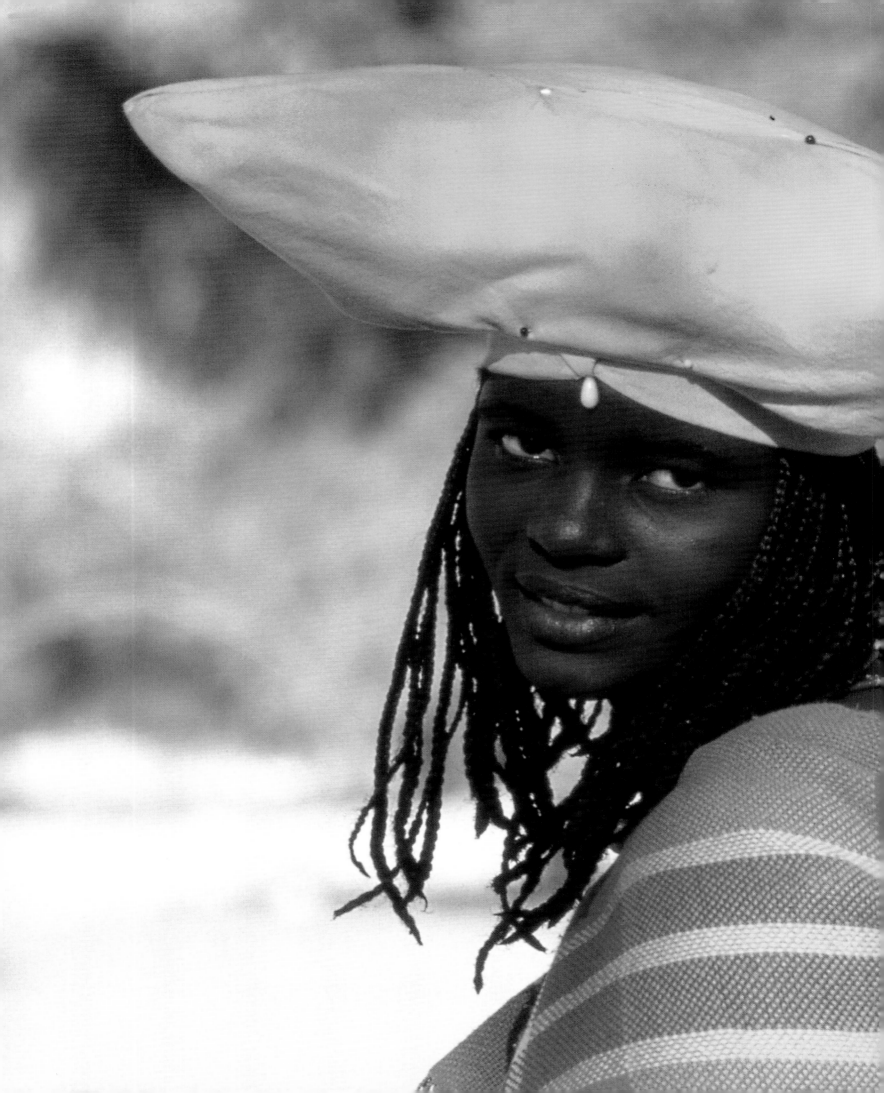

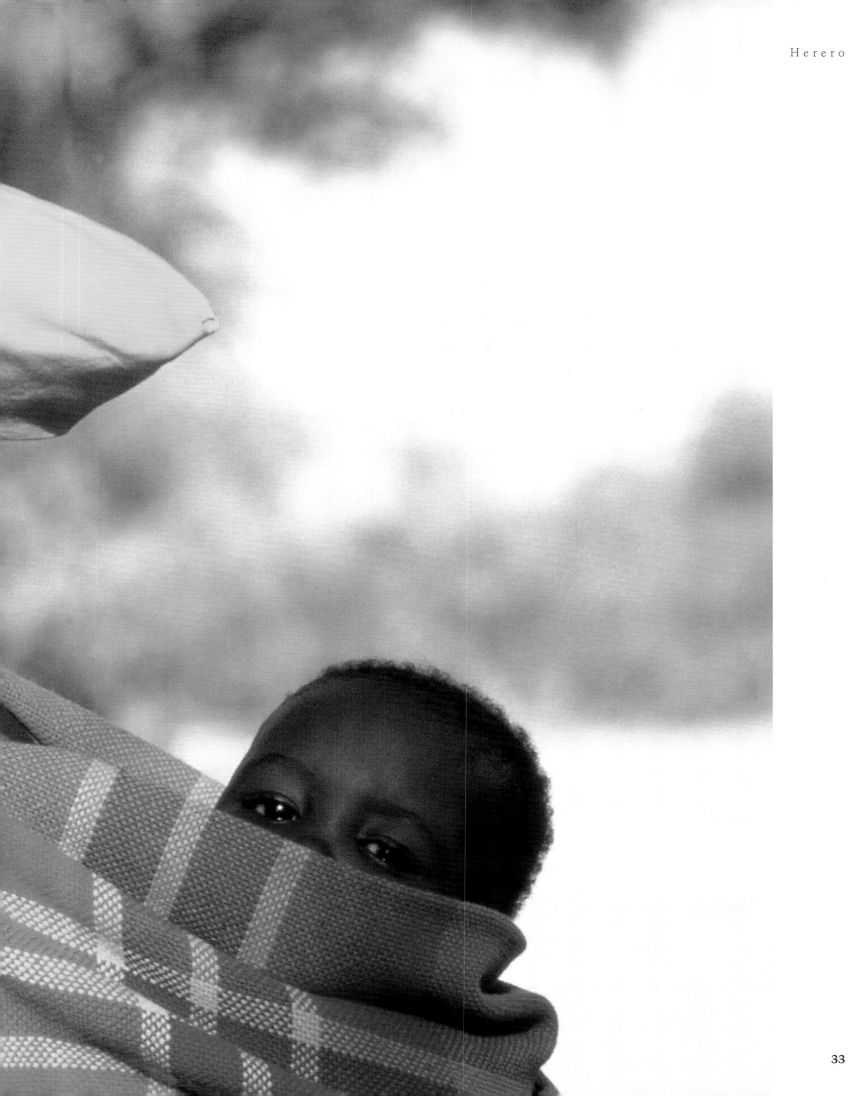

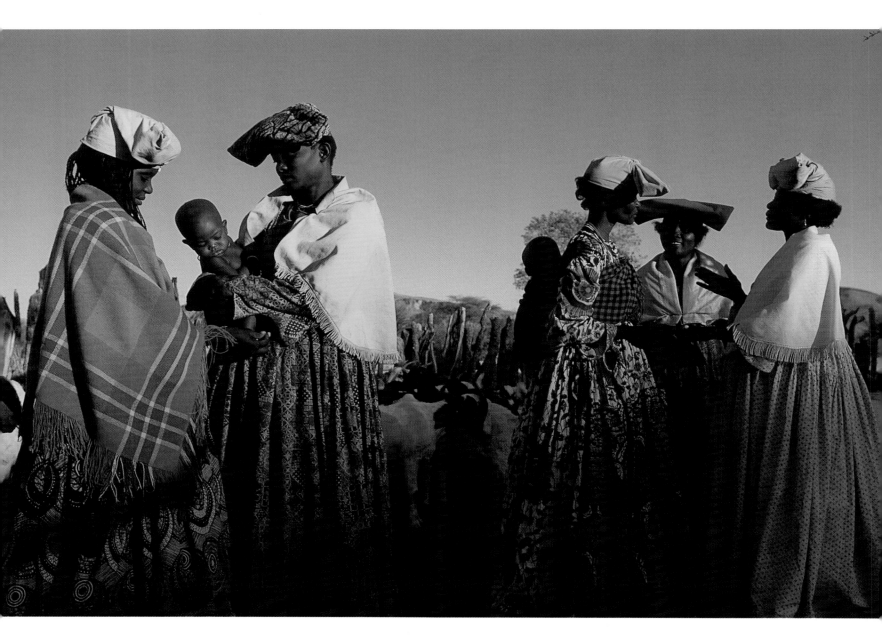

SUNDOWN IN THE CORRAL
(ABOVE)

In the last rays of the sun, women chat in the corral – the enclosure where livestock are held overnight to protect them from theft or attack by predators. Herero women wear distinctive long, flowing Victorian gowns and headdresses. Multiple layers of petticoats made from over 37 ft (12 m) of material give a voluminous look – two women walking side-by-side occupy the whole pavement. Missionaries, who were appalled by the Herero's semi-nakedness, introduced this style of dress in the 1800s.

GATHERING FIREWOOD
(OPPOSITE)

Like fetching water, gathering firewood is the responsibility of the women. These tedious daily chores are demanding in effort and time, particularly during the heat of day. For tribes like the Herero that live in precarious drought-prone environments, bilateral descent is advantageous, as during a crisis it allows an individual to rely on two sets of relatives, spread over different areas, for support.

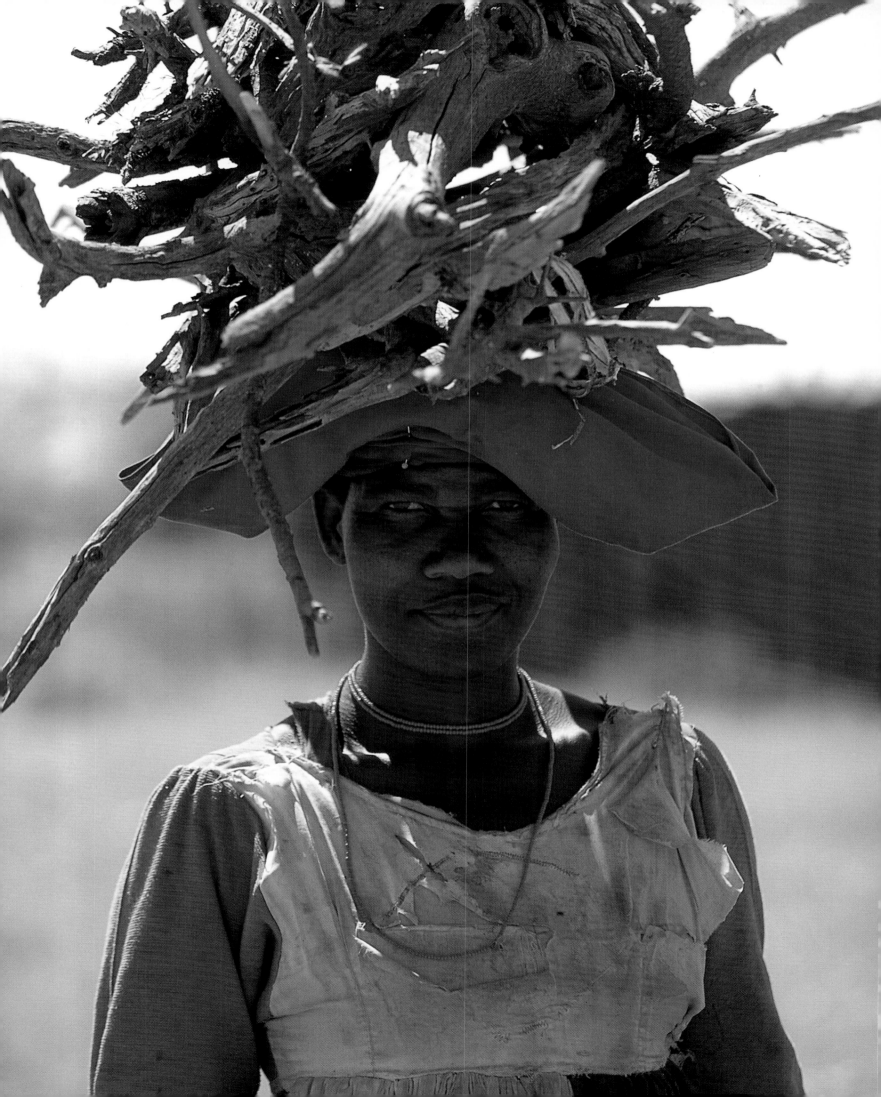

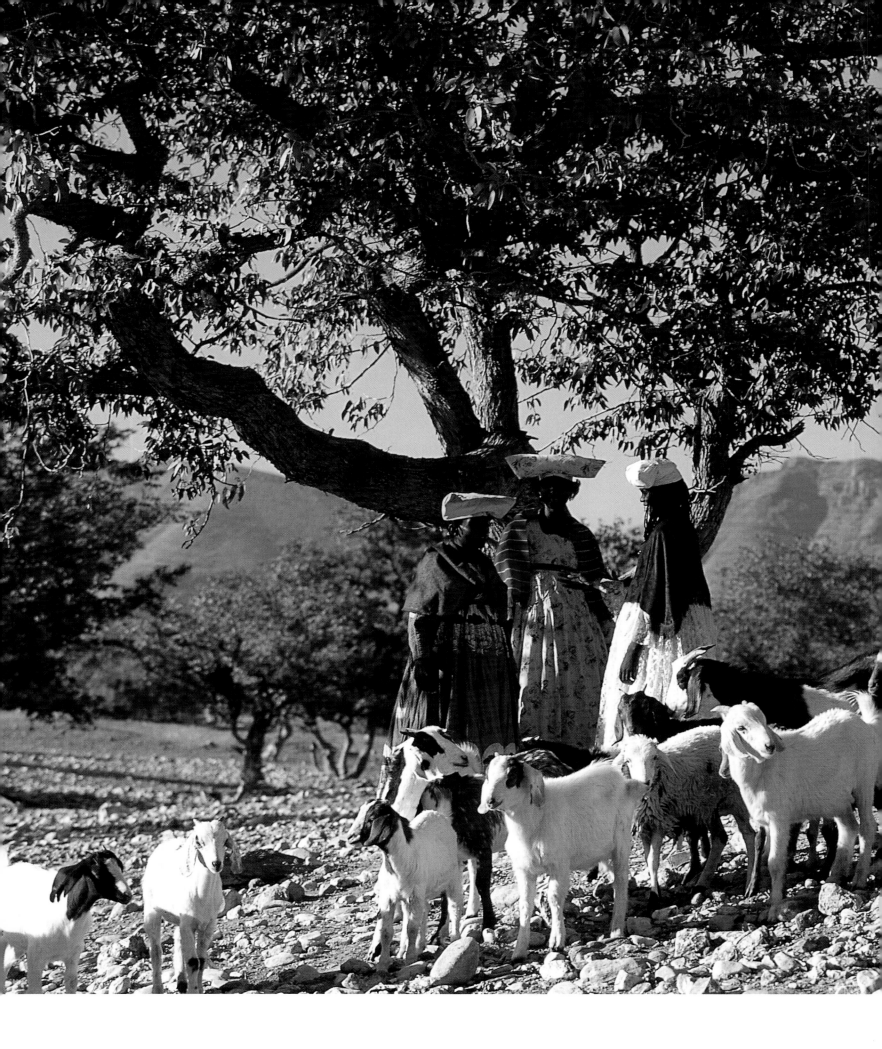

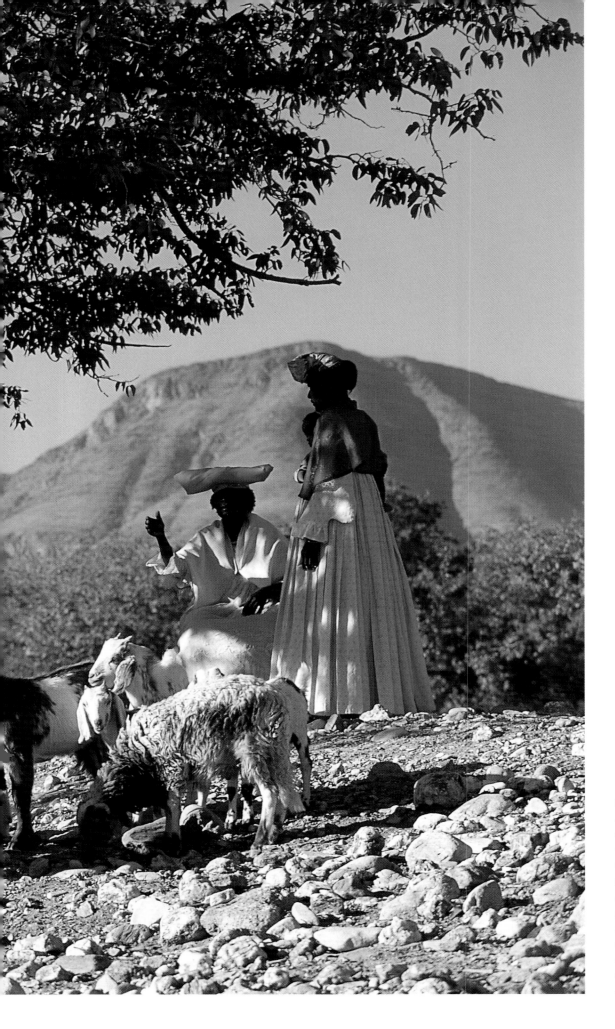

SESFONTEIN VILLAGE (LEFT)
Each Herero patriclan is led by the oldest man in the family. Sons live with their fathers; following marriage, daughters leave to join their husband's family's household and become a member of that patriclan. But the inheritance of material wealth – in the Himba's case, primarily cattle – is determined by the matriclan. Accordingly, a son does not inherit his father's cattle but his maternal uncle's.

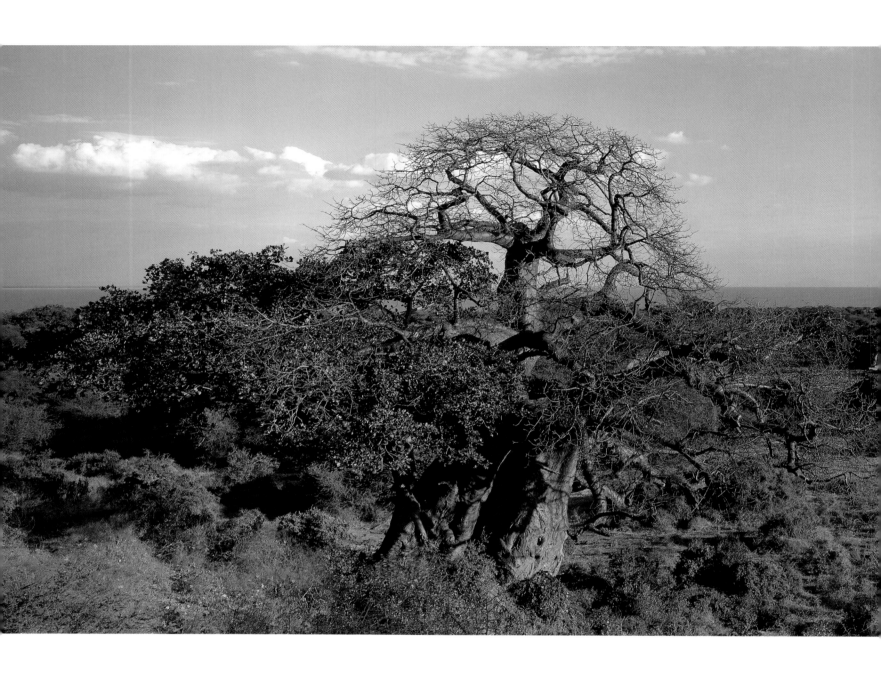

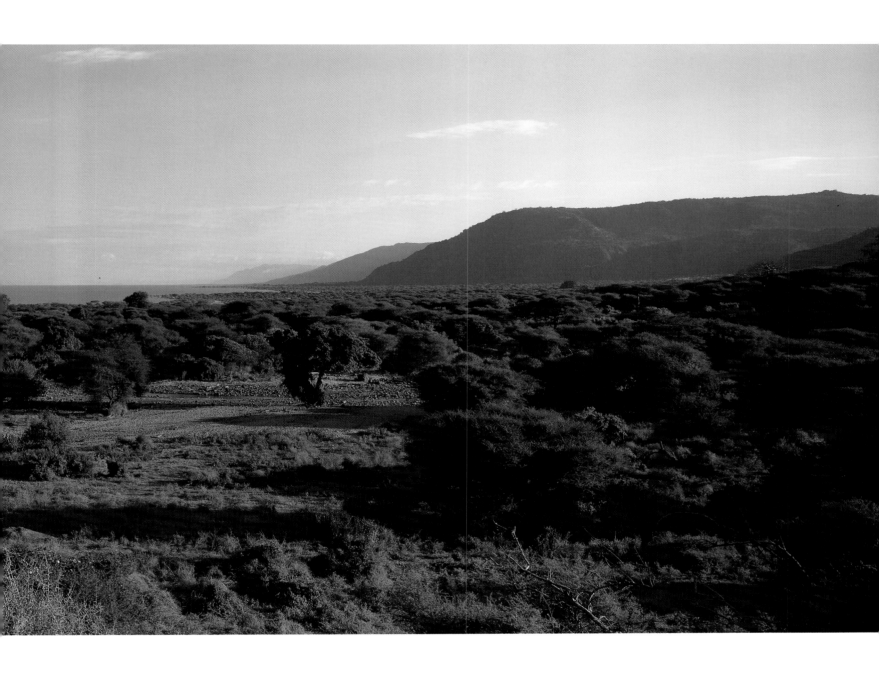

ACROSS THE DRY SAVANNAH

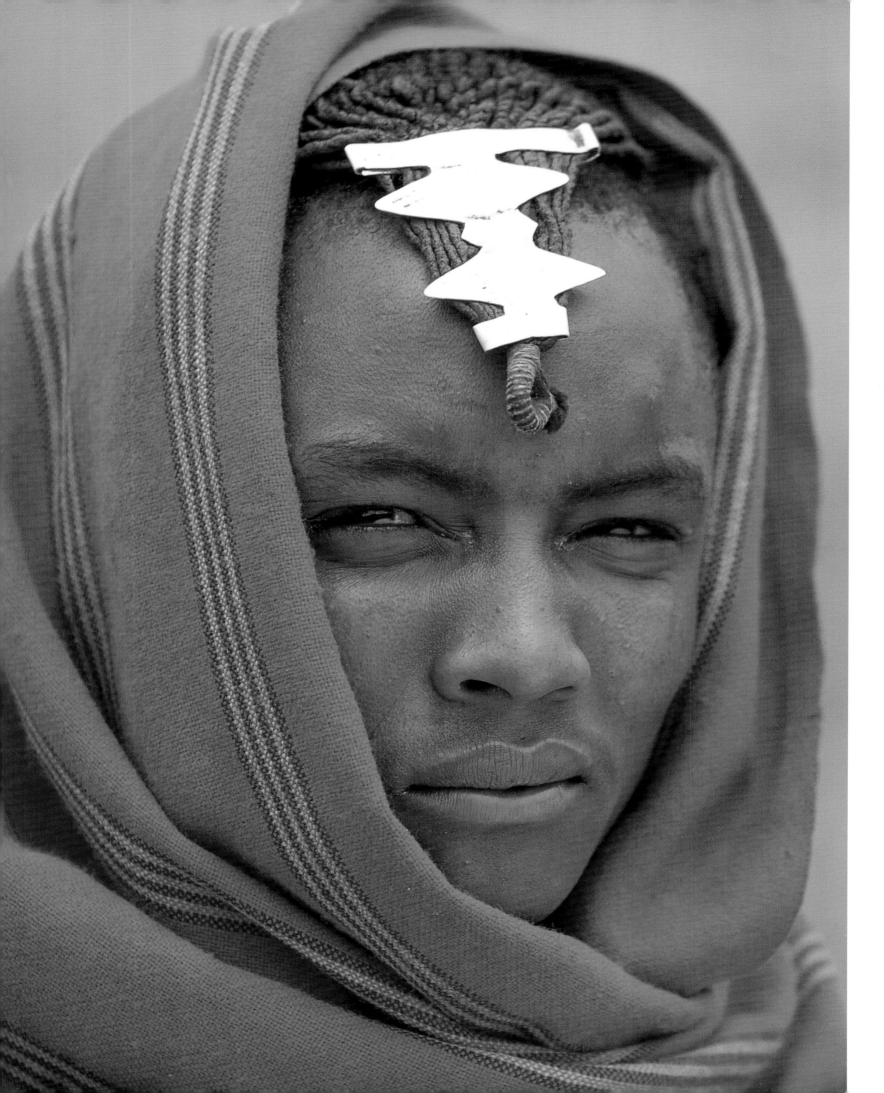

Maasai

The red-skinned, decorated warriors of East Africa's savannah have come to represent exotic Africa. The 350,000-strong Maasai have inhabited the region straddling the Kenya–Tanzania border since some time in the 15th century. Until the late 19th century, Maasai land had extended from Laikipia in central Kenya to Ugogo and Ukene in central Tanzania (Arhem, 1984). But then cholera and cattle diseases nearly wiped them out and the northern part of their land was taken over by European settlers.

Traditionally pastoralists, the Maasai moved their herds from place to place to find new water sources and let the grass regenerate, their migrations shadowing the movements of wild ungulate herds. They lived in semi-permanent camps, or *enkang*, clusters of mud and dung huts. Responsibilities were divided up according to age-set: young boys *(layiok)* tended flocks; young male warriors *(lmurran)* defended their communities and helped move cattle around; and elders *(lpayani)* used their wisdom to make decisions and guide their people (Galaty, 1981). Once a person had been a senior elder for 15 years, he would be eligible to become the *oloiboni,* a tribal leader, soothsayer, priest and prophet.

For a Maasai male, being a warrior is still something to be particularly proud of. The passage from boyhood towards warriorhood is marked by an elaborate circumcision ceremony, with all boys in one area initiated together in their early teens. As Maasai Tepilit Ole Saitoti wrote of his time as a warrior in his book *Maasai,* "We were supposed to be brave, brilliant, great lovers, fearless, athletic, arrogant, wise and above all, concerned with the well-being of our comrades and of the Maasai community as a whole."

But the lives of the Maasai have changed considerably in the last few decades. In the 1960s, the Kenyan government began converting "communal" land to private farms. Although land was allocated to the Maasai, the government wanted to shift land-use away from pastoralism and towards market-oriented beef, dairy and wheat farming (Arhem, 1984). This left the Maasai with only marginal lands; now these too have been encroached upon by wildlife parks. Some groups are battling to gain rights to their previous rangelands including sites they consider sacred at Endoinyo Ormoruwak (hill of the elders) and Entim e Naimina Enkiyio (forest of the lost child) (Survival, 1998).

Seeing the odds stacked against them, some entrepreneurial Maasai are experimenting with new areas of animal husbandry. The people of Kilonito, Elangata Wuas and Torosei are venturing into ostrich, gazelle and bee-keeping businesses. Tourism, too, is helping to bring in funds, with some Maasai running ecotourism ventures.

BAOBAB TREE (PAGES 38-39)
Lake Manyara National Park derives its name from the Maasai word manyara*, the name for a plant used for livestock stockades. The park is only 127 sq miles (330 sq km) in area – of which about 89 sq miles (230 sq km) are lake – and contains a large variety of habitats.*

NGORONGORO (OPPOSITE)
During warriorhood (lmurrano)*, males are at the peak of their physical prowess. From the moment a new warrior's head is shaven at his initiation into* lmurrano *until he becomes an elder, he will only cut his hair if his father or a close relative dies. Warriors spend hours braiding each other's hair.*

MONTH OF THE BIRDS
(PAGES 42 AND 43)
Laibartok*, circumcised initiates approaching warriorhood, wear headdresses appropriate to their status during the "month of the birds". Bands of doum palm twine form the basis of the headdress. Feathers are inserted either side above the ears, and the capes of gutted birds are attached by the beak to hang down the nape.*

Roughly one month after circumcision, at a time dictated by the lunar cycle, their passage towards warriorhood will be marked by the lmugit loungwen *(feast of the birds). On the morning of the feast day the* laibartok *wake and leave their bird headdresses in their huts. Their mothers then wear them and give feathers to other married women or their close family.*

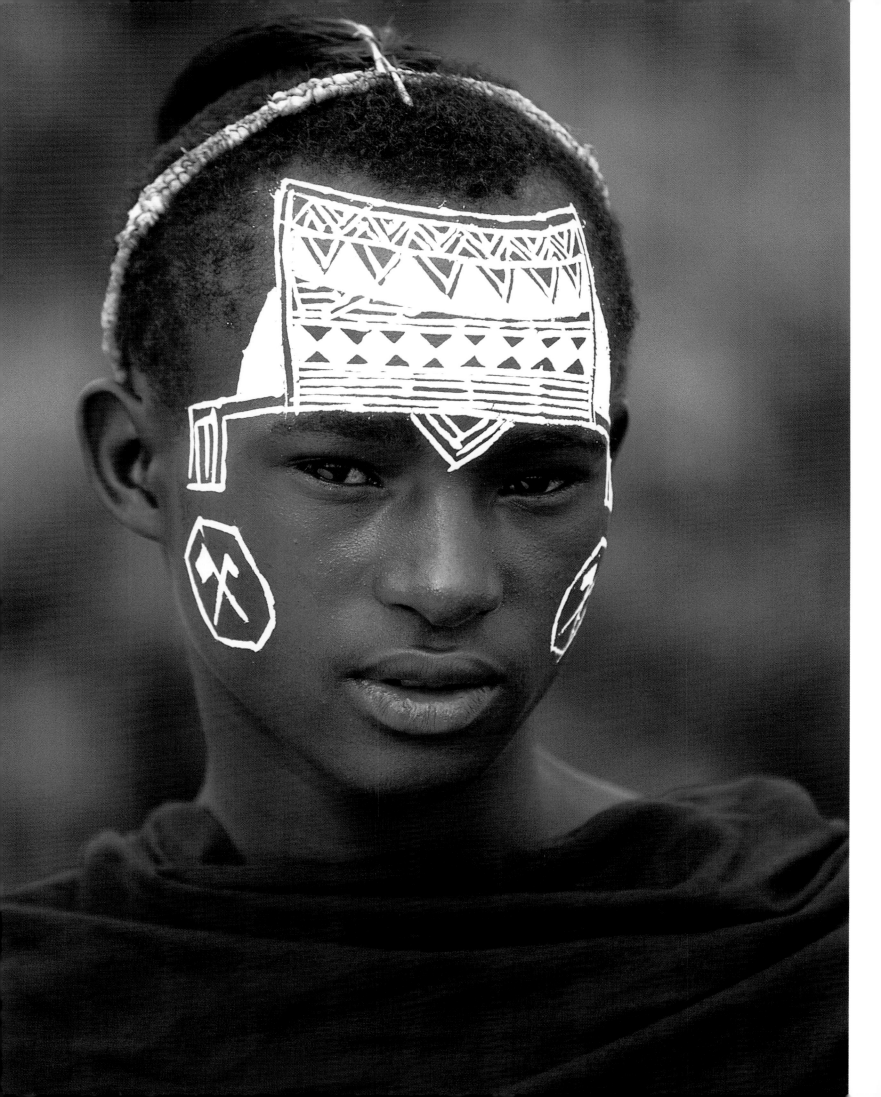

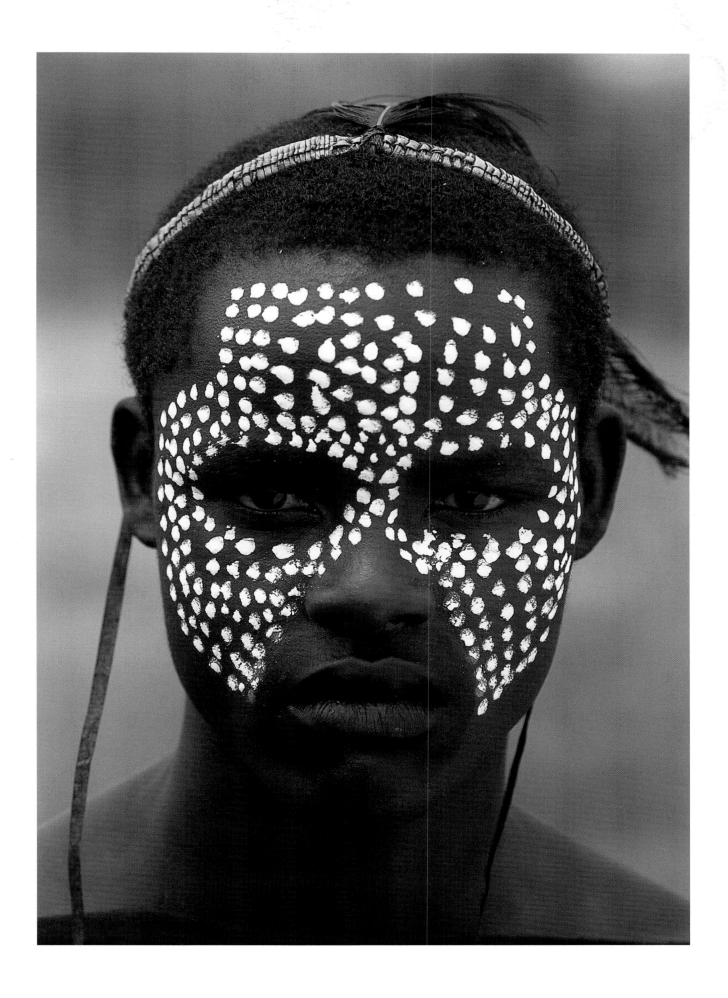

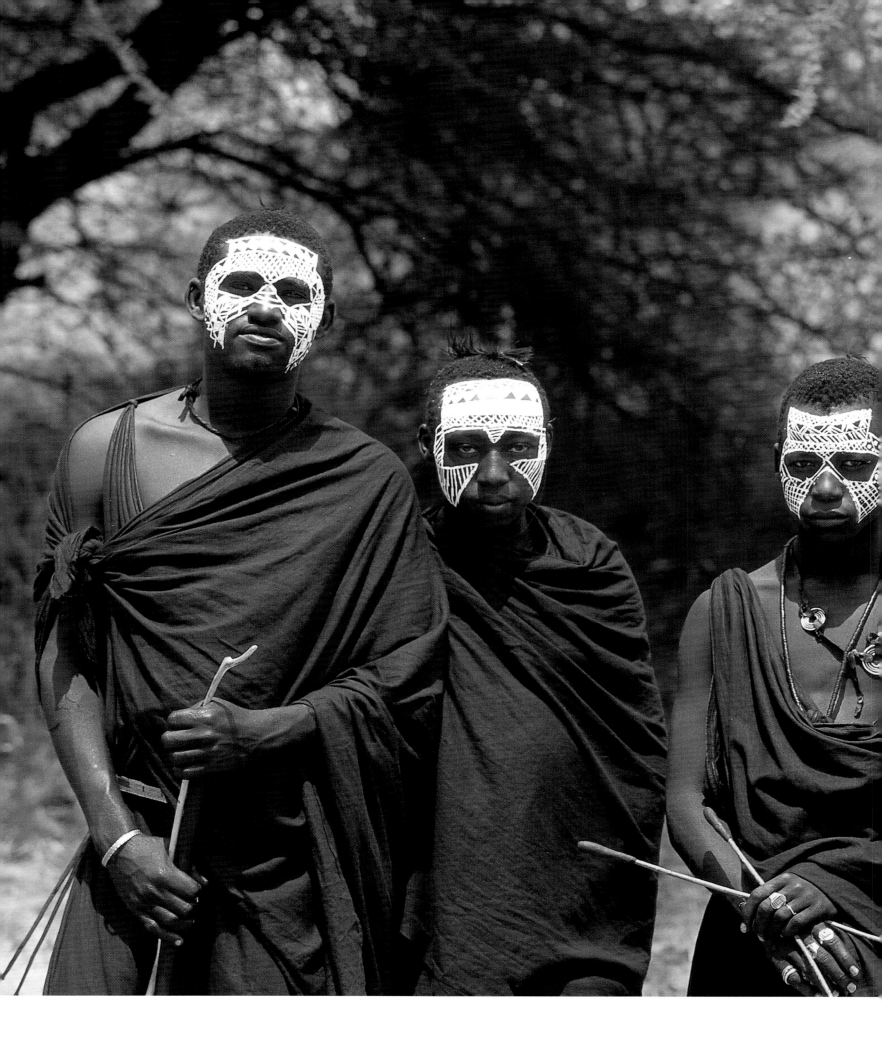

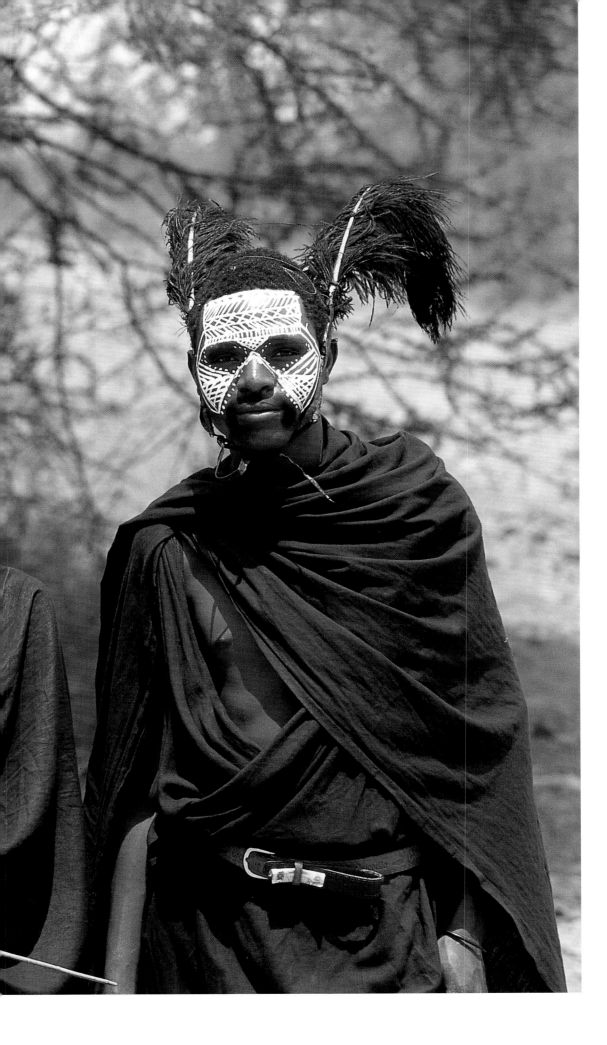

LAIBARTOK (LEFT)
The laibartok *wear black leather capes, made from sheepskin darkened with burnt cow dung mixed with sheep fat. Wet white chalk is used to decorate their faces with symbolic patterns and on their feet they wear rawhide sandals. The morning after circumcision, the elders make each boy a bow and eight arrows from sticks he collected before circumcision. With these blunt arrows the boys shoot the birds for their headdress – and at young girls. It becomes a game; the girls run and hide and if a boy manages to hit a girl she has to give him a cowry shell, which he ties around his waist.*

MAASAI WOMAN (PAGE 46)
On her way to the Sunday market at Mingingu I came across this Maasai woman with striking jewellery. Some women wear long beaded earrings which, in addition to small circular brass earrings, denote married status. These are made of hide oversewn with beads and are threaded through large holes in the earlobes made shortly before marriage.

GIRL WITH NKARAU (PAGE 47)
A Maasai woman carries a selection of nkarau *in a wicker basket. Milk, dried meat and water are carried in differently shaped* nkarau, *which are made by the women from wood, leather, or gourds. They also make small tube-like containers from hollowed branches, which they cap with goatskin and use to store tobacco, fat or a type of butter. Some families use hollowed animal horns, bones and ivory as containers for tobacco, which the elders wear around their necks.*

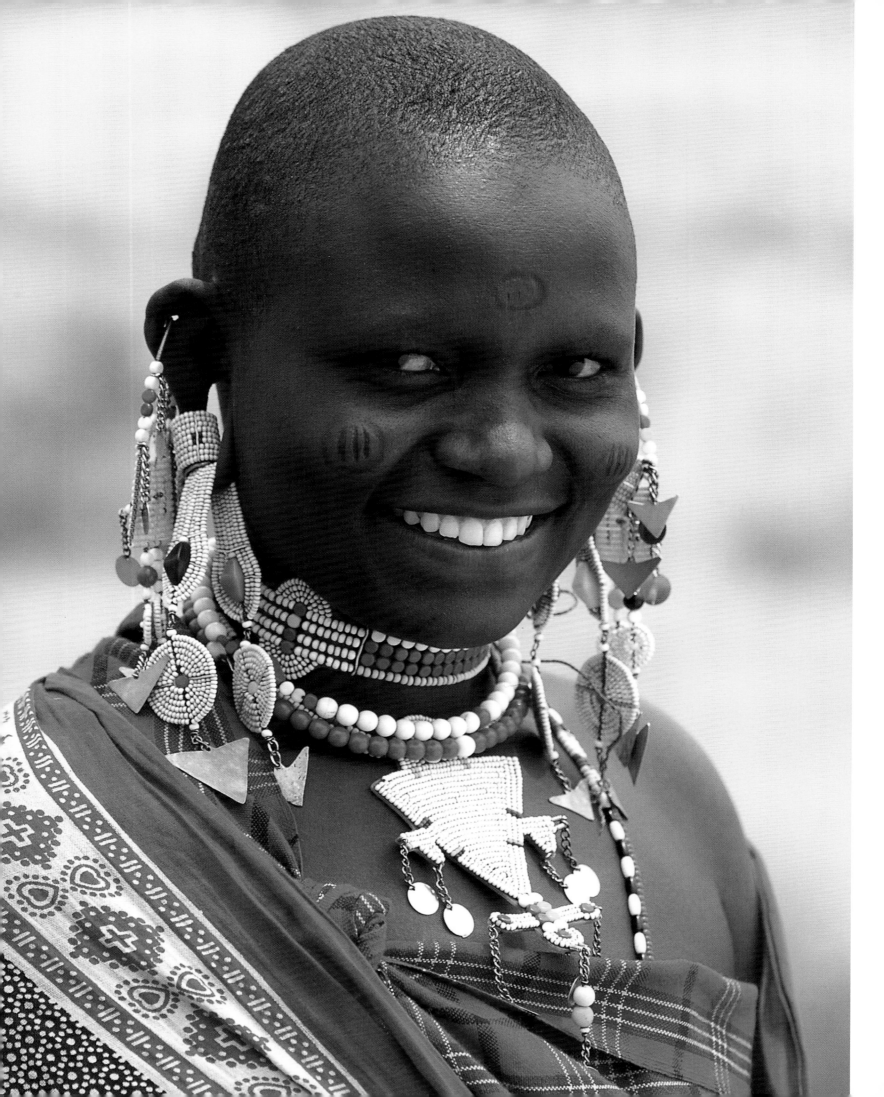

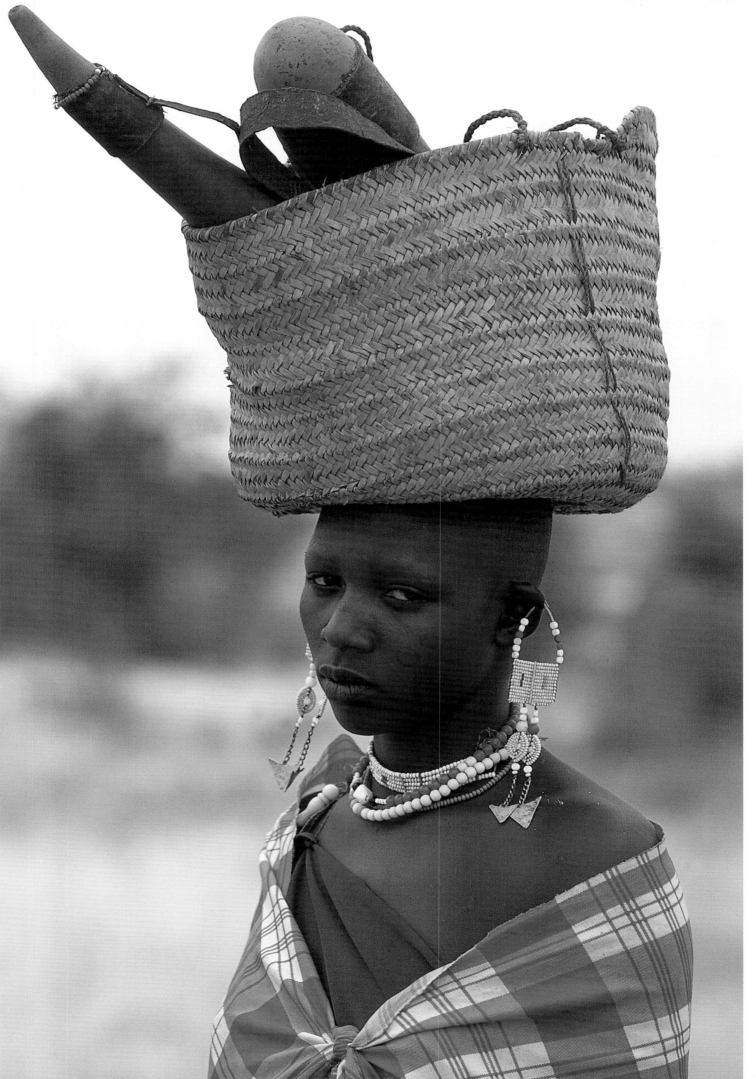

BESIDE THE JADE SEA

Turkana

The Turkana live mostly in the desert of northwest Kenya and around Lake Turkana, having moved east from the borders of Uganda and Sudan in the 17th century. They number about 250,000 and are historically divided into forest people (Nimonia) and people of the plains (Nocuro).

Turkana society is based around neighbourhoods or *adakar*. Primarily, they are cattle herders but also keep dromedary camels, fat-tailed sheep, goats and donkeys (Little, Leslie and Campbell, 1992). Helped by missionaries and nongovernmental organizations, many have settled. Some have swapped cattle herding for fishing on Lake Turkana and, weather permitting, growing crops. Failure of the rains has had terrible consequences for the tribe in the past; the prolonged drought of the 1980s killed a large number.

While their isolation has helped the Turkana maintain some traditions, they have abandoned many. For example, they no longer practise circumcision; rather the men undergo an initiation called *athapan*. The Turkana's unique concept of marriage has, however, prevailed. It involves the kidnapping of the woman (agreed by both partners in advance) but made to look real. The alliance is only ratified after several years, once the first child is weaned.

Many Turkana continue to wear their traditional dress. It's not unusual to see Turkana wearing western clothes while working in town, later reverting to their tribal regalia. The women wear leather skins and skirts adorned with strings of multicoloured beads. Unmarried girls wear an *arrac*, a triangular leather apron decorated with chipped ostrich eggshells and beads. Perforation of the ear lobes is still common, and many women also wear a lip plug. At special occasions the men decorate their hair with feathers and sport a blue-painted cap. Despite the heat, they drape a woollen blanket around their shoulders. Tattooing is still common; historically men were tattooed on their right shoulder each time they slayed a male enemy and on the left when they killed a woman.

The Turkana have always been renowned for their bravery in fighting. Cattle rustling has repeatedly taken place between rival tribes but today's raiders are armed with assault rifles and the aggression has taken on a new ferocity. In 1996, the army was forced to intervene in a clash between Turkana and Samburu tribesmen. An influx of refugees from conflicts to the north, south and west has put pressure on the region's scarce resources, a situation exacerbated by the poor state of the Kenyan economy.

THE JADE SEA (PAGES 48-49)
A seemingly endless drive through lava fields, punctuated by isolated leafless trees and solitary acacias, terminates on the shores of Lake Turkana. In saline pools, feeding flamingos contrast vividly with the turquoise waters of the Jade Sea, beyond which lies the South Island National Park. As we continued along the path towards Loyangalani, Turkana men in the shade of tall doum palms lifted their gaunt angled faces to watch us.

APENYO LOKITO (OPPOSITE)
In a region where the annual rainfall is seldom over 2 in (50 mm) and temperatures, though mitigated by the wind, reach 113°F (45°C) and more, Apenyo Lokito had just walked for two days to take food to family members grazing donkeys some distance away. Aged 18 with a baby of 17 months, her healthy complexion is testament to the resilience of the Turkana people. Later that evening we saw her dancing with her friends and family.

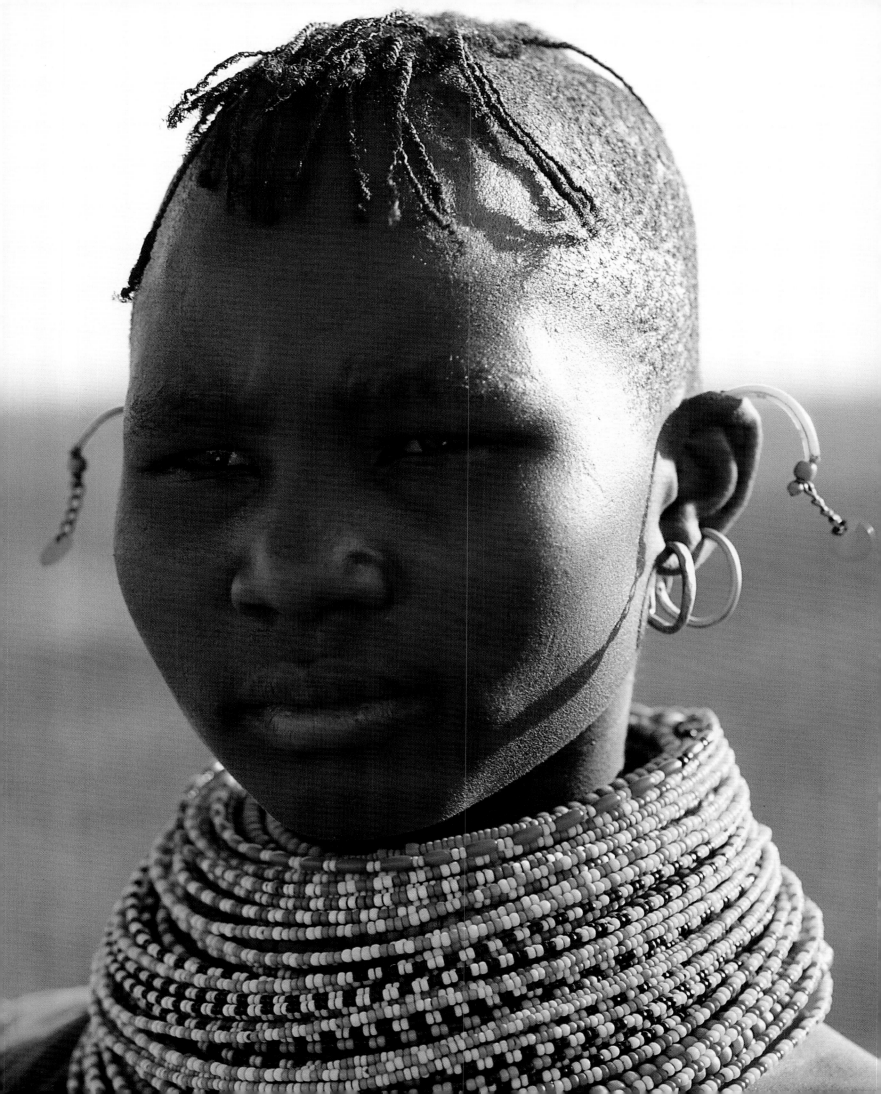

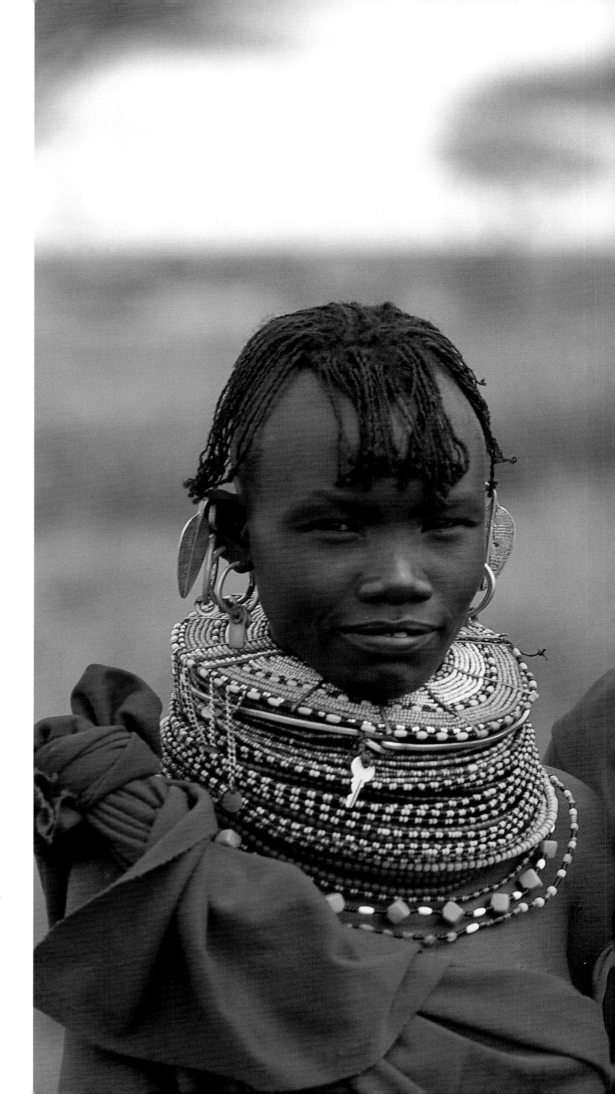

OBOLIO (RIGHT)

Originally made from chipped ostrich eggshells, the characteristic beaded necklace worn by many Turkana girls is called the obolio, *around which a neck ring of brass or aluminium, known as an* alagam, *is worn. Earrings called* aparaparat *are fashioned from brass and copper or from aluminium cooking pots if there is a scarcity of metals. In my naïveté, I asked the purpose of the keys worn around the girls' necks. Their bemused reply was as much a surprise to me as the question had been to them. "For our front doors". Their homes are entirely made from the leaves of the doum palm.*

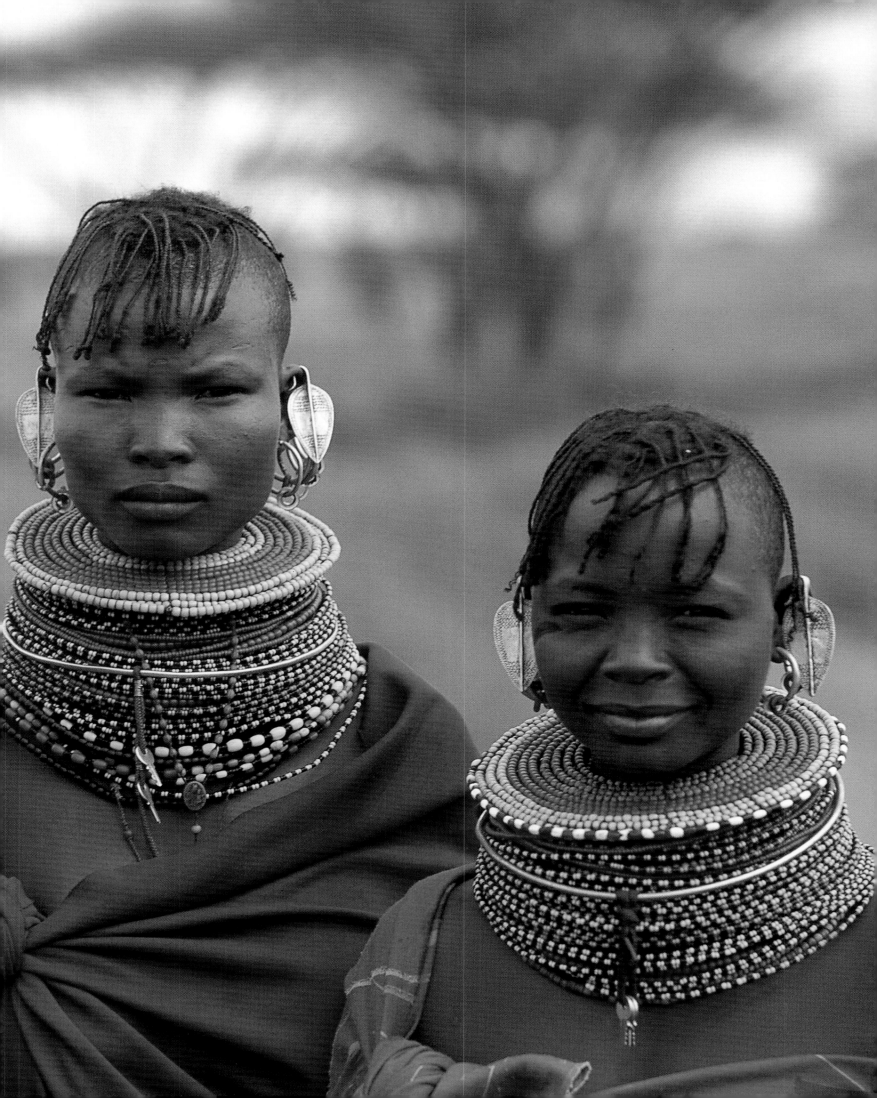

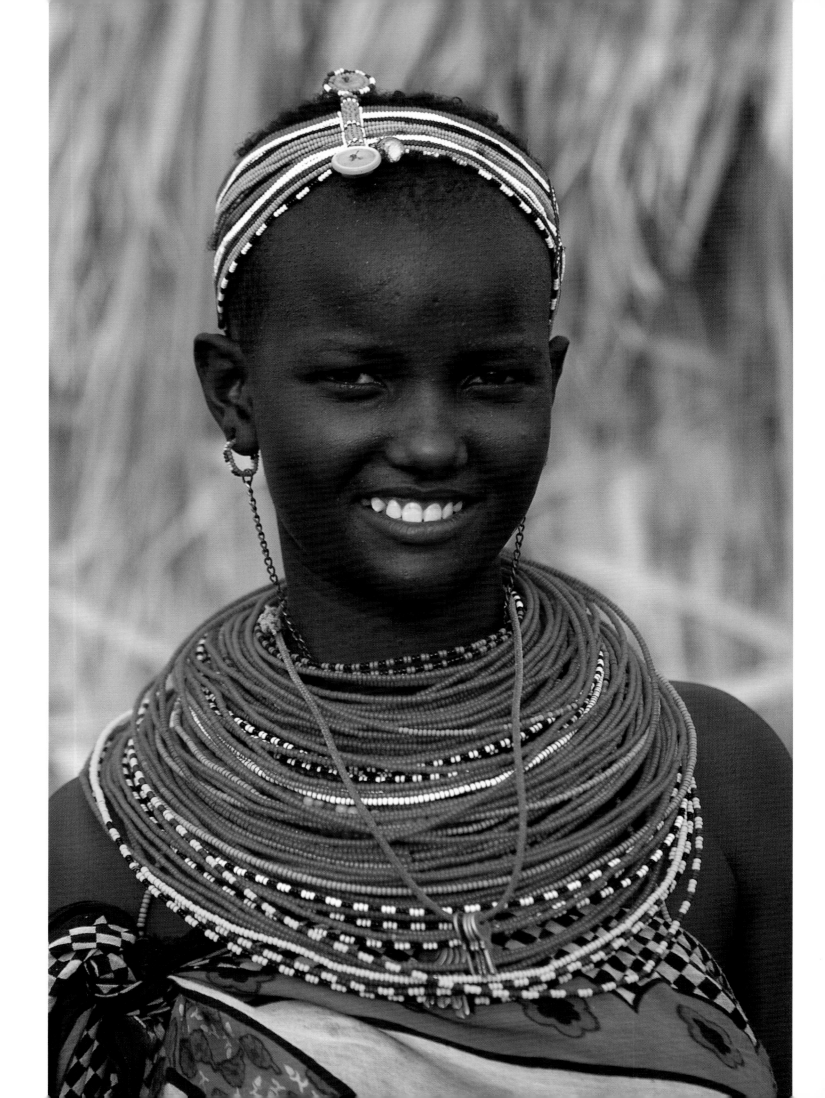

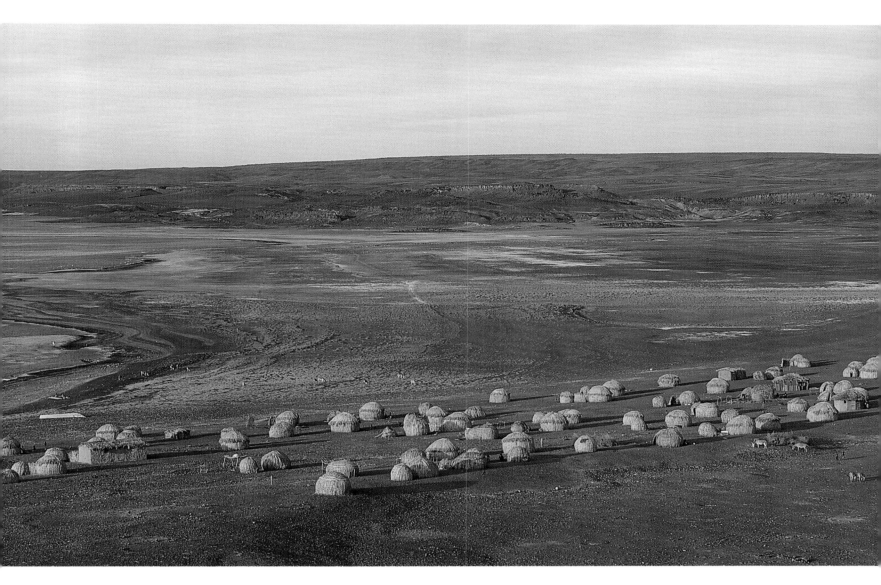

EL MOLO GIRL (OPPOSITE)
In the shade of her home a young El Molo woman pauses from carving a calabash from doum palm. The calabash, a container used to store milk or blood, is sterilized with smouldering wood ash which infuses a smoky character to milk. Women are expected to fetch water, cook, attend to the needs of the children and collect firewood. The male day by contrast is usually spent playing ajua – *a primitive board game with stones.*

LAYENI (ABOVE)
Originally inhabiting an island near to Loyangalani with a few goats, subsisting on fish, crocodile and hippo, the 500-strong El Molo people are partly integrated with the Turkana. The El Molo villages of Layeni and Kelote have around 50 domed huts of doum palm randomly arranged facing the lake. Despite their tiny number, they manage to retain their own culture in the face of the Turkana's dominance, and consider the Turkana to be poorer fishermen.

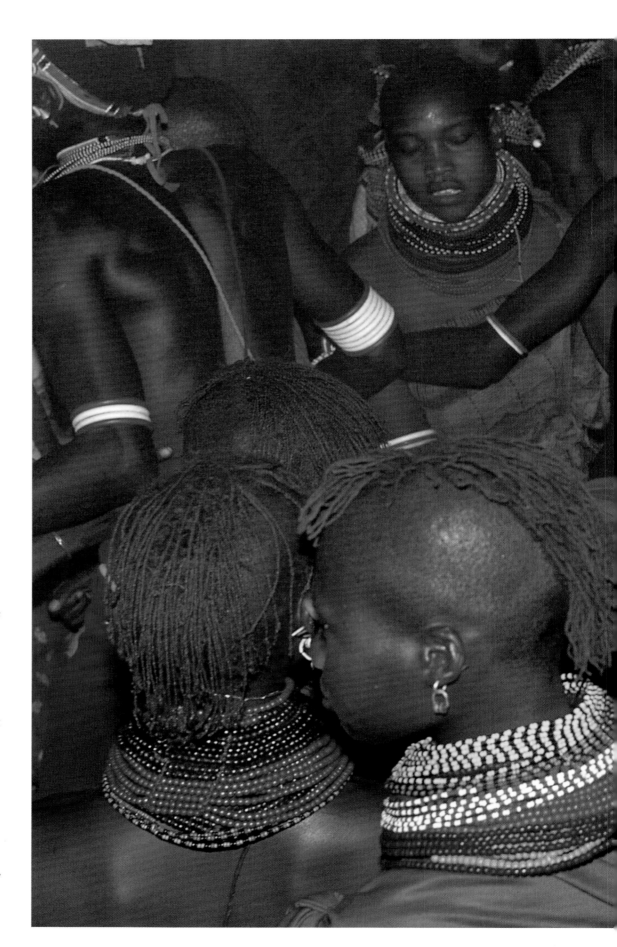

TRIBAL DANCE (RIGHT)
Without the aid of musical instruments, some 80 tribe members enjoy ritual chants and dances — some of the men wearing bells bound in a leather pod fastened to their knees with buckles. A combination of voice, rhythm and bells produces a heady atmosphere with great excitement and posturing by both sexes. The blend of remoteness and music transported me momentarily, an instant I will never forget.

FEATHER (PAGES 58-59)
Men sport ostrich feathers in their hair at the dance. This practice is common among Turkana men on special occasions and is traditionally combined with the wearing of an ostrich skin cap over the hair which is painted blue.

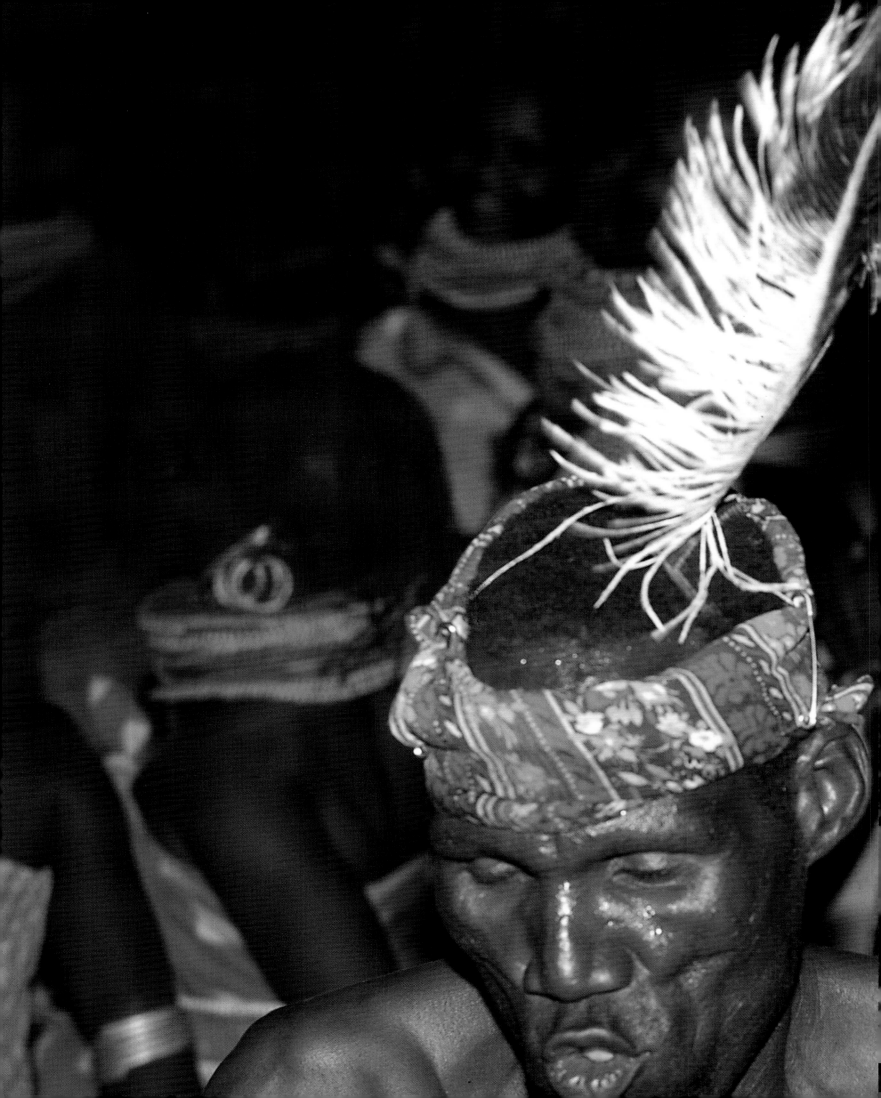

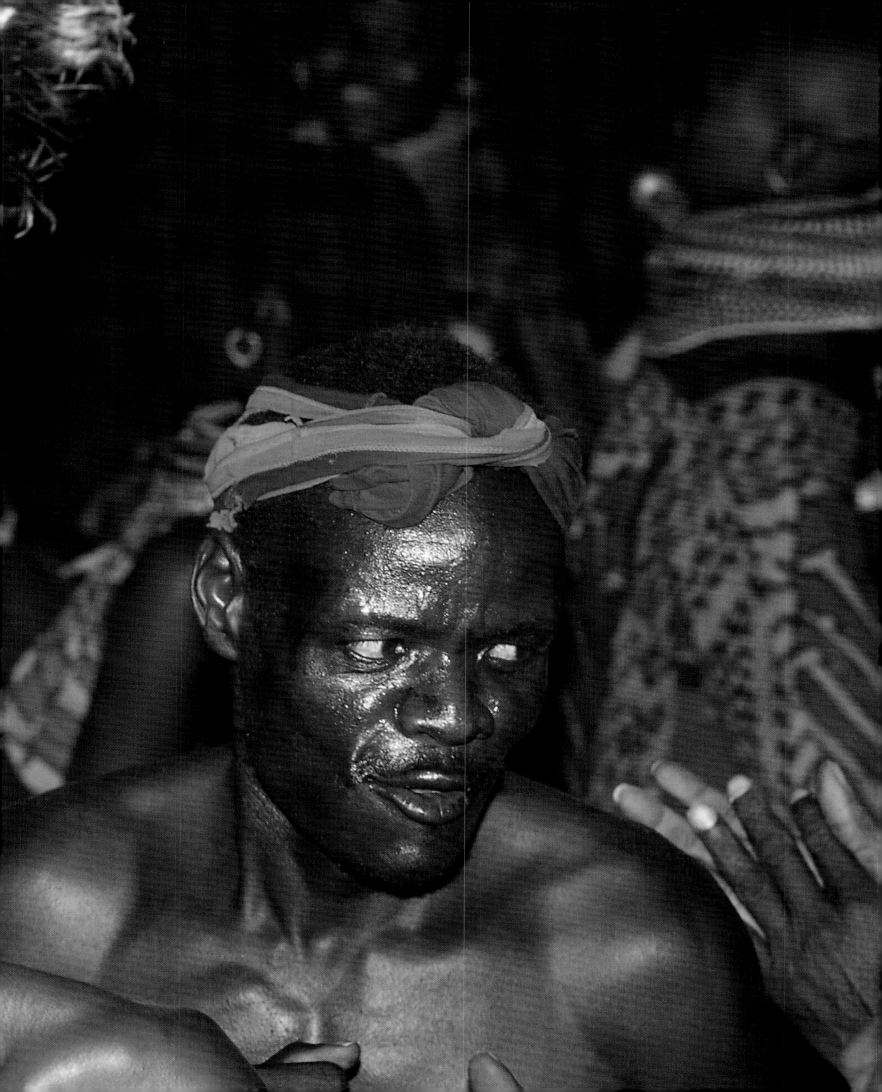

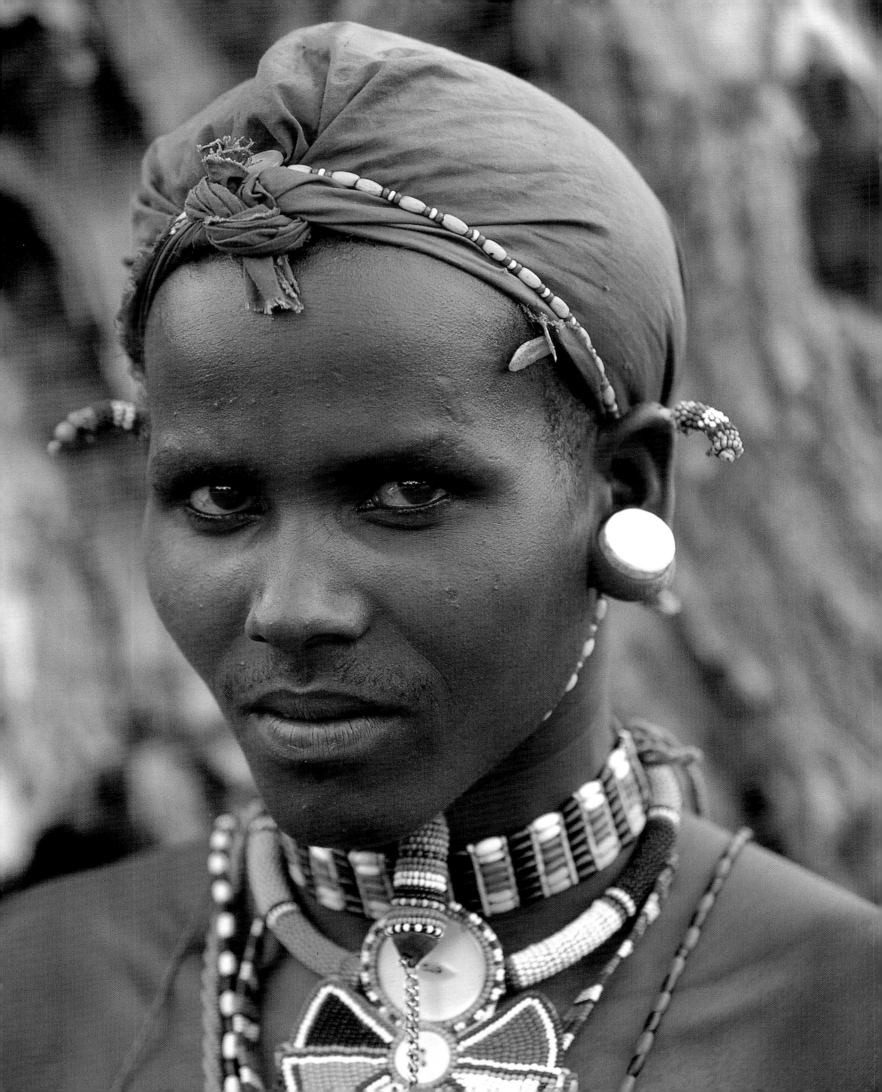

Samburu

Like the Maasai, the Samburu speak Maa and live in Kenya. However, their ancestors did not travel as far south as their tribal cousins, settling instead to the south of Lake Turkana. Today they inhabit Samburu District, where Kenya's forested highlands give way to scrub and grass-covered lowlands plains. They are neighbours with the Rendille and Turkana and dress similarly. The women wear huge collars of beads and the men sport bead fringes to shield their eyes from the sun (Kennett, 1994). Sometimes these decorations extend to a swag below the chin.

The Samburu have historically had a good relationship with the Rendille. Years of intermarriage and intermigration have forged strong kinship and political bonds, and in times of hardship the two tribes have shared land and livestock. Samburu links with the Turkana, however, have been less positive. Historically they have viewed each other as enemies and raided each other's herds. The Samburu, who circumcise their men and women to initiate them to adulthood, find it odd that the Turkana have no such ritual. The Turkana's liberal food habits (eating fish as well as meat) and their position as menial labourers in Samburu towns have further widened the cultural divide.

The Samburu have a healing tradition which separates illnesses caused "by God alone" *(nkai openy)* from those caused by the malicious forces of sorcery sent by a human enemy *(nkuruporen)*. Curing an illness prompted by God alone requires a visit to the local herbalist or western health clinic. An ailment linked to sorcery, however – for example, infertility, insanity or death in unusual circumstances – demands a consultation with the *laibon*, a diviner and healer who will prescribe a ritual medicine. Both the Samburu and Maasai make great use of herbal medicines. The Samburu use over 120 species of trees and shrubs, many of which are toxic and are used to purge the body of polluting influences (Fratkin, 1996).

Until the 1960s, the Samburu were successful cattle breeders, but in the following years their herds were decimated by raids, drought and disease. The 1971 drought, recalled as "the Terrible Hunger", was particularly destructive, as was that of 1979–80. In 1980, the Samburu District Development Plan estimated that 50 percent of the population should qualify for famine relief, with 10 percent being virtually destitute (ROK, 1980). With cattle rearing no longer a secure way of life, families began supplementing their herds with camels which can produce milk long after cows have run dry. Today, many keep camels, but may also seek wage-paying jobs in order to send one or two children to school (Sperling, 1987).

LMURRAN (OPPOSITE)
All lmurran *(warriors) wear ivory earplugs in the stretched holes in their earlobes. As little as two* laji *(age-set) ago, they would find ivory lying in the bush, but nowadays, as a result of poaching, few elephants die of natural causes. Warriors who have become elders now pass on their earplugs to their brothers or male relatives.*

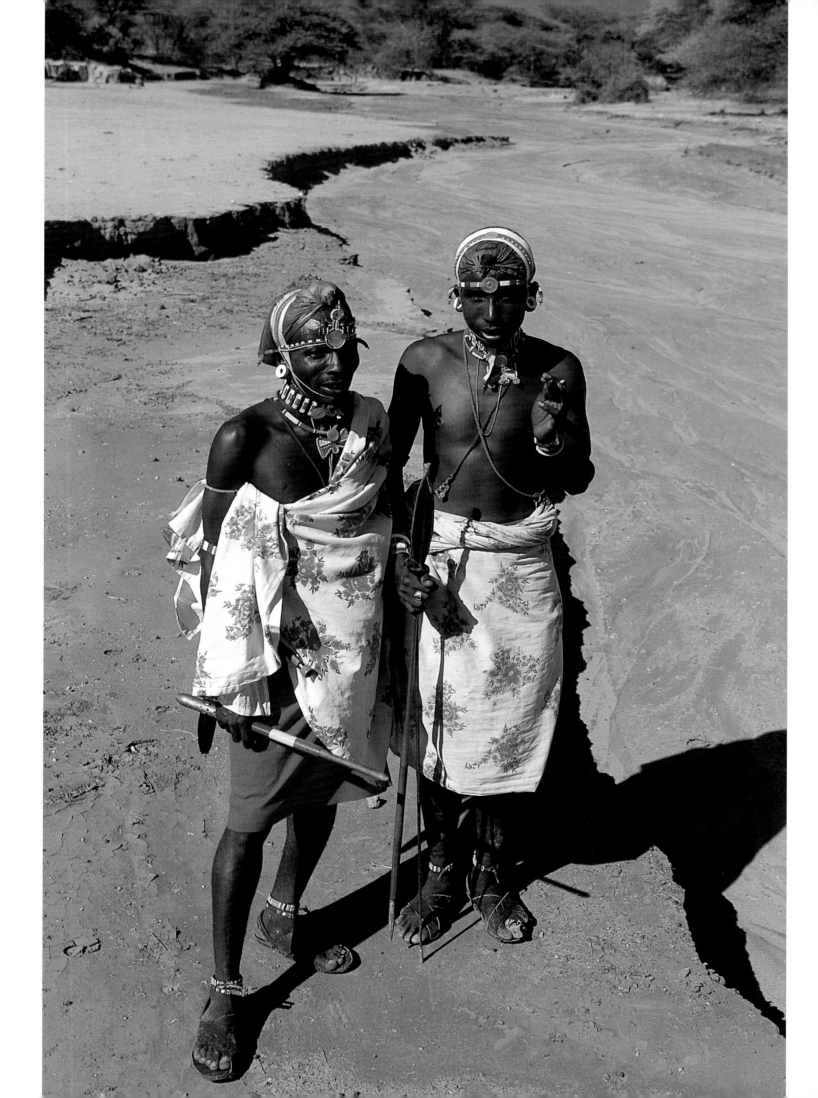

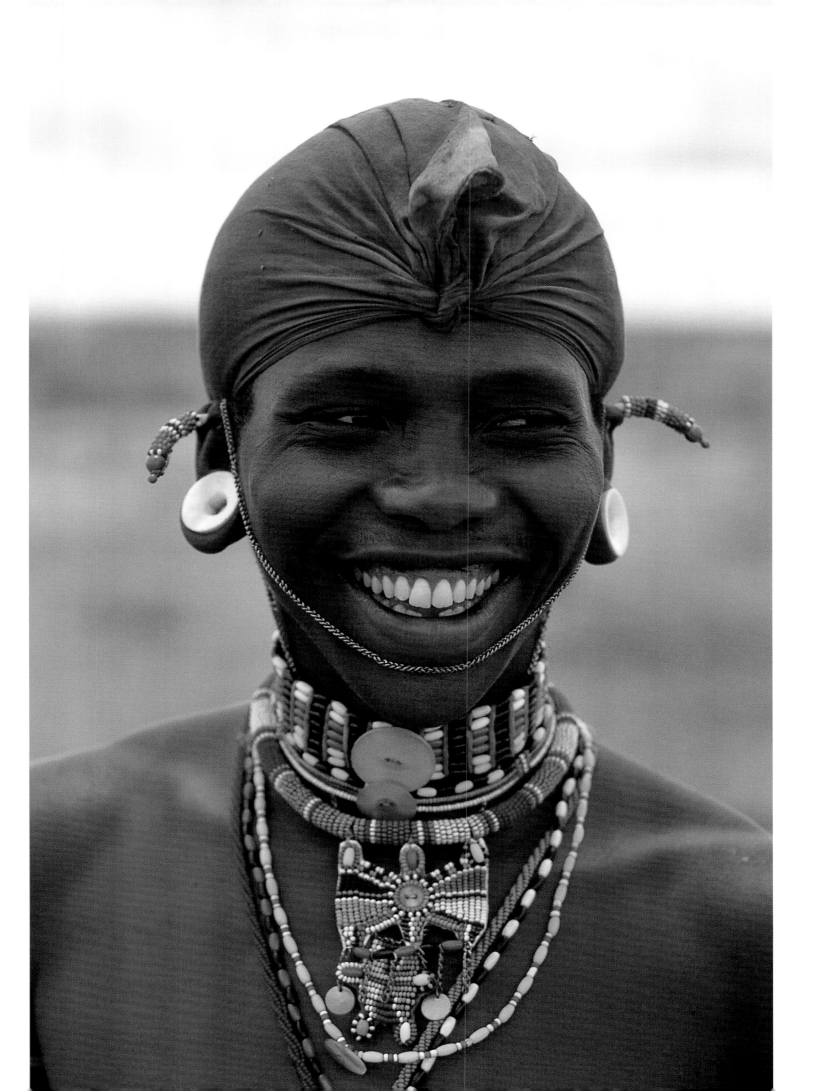

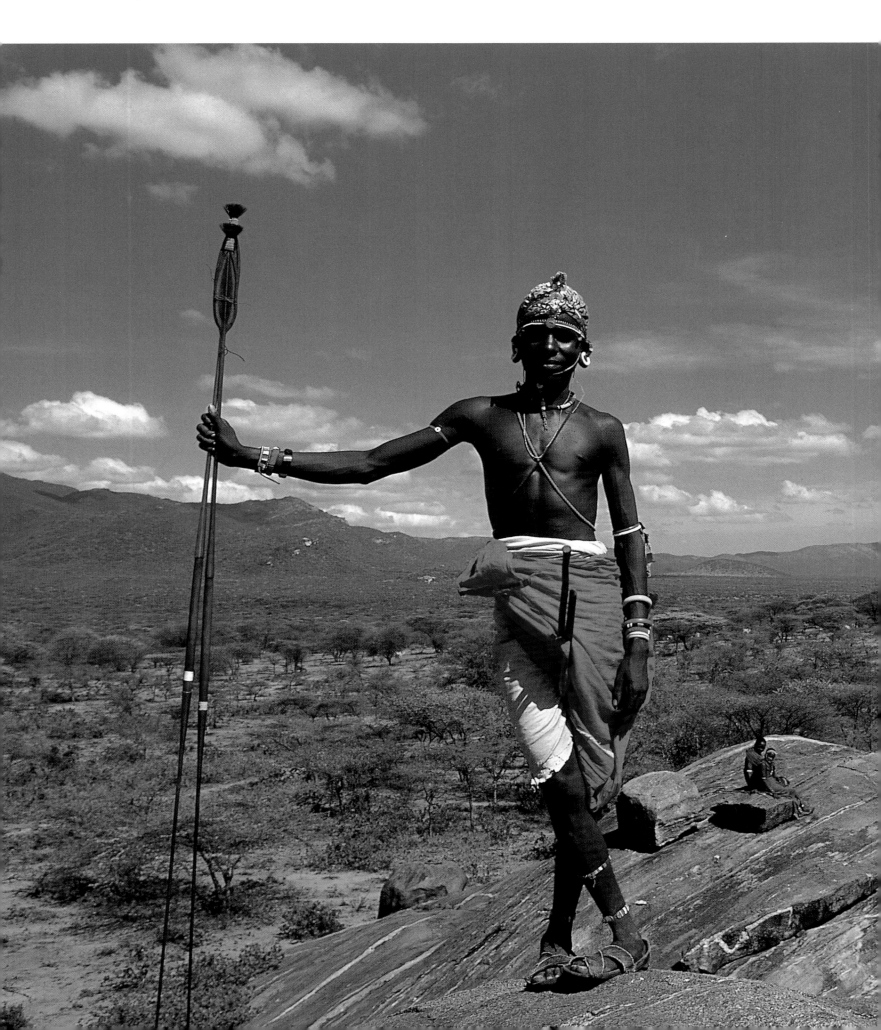

WARRIORS ON LBAAN (PAGE 62)
Warriors normally carry two spears; other weapons include the lalena, *which is worn in a scabbard secured at the waist, and a club stick called a* rungu. *Around their waist they wear two pieces of cloth, and in the chill of early morning they wrap one around their shoulders. Until recently warriors wore leather sandals made from giraffe hide, but since the introduction of licensed hunting, cow leather has become usual and latterly even rubber treads from discarded tyres are used.*

LMURRAN AT ISIOLO (PAGE 63)
A warrior at Isiolo dressed to perfection – aggression, pride and an uncompromising attitude are an integral part of a warrior's demeanour. Lmurran *have to prove themselves constantly and rival each other. As an ultimate challenge and insult they will plant their spear in the ground point first.*

WARRIOR ON OUTCROP, WAMBA (LEFT)
The honoured time of lmurrano *seems vulnerable to change, not just because of the incursion of western culture, but also because there is less need for armed warriors. There are fewer hostile encounters, other than those with* shifta *(bandits), and the game that once predated on flocks and herds is being steadily exterminated outside the national parks. One aspect of* lmurrano *which may survive is its function in instilling* nkanyit, *the respect on which the continuation of Samburu social and moral codes depends.*

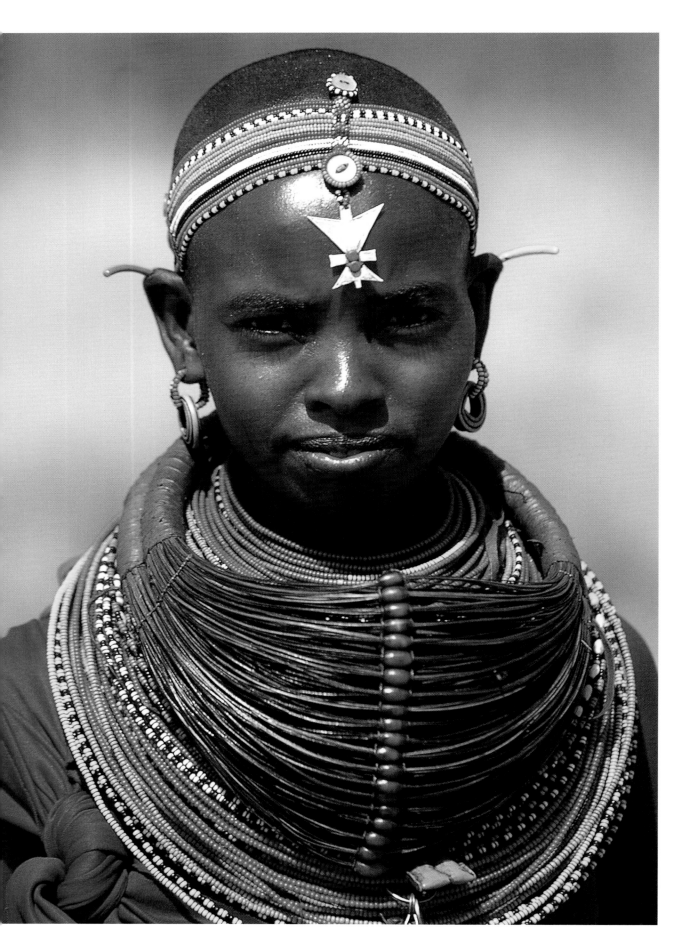

MARRIAGE NECKLACE (LEFT)
*As well as the symbols of their
married status, newly married
women may wear the jewellery and
adornments of their girlhood before
discarding them altogether. Many
married women wear thin metal
ornamental crosses at the front of
their beaded headbands. This
decoration appears to have derived
from the elaborate Christian crosses
of Ethiopia. Some of the warriors
also wear smaller versions of these
crosses hanging from the visors of
their headdresses.*

**SAMBURU GIRL, ARCHER'S
POST** (OPPOSITE)
A nkoliontoi *(unmarried girl)
wears jewellery appropriate to her
status: a beaded headdress, a metal
chain across her face, earplugs and
necklaces. Girls are considered old
enough to be married just before
they reach puberty. They may only
be married to warriors at the end of
their warriorhood or to an elder as
his second wife. All women are
circumcised before marriage – the
Samburu continue to practise this,
and a newly circumcised girl is called*
nkaibartani *(shaved by God).*

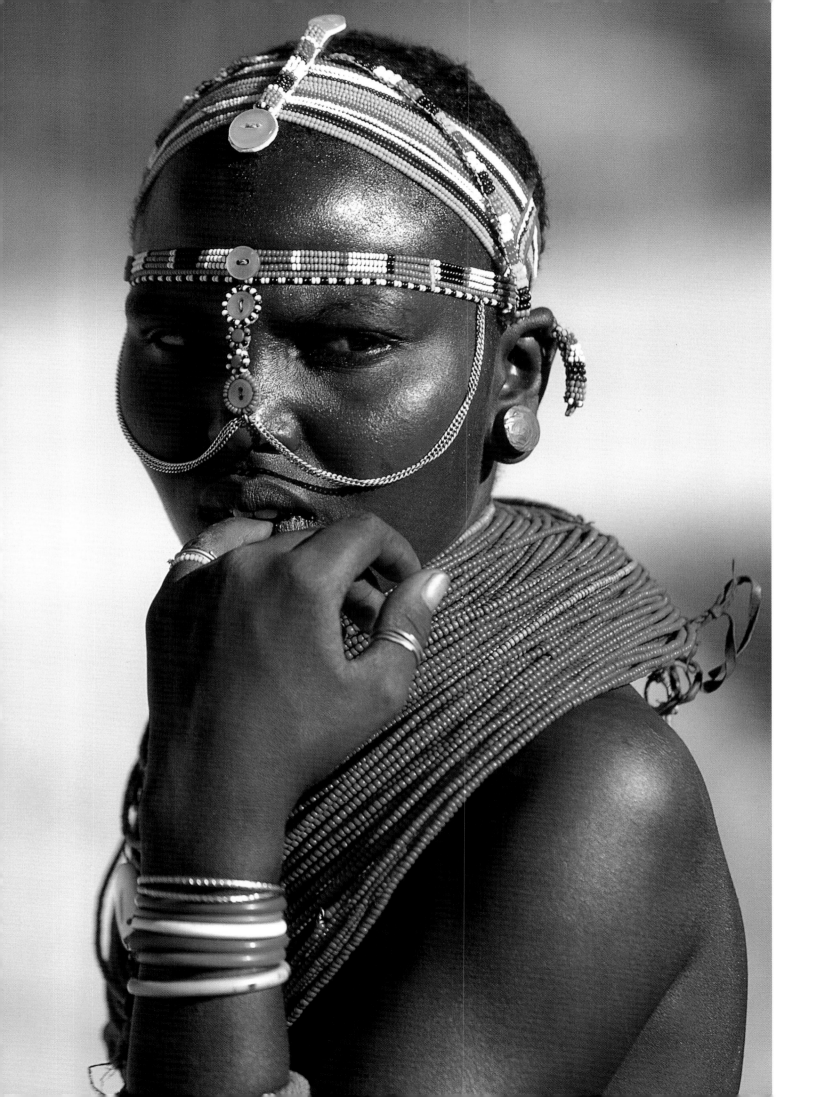

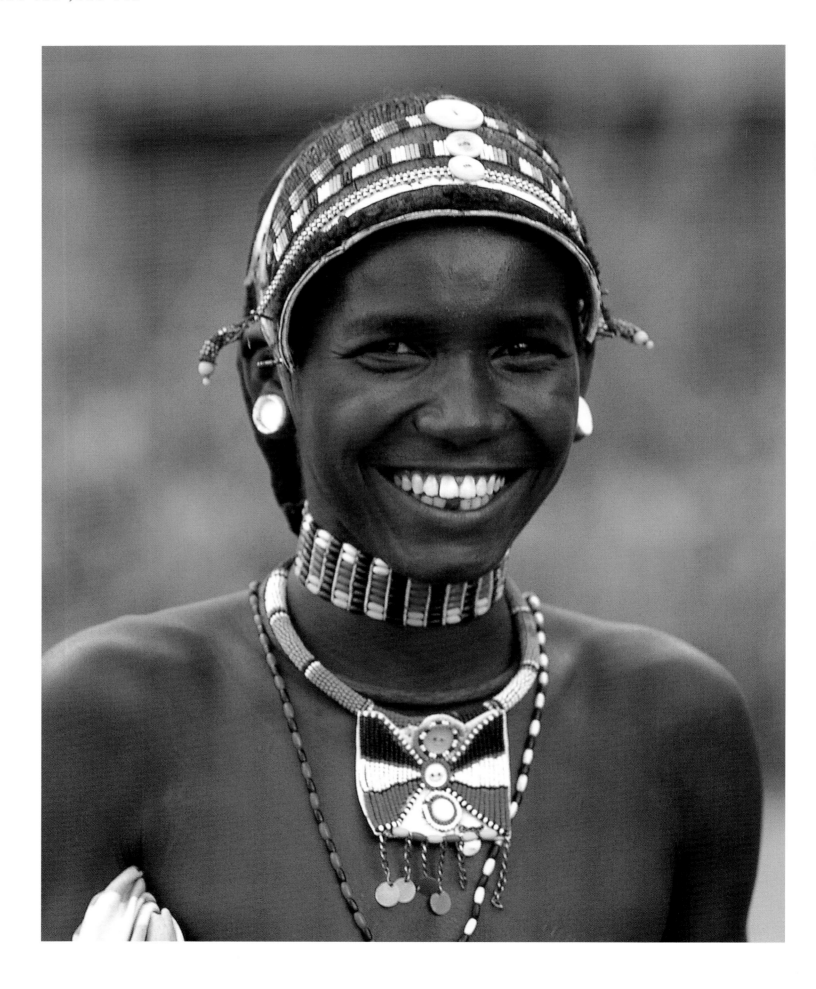

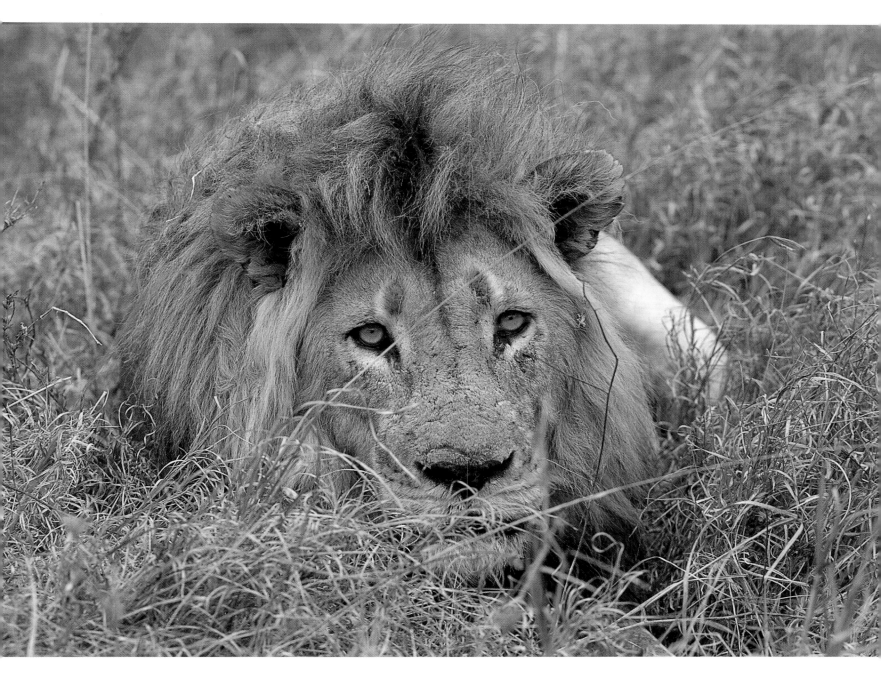

WARRIOR AT SOUTHHORR
(OPPOSITE)

The friendly smile reveals one of the initiations of warriorhood – two lower teeth have been removed. It took me a while to realize this dental hiatus was intentional and not the result of neglect. Over each shoulder are looped the long strands of beads which denote his status as a warrior. Visors are made usually from stiff animal hide overlayed with braids of hair, held in place by leather strips, which are then decorated with beads and buttons.

LION IN AMBUSH (ABOVE)

It was once expected that every warrior would kill a lion and although these expectations are dying out, lmurran *are still undaunted by a fight to the death. Once a warrior killed a lion, he would cut off its right ear and skewer it on the shaft of his spear. The lion's head would be placed by the entrance to his mother's village, facing the family's cattle in the compound. The claws and skin are potent symbols of courage: the claws being used for jewellery, the skin for ceremonial thongs and sandals worn by a groom at his wedding, and by fathers at their sons' circumcisions. Any hairballs found within the lion's stomach are secretly prized omens of fortune, wealth and strength.*

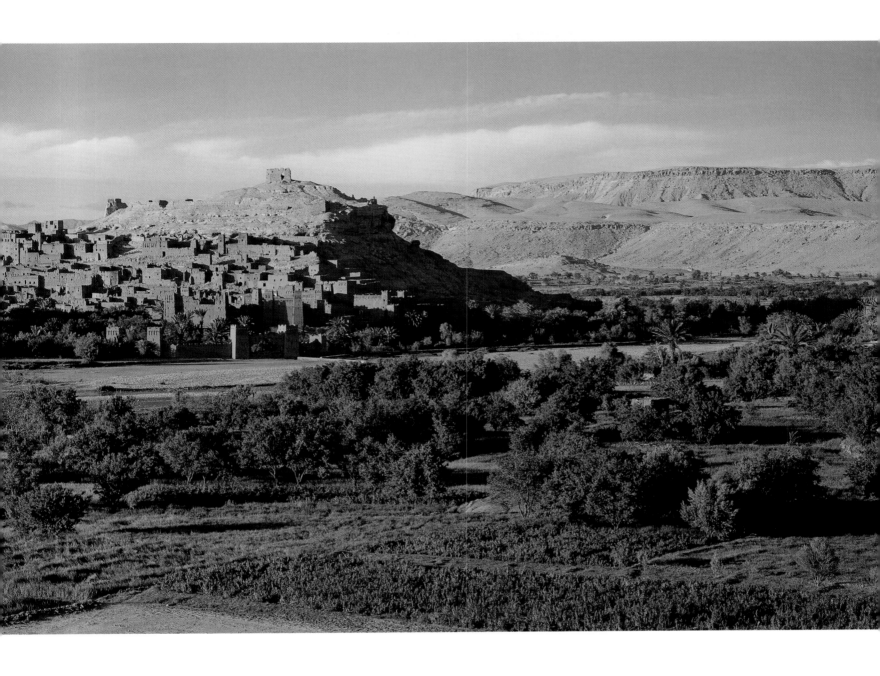

HIGH ATLAS AND BEYOND

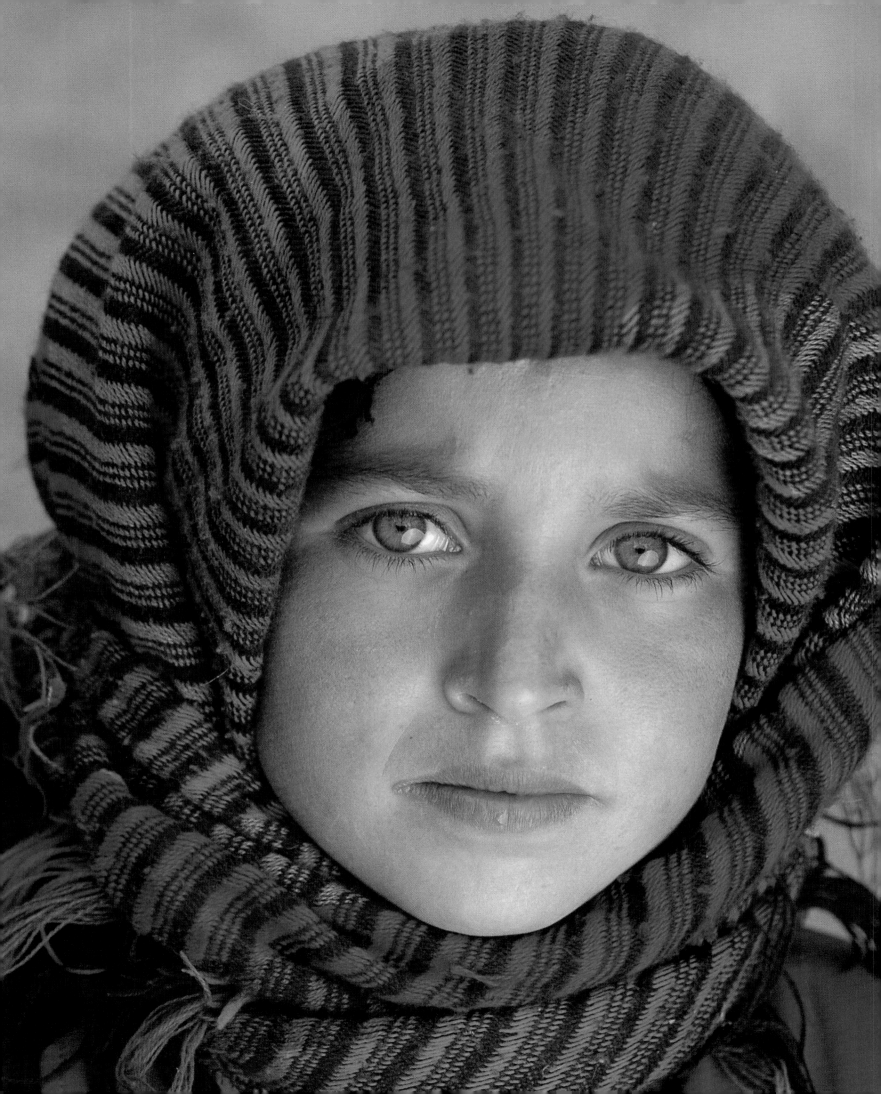

Berber

The name Berber is lent to various heterogeneous groups sharing similar cultural, political and economic practices. Today, roughly five to six million Berber-speaking people live across north Africa – from Tunisia to Morocco and Mauritania. However, the Saharan Tuareg people who live further south in Mali and Niger are also Berber, and as many as 40 million people claim to be of Berber descent. Of those living in the Maghreb (an Arab term for north Africa, meaning "far west"), many are sedentary farmers, grazing goats, sheep, cattle and camels while cultivating barley, wheat, maize, alfalfa, root vegetables and apples.

The Berber's ancient ancestors settled in an area that stretched from the east of Egypt, inland of the Mediterranean, west as far as the Canary Islands. Over time, they exerted great influence on the history of Africa and beyond. Accounts by Romans, Greeks and Phoenicians, from as early as 1100 BC, all mention a people known as Berber. Five major trade routes from western Africa to the Mediterranean enabled merchants to peddle pottery, ivory, copper and ostrich egg shells to southern Europe thousands of years ago.

For a while the Berbers embraced the Romans' Christian beliefs, but most converted to Islam after the prophet Muhammad moved from Mecca to Medina in AD 622. Today, they are predominantly Muslim but retain pre-Islamic customs. They believe in the evil eye and the power of magic, but shrines that dot the parched countryside show their reverence for saints. Berber society follows what anthropologists call the "segmentary lineage model" where peace and order are maintained by balanced opposition rather than by institutions of a state.

Some Berbers, for example those of the High Atlas area of Morocco, practise transhumance, where animals are grazed in high pastures in summer and on the lowlands in winter. Until the 1920s, the social structure of Atlas settlements was feudal, based on the control of three main passes or *tizis* by "the Lords of the Atlas". Although the region is now under government control, distinctive *kasbahs* – feudal castles – serve to remind of the Berbers' past resistance to outside influence.

The arrival of tourism and television – and the Arabization drive since Morocco gained independence in 1956 – has inevitably diluted Berber culture, but it lives on in the designs of rugs and pottery made by Berber women. Symmetrical angular patterns reflect the jagged mountain peaks of the Atlas, while carvings of snakeskin and the leaves of the ash tree are symbols of prosperity and protection. The partridge, too, is frequently represented in decoration: a husband will flatter his wife by calling her "eye-of-the-partridge" and will often give her a partridge to hang in the door of her home (Courtney-Clarke and Brooks, 1996).

KASBAH (PAGES 70-71)
The Berber town of Ait Benhaddou has been declared a UNESCO World Heritage Site. Described as "architecture without an architect", its structures grew out of the lives of the people who lived in them. Built primarily of adobe, the thick-walled buildings remain cool even in the blazing noonday sun. Every door and window has been placed for a practical, aesthetic or religious reason. Roofs were woven from a type of willow whose bitter taste repels insects. Efforts are being made to entice merchants, craftsmen and families back into the old dwellings.

ZORHA BENT CHANTI
(OPPOSITE)
Driving into the hamlet of Tadrokht, Douar Kik we found ourselves surrounded by children, and I was immediately drawn to one particular girl with piercing green eyes and vibrantly coloured headwear. With the sun overhead, the gable end of a house provided just enough shade for the portrait I had in mind. After frequent gesticulations to the children, a small stool was found on which five-year-old Zorha would sit. All went well until I opened my white reflector, when she suddenly took fright. I managed to entice her back by appearing to bring her two friends into the photograph, although she alone remained the subject.

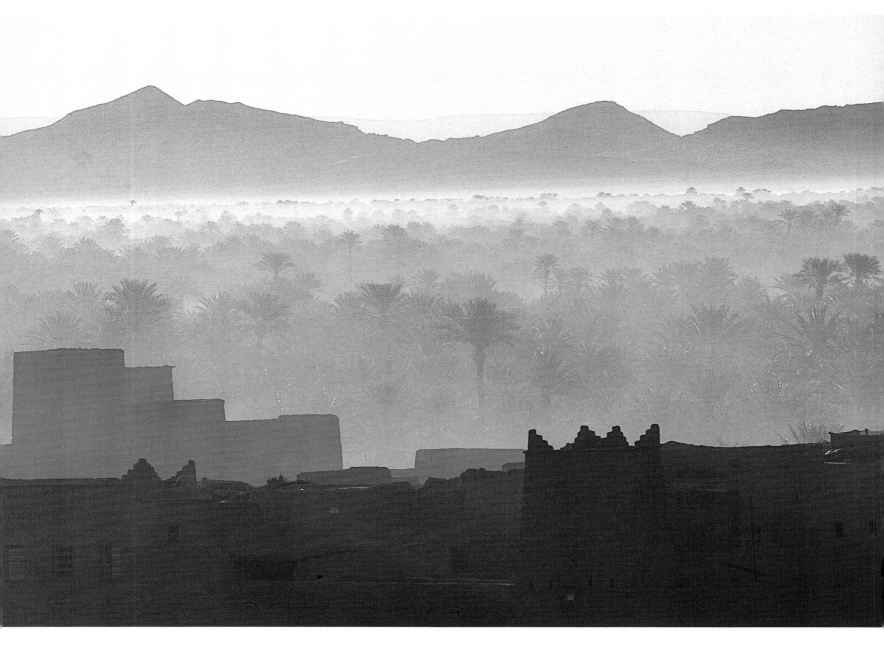

KSAR (ABOVE)

In the far south of Morocco, beyond the High Atlas mountains, the Draa river stretches into the Sahara. As the river penetrates the arid landscape it becomes smaller, but it stills contains enough water to sustain a riverine oasis dominated by date palms for about 100 miles (160 km). In this narrow strip, desert villages punctuate the landscape and are often walled, built of adobe, and present a crenellated appearance from a distance. Known as a ksar, Berber villages like this are common in the Sahara.

PALM POLLINATOR (OPPOSITE)

At Oulad Msaad in the Draa valley, 60-year-old Dami Masoud precariously balances on the bark of a Nakhla palm. Some 35 ft (ten metres) from the ground, he shakes pollen from the stamens over the stigma of the palm flowers to ensure a good date crop in December. Dates take a full year to mature, and they thrive where groundwater is plentiful and where it is hottest. There is a local saying that the date palms have "their heads in fire and their feet in water".

REMINISCING (PAGE 76)

In a moment of joy, 75-year-old Hassan Ben Muhammad Elfakir enjoys a recollection from his youth. Tamazight is the language spoken amongst Berbers, and is all-important to the Moroccan Berbers because it is the uniting factor in their pluralistic culture. Though most are Muslim, a few are Jewish and others are Christian. They are ethnically mixed and are spread over the country, from the Rif mountains in the north to the High Atlas and the desert in the south.

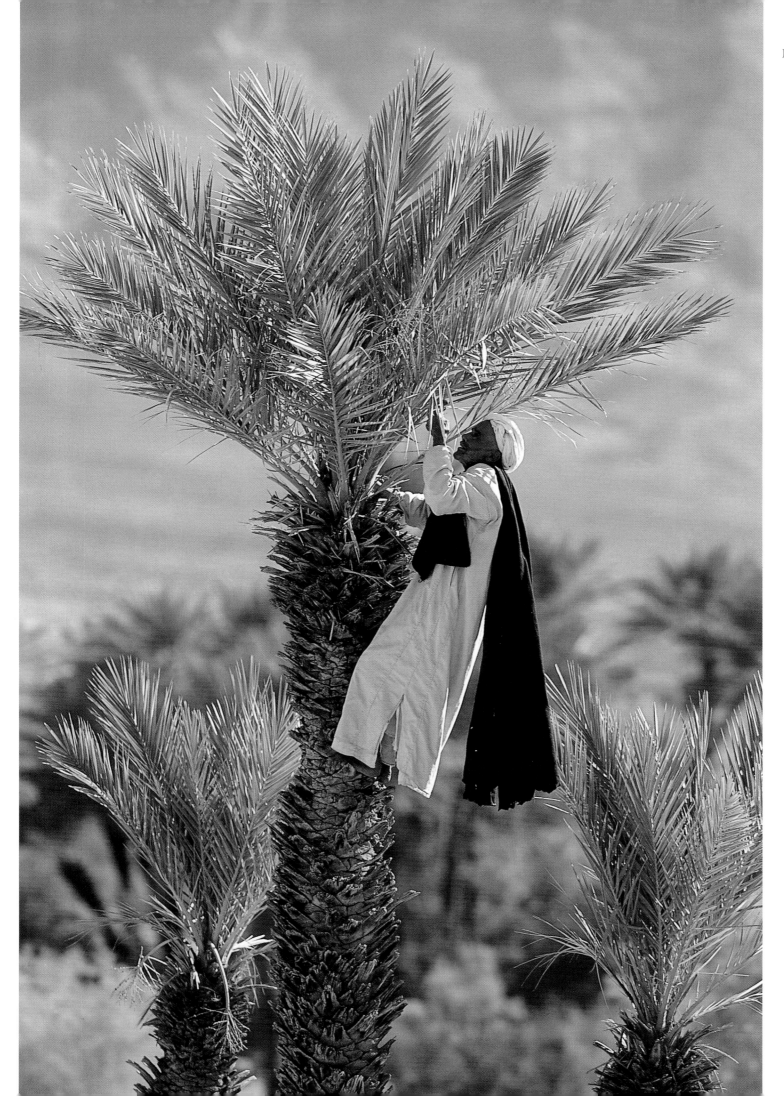

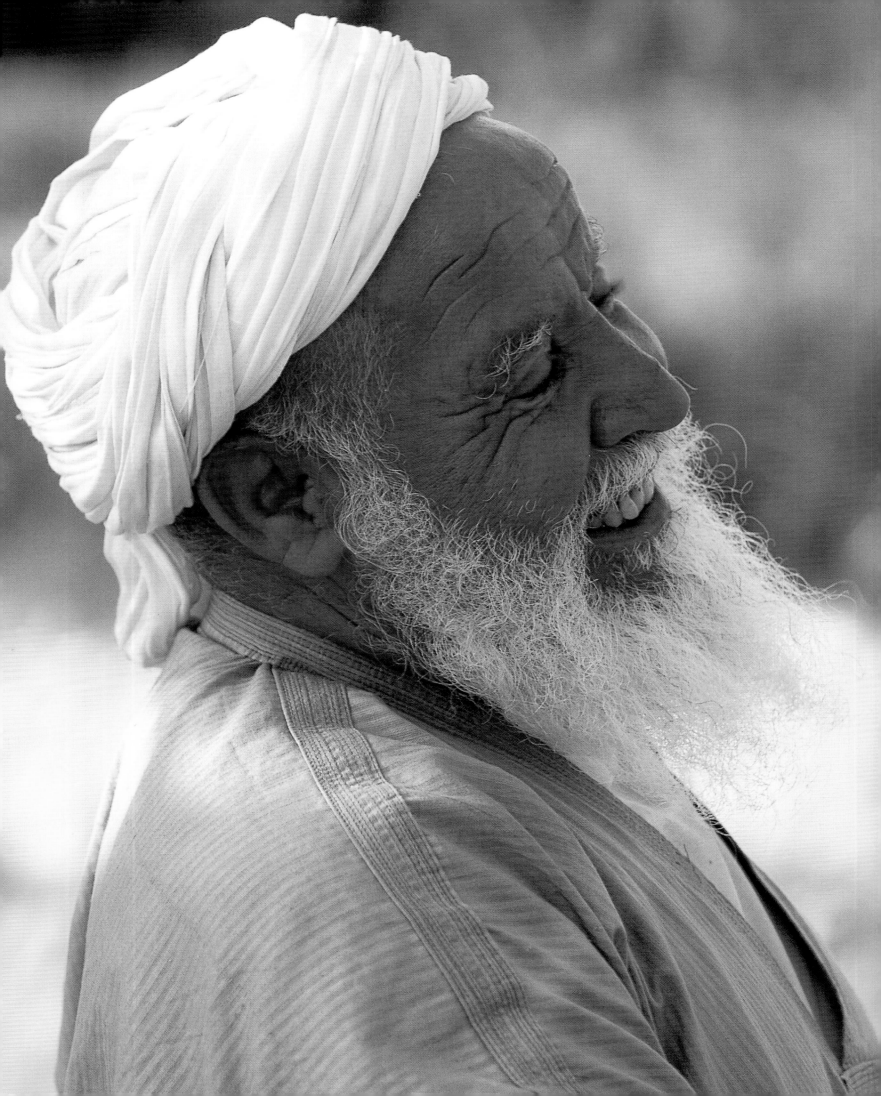

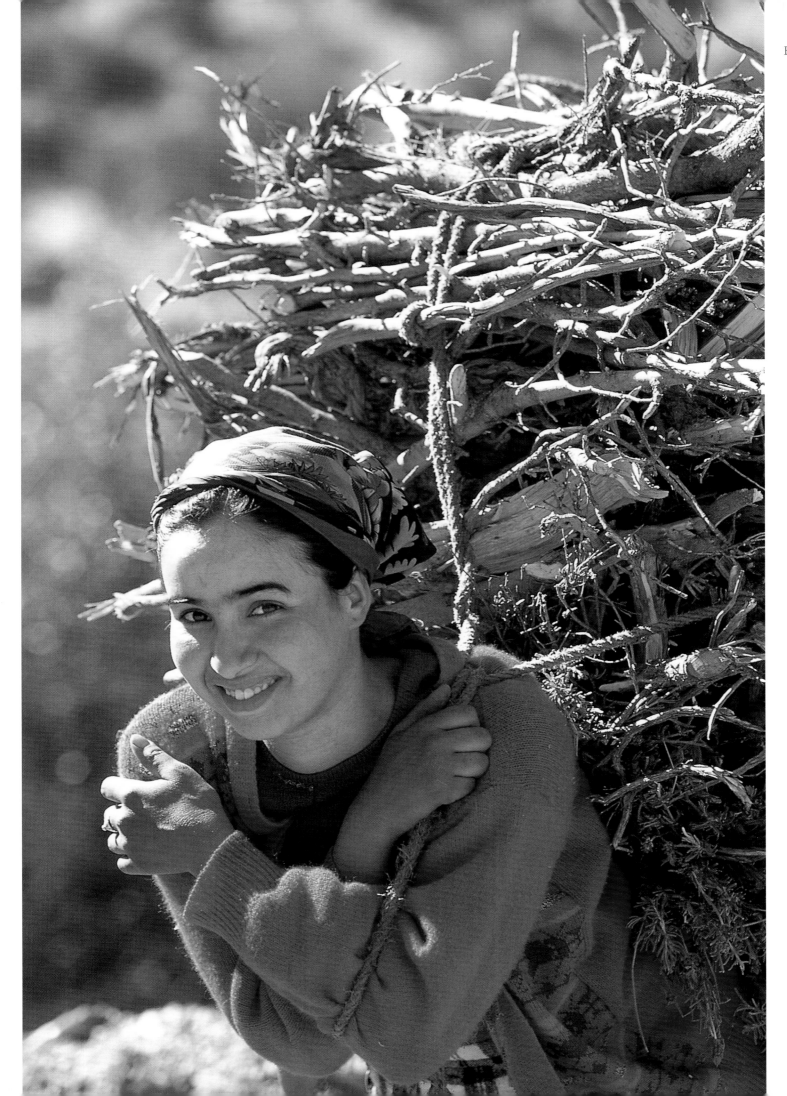

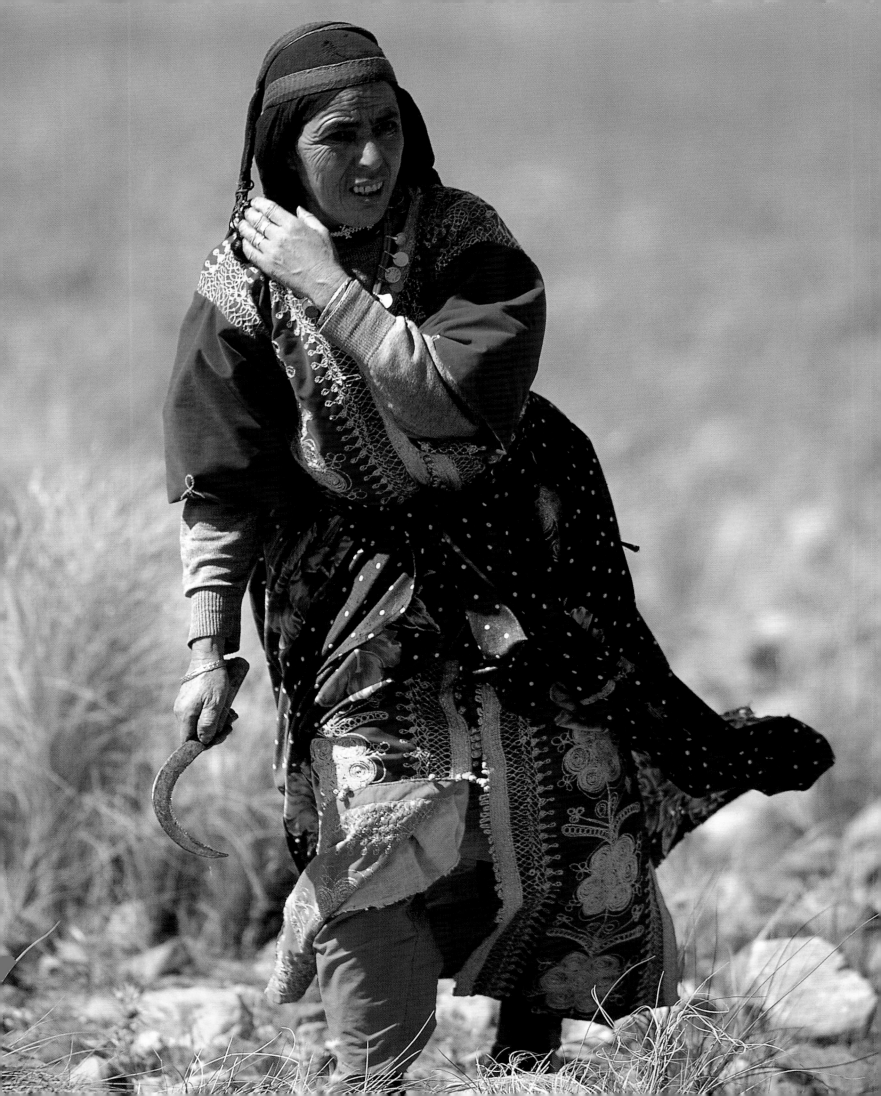

COLLECTING FIREWOOD
(PAGE 77)

Near the village of Oukaimeden, I came across three girls with huge bundles of firewood on their backs. Despite their burden, they were in surprisingly good spirits and stopped to chat with us. Villages like Oukaimeden have access to a collective agdal *or pasture which is opened and closed at set times of the year. Who uses the communal land, and when, is determined by climate, distance from villages, conflict, socio-economic status, and size of household.*

TOUIZA (OPPOSITE)

In the village of Tadarte, Douar Kik, a woman cuts grass for animal feed. Among the Ait Mizane, a Berber group in the High Atlas mountains, people work together on demanding tasks such as ploughing and planting, threshing and winnowing. When a family needs to plant a crop, assistance will be given by neighbours in reciprocation for similar help. This labour system is cooperative and rotative, and is termed touiza. *The basic approach is "I'll help you today; you help me tomorrow".*

POPPIES (ABOVE)

Fields of pastel greens punctuated with a profusion of red poppies and other wildflowers are a striking feature of the High Atlas. Here on the back of a donkey, two children have gathered fodder for livestock in two raffia panniers. For tasks like this, or for example repairing the rock walls that face the terraced fields, a given time is set aside.

TAZLIQA (ABOVE)

Through the compression of a telephoto lens a candid glimpse of village life at Tazliqa is possible. Homes are built on a hill, of a dry-stone construction with a timber roof structure, covered with matting and then earth for insulation. Windows are unglazed and houses have neither running water nor electricity. Daily life demands both the fetching of water from a nearby well and the collection of firewood.

TAHRBILT DRESS (OPPOSITE)

Overcoming her shyness, Aziwan Najat peers from the door of her home. Wearing traditional Tahrbilt dress, the vibrant colours of her pink blouse and scarlet-and-green hairpiece were in stark contrast to the monotony of the adobe walls of the village of Fint.

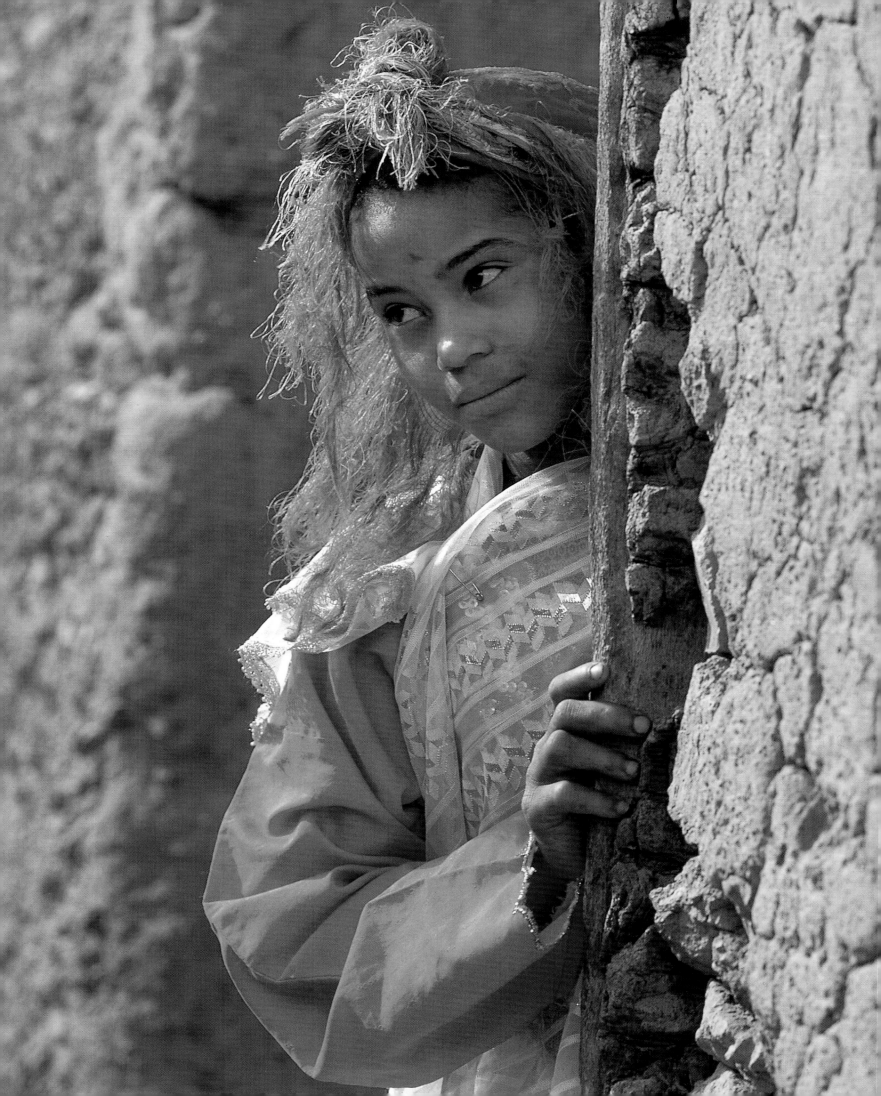

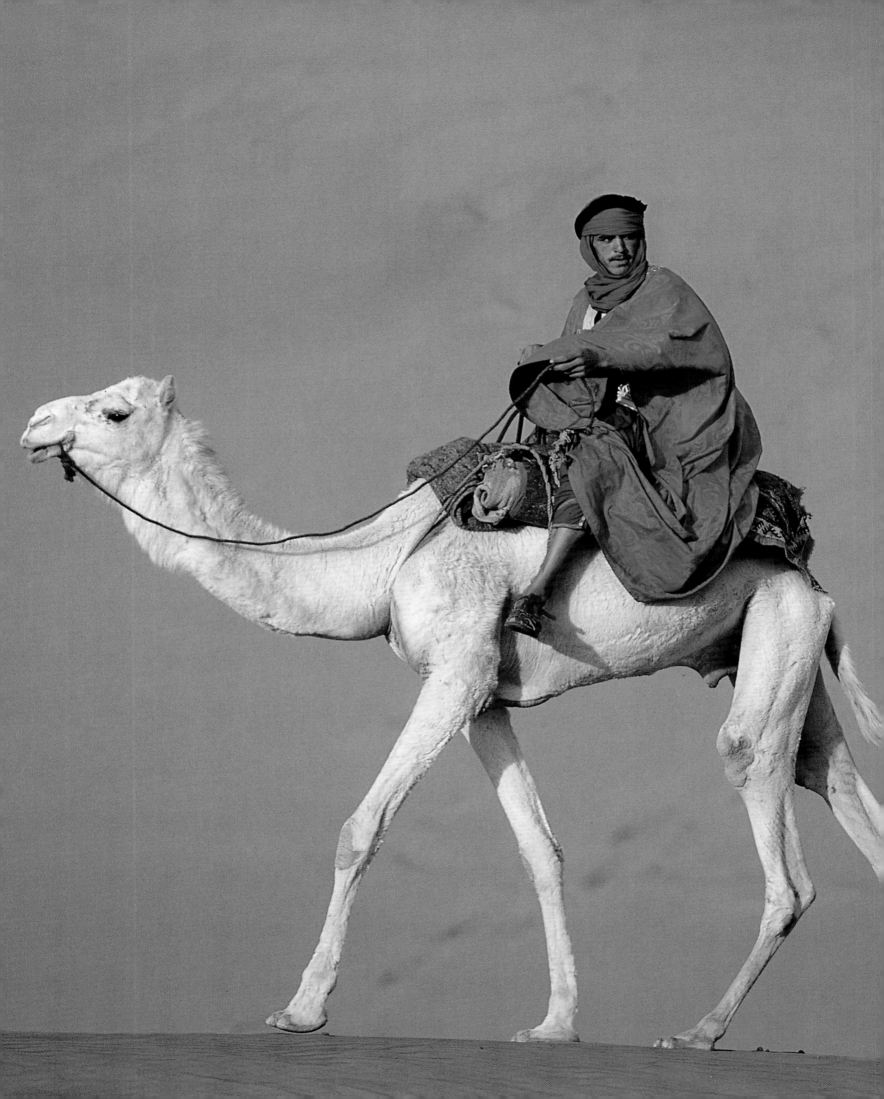

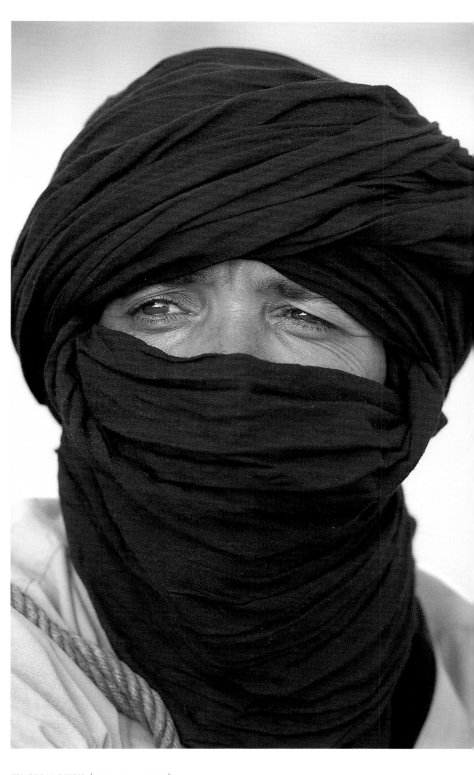

TAGELMOUST (LEFT AND ABOVE)

A Berber rides across the burning
sand. In the desert most tribesmen
cover their faces against the sun or
cold with the tagelmoust.
Evolution, however, has equipped
the camel with natural features to
deal with such extremes: notably,
long eyelashes and bushy eyebrows
to protect their eyes from sun and
sand. Their ears are also furred
both inside and out to protect them
from blowing sand, and they are
able to close their slit-like nostrils.

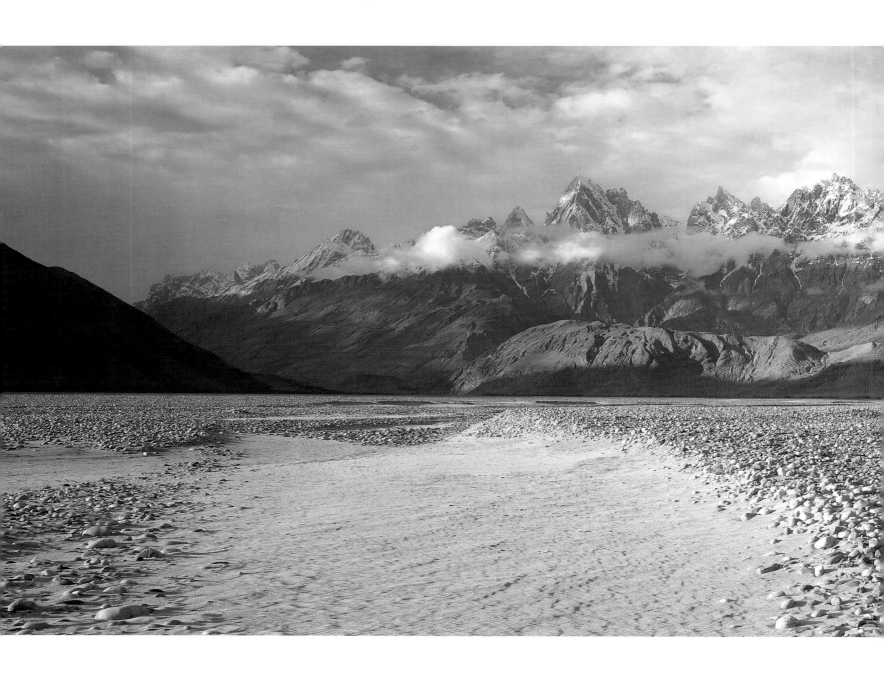

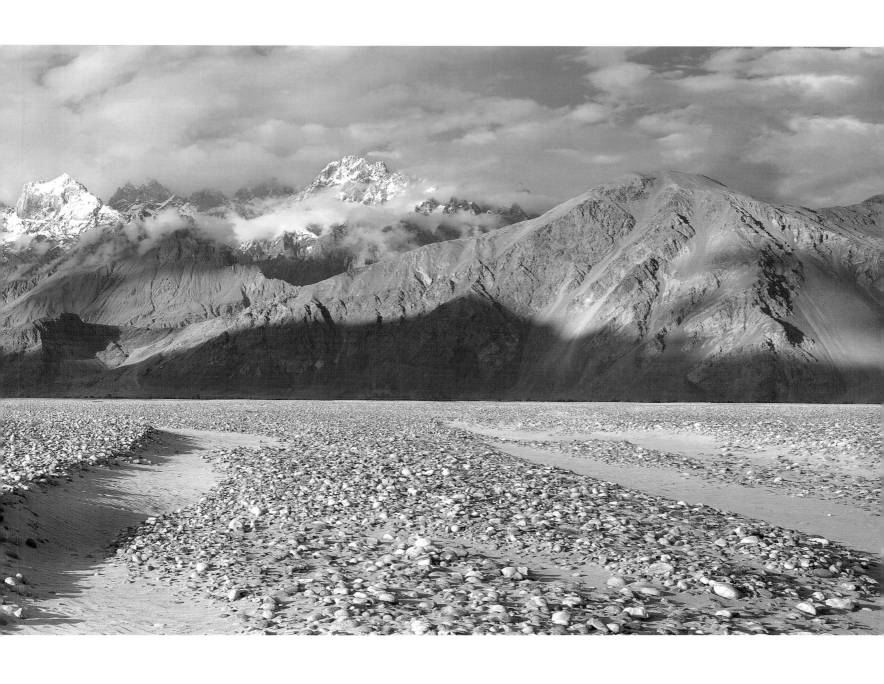

HEART OF THE KARAKORAM

Balti

The Balti people live in the heart of the Karakoram mountains, in northern Pakistan. Originating in Tibet, they migrated to the region, now known as Baltistan, 600 years ago. This region was first mentioned in the fifth century when it was known as Great Bolor in Arabic literature or Po-lu-lo in Chinese accounts. Buddhism was the dominant religion here until a man named Amir Kabir Syed Ali Hamadani arrived in Shigar in AD 1379 bringing with him the Shiah sect of Islam that today's Baltis follow. They are an extremely pious people, holding their religious leaders, the *aghas*, in very high esteem.

Extreme followers of Shiah have a code of cleanliness which dictates they cannot use food or water that has been touched by a non-Muslim. In the past, Baltis would not take medicine from a non-Muslim. Some also believe that entertainment such as singing and dancing are against the principles of their faith. For all Baltis the daily recitation of the holy Quran is an essential task. Each village has a seminary, presided over by an *agha* or sheik, who gives instruction in the faith.

The Shiah Baltis follow a system of temporary marriage called *muta*. Under this system, all marriages are temporary but are contracted for a set period of time. This period is agreed by both parties before the marriage can take place; it can vary from a week to many years. When the time is up, both parties are free to continue the relationship for another specified time – or terminate it.

The Baltis believe that glaciers, as well as people, can be induced to "mate" and produce offspring. Glaciers are believed to be male or female, with the former responsible for producing higher yields of crops in the nearby area, and the latter for lower yields. Traditionally, Baltis would take chunks from one male and one female glacier to a site in order to create and "grow" a new glacier when the winter snows came.

Most Baltis live in remote valleys subsisting on pastoral grazing and crops of barley and wheat. The climate is severe, with little rainfall and winter temperatures of -22°F (-30°C). With a burgeoning tourist trade in climbing and trekking, some have taken to working as porters for wealthy visitors. Baltistan is the gateway to one of the world's most spectacular mountain landscapes, including K2, at 28,850 ft (8,611 m) the second highest peak in the world. While portering work brings in much needed cash, those leaving their farms risk losing centuries-old self-sustainable farming methods.

SALTORO SPIRES (PAGES 84-85)
Beyond the flood plain of the Skyok river stands the magnificent group of peaks known as the Saltoro Spires. On returning from an abortive trek to the Gondoro glacier where torrential rain had fallen for five days, I managed to capture this image at the lower altitude between two weather fronts. For the entire journey we had been plagued by constant rockfalls with massive boulders crashing to the ground from the precipitous mountains.

MILLER (OPPOSITE)
At the village of Hushe I found this 70-year-old miller. He looked after a mill seemingly out of the Stone Age, with a large flat stone slowly rotating with the aid of a water wheel, grinding wheat to a fine dust. Built from drystone, the cramped interior was draughty, impregnating the miller's hat and clothing with flour.

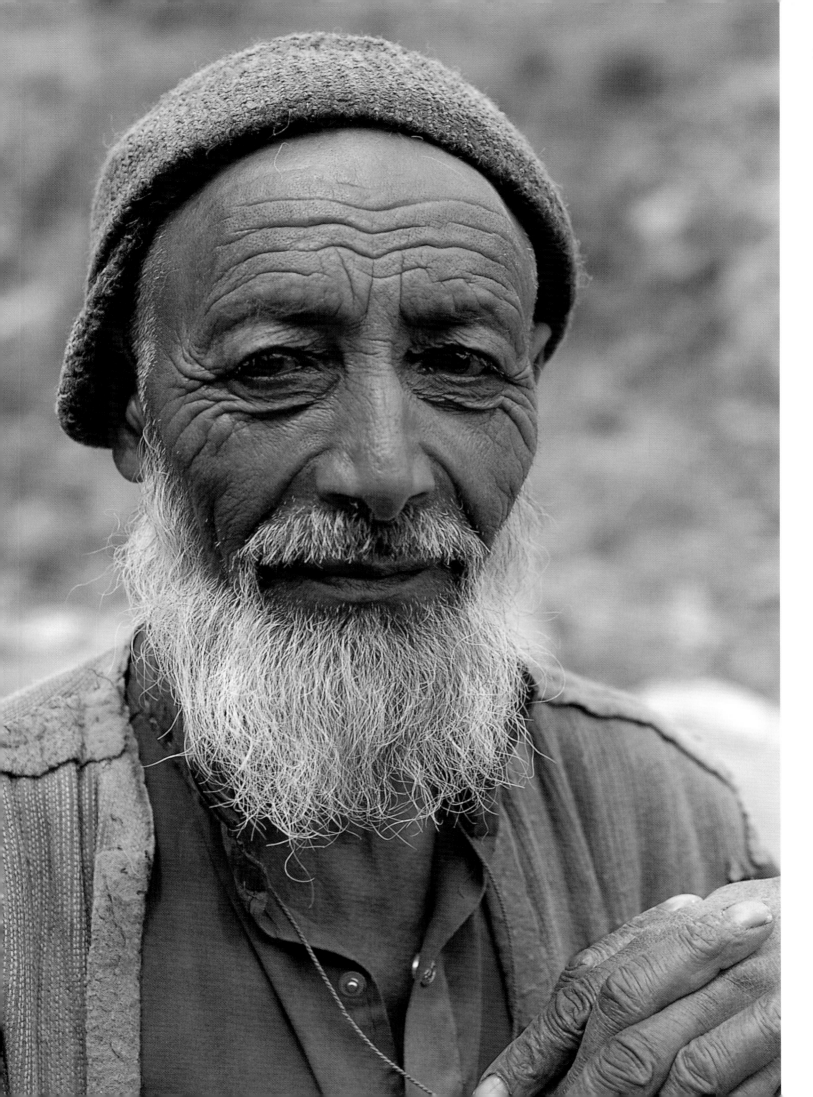

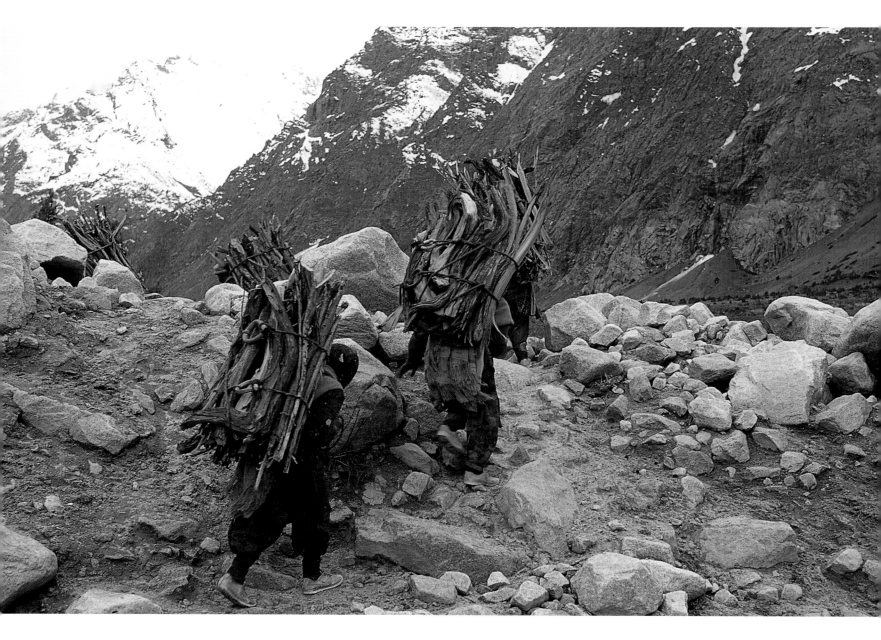

COLLECTING FIREWOOD (ABOVE)

The Balti people of Hushe eke out a living in one of the harshest physical environments in the Himalaya. The people who live in the Hushe valley are primarily subsistence agriculturists and pastoralists who raise wheat, potatoes, goats and sheep. They also raise yak for food and draught needs. Most of the villagers' food and fuel needs are met by using local resources and household labour, although many of the village men work as porters as well.

BALTI PORTER (OPPOSITE)

With numerous climbing expeditions into the Karakoram mountains, the fine balance of life in villages such as Askole has changed from a cashless self-sufficient society to an environment driven by dollars. Wheat, barley and apricots have been largely replaced with a cash economy necessary to provide villagers with goods and services that include clothing and household items, children's education, medical care, and religious pilgrimages to Mecca.

VILLAGE FEAST (PAGES 90-91)

In recognition of a villager's pilgrimage to Mecca, a village feast was organized at Hushe. Goats, slaughtered earlier, were butchered and lowered into a large steaming cauldron which was stirred by three men with sticks. Roti, unleavened chapatti bread eaten with salted butter, formed the base for the feast – with the men breaking tradition and serving the women first. After the women's departure, the men took their turn to eat.

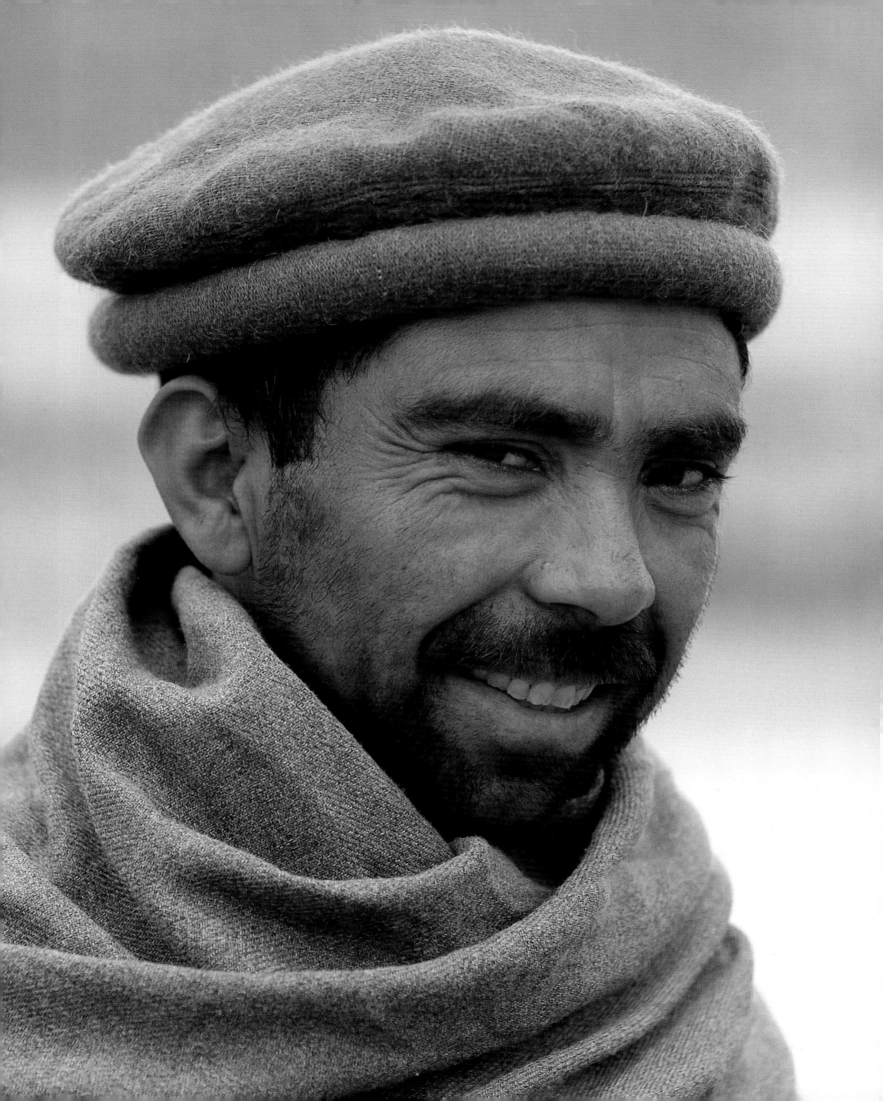

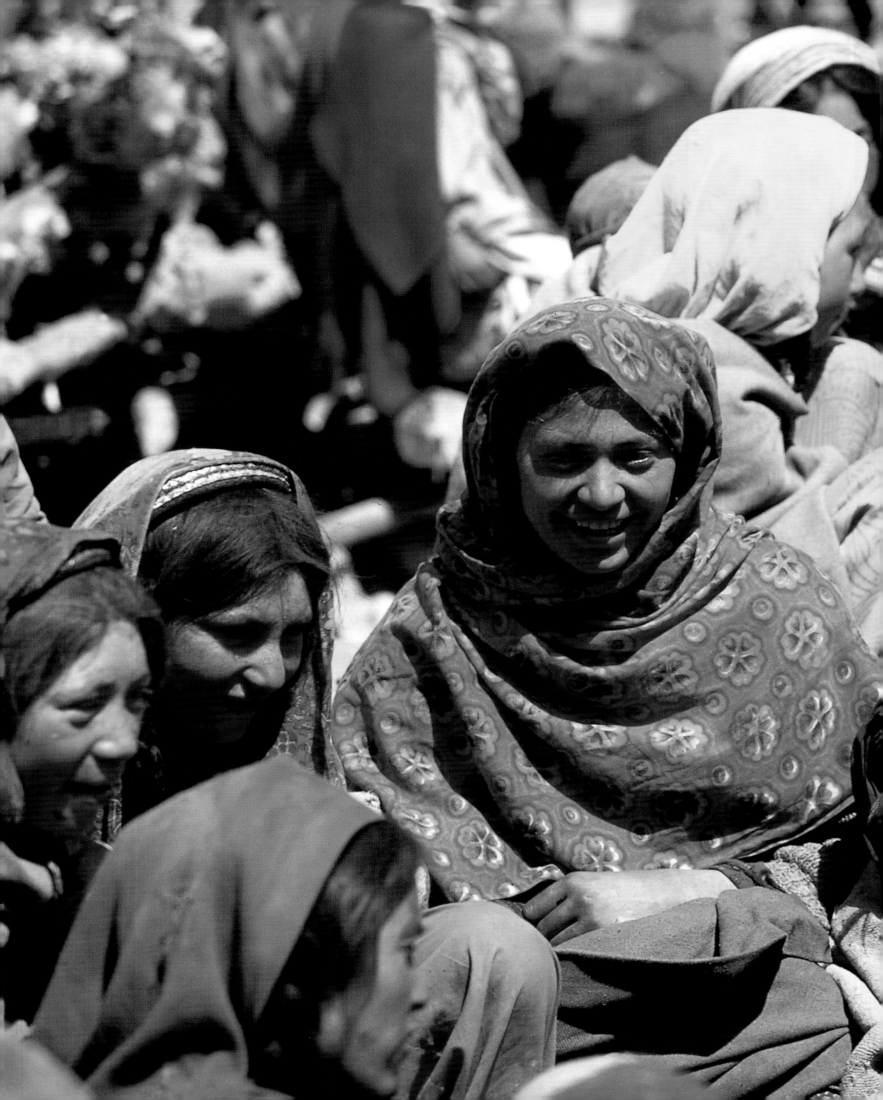

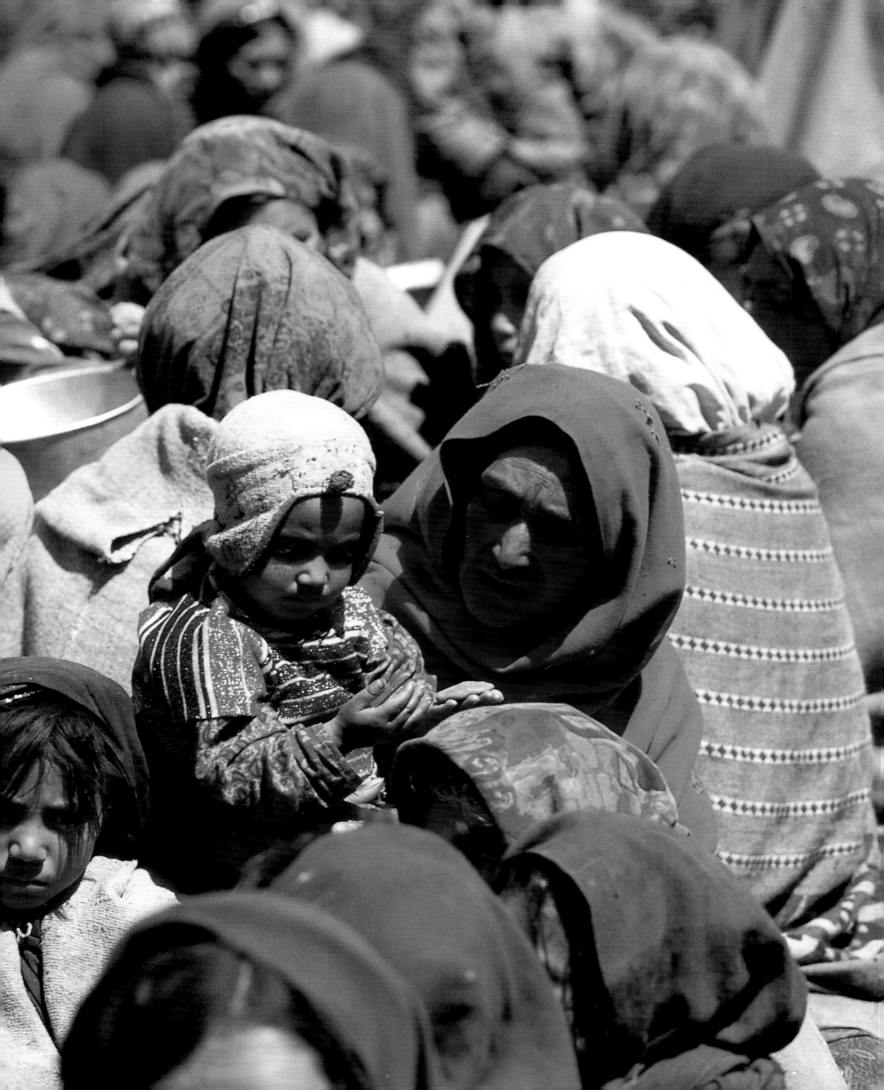

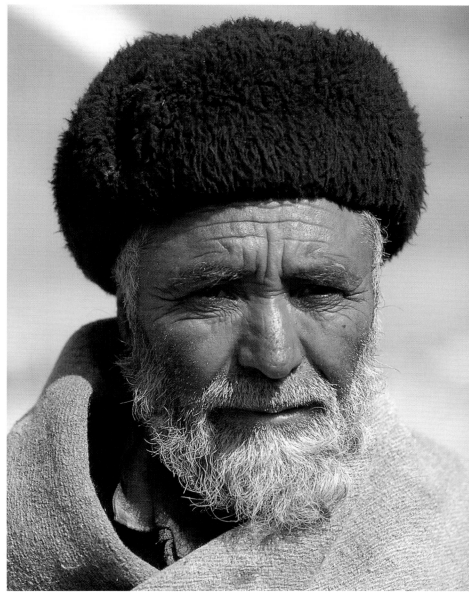

FRUIT MERCHANTS (LEFT)

In the bustling main street of Skardu, fruit merchants carry baskets of lemons. Skardu, the capital of Baltistan, is the centre of commerce and gateway to the Karakoram mountains. Nearby glaciers include the Siachen glacier, the Baltoro glacier, and the 76-mile (121-km) combination of Hispar and Biafo, which connect at a pass. The Baltoro glacier is especially significant, as ten of the world's 30 highest peaks cluster around it.

RAJA (ABOVE)

Inside the village there are two people of great importance. There is the raja, representative of culture and tradition, and the religious leader, or political activist. Although it is claimed that at present 90 percent of boys and 75 percent of girls attend school, literacy rates for Baltistan are 3 percent for females and 20 percent for males. Health status is poor, caused by a number of deficiencies which include iodine and iron, especially in women and children.

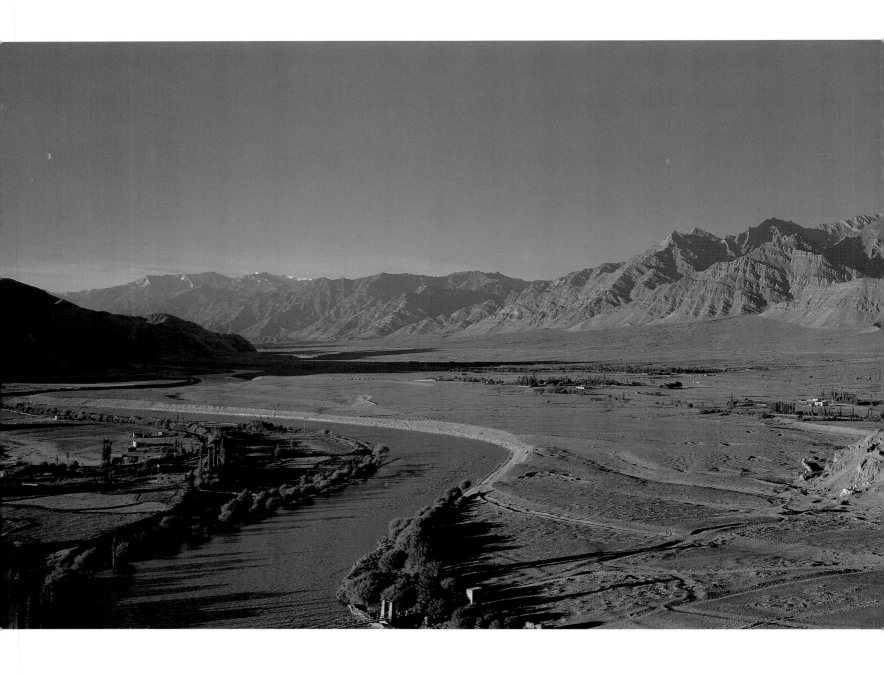

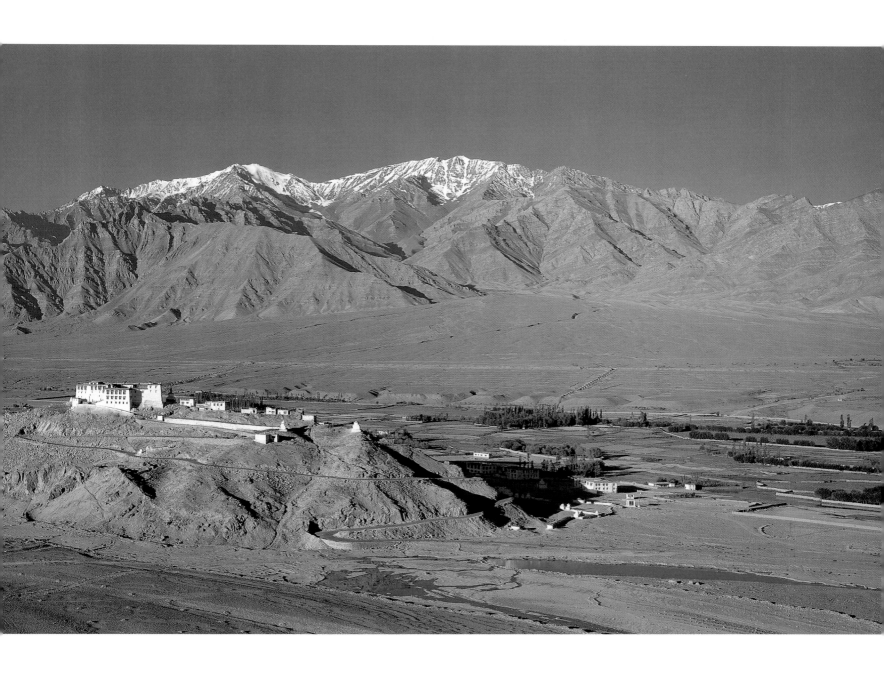

WHERE EARTH AND SKY MEET

Ladakhi

Ladakh has one of the lowest population densities in the world with little over seven persons per square mile. The lives of the few that do inhabit this remote north Indian region are shaped by the inhospitable mountainous landscape. Villages necessarily lie close to the Indus, whose glacial waters are diverted to irrigate terraces chiselled from the steep mountainside. Here, families sow barley, wheat, oats, peas and beans in the spring, hoping for a good crop before the winter snows.

The term Ladakhi refers to a specific ethnic group, of Mongolian descent, rather than all the inhabitants of Ladakh (Mann, 1985). Ladakhis are followers of Mahayana Buddhism, a religion which developed from Indian Buddhism and the indigenous Bon-Chos faith. However, Muslims have a long-standing presence in the region, and there are also Christians and Hindus. Ongoing political unrest stems from India's decision to incorporate Ladakh into the Muslim state of Jammu and Kashmir, essentially turning it into a Buddhist minority enclave.

Gompas or monasteries are the spiritual, political and geographical centres of Ladakhi villages. The abbot, whose soul is considered immortal, is responsible for the monastery. He is served by monks, who in turn stand above the general population on the spiritual ladder. This hierarchy is mirrored in the physical layout of villages. Decked with colourful flags and prayer wheels, the monastery dominates the skyline. Below it, monks' cells line the valley flanks, while the villagers live on low-lying land (Michaud, 1996).

Traditional Ladakhi hierarchy comprised the *rgyal-rigs* (royalty), *sku-drag* (nobles), *dmans-rigs* (peasants) and *rig-nan* (outcasts). However, China's invasion of Tibet in 1950 prompted change that has accelerated in the past two decades. Tibetan refugees have swollen the population, while tourism has opened the eyes of this once self-sufficient nation to commercialism. Many men now seek paid work rather than toil in the fields; this is now left to the women who have seen their status slip in recent years.

There are moves, however, to encourage Ladakhis to see the wisdom of the old ways of working. Groups have formed to promote organic farming above the use of cheap pesticides, while some scholars are trying to revive the role of *amchis*, or medicine men, before generations of knowledge about local plants are lost. These few are recognizing that fast living and expensive possessions are not substitutes for community life. "Life was very simple, but people always had enough, and more than anything they were happy," says Tashi Rabgyas, Ladakh's leading poet, scholar and philosopher.

STAKNA MONASTERY (PAGES 94-95)
Standing on a hill shaped like a stakna (tiger's nose), Stakna monastery is situated some 15 miles (25 km) from Leh. It was founded in 1580 and contains an important statue known as Arya Avalokitesvara, believed to have come from Assam. An early morning departure and a short scramble up a highpoint gave perspective on the monastery, the Indus Valley and Stok Range behind.

RINCHEN STANZIN (OPPOSITE)
From the plains of the Chang Tang we passed through the village of Rumtse where I noticed a man in a field, spinning wool from one hand onto a bobbin in the other as he moved about his crops. After restraining his not-so-friendly dog, Rinchen Stanzin agreed to be photographed and we moved into the shade of his house where I used a white reflector to illuminate his fine features.

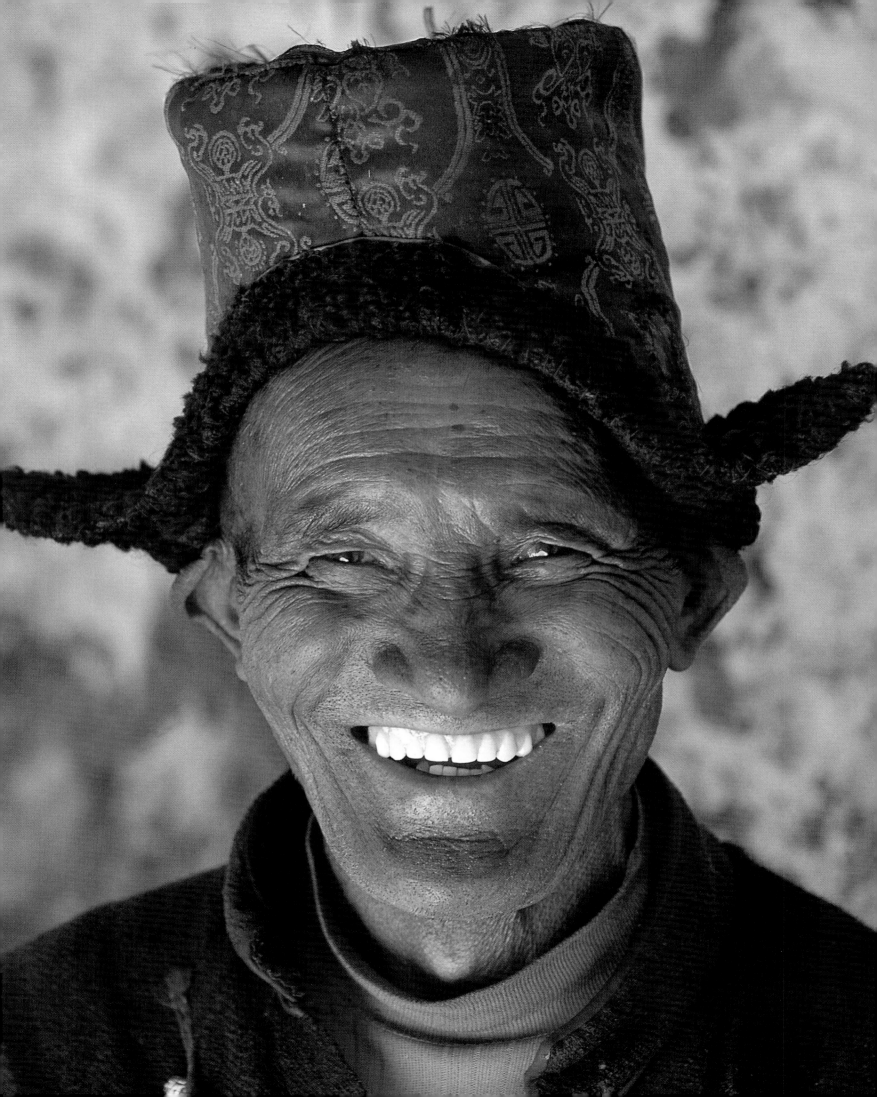

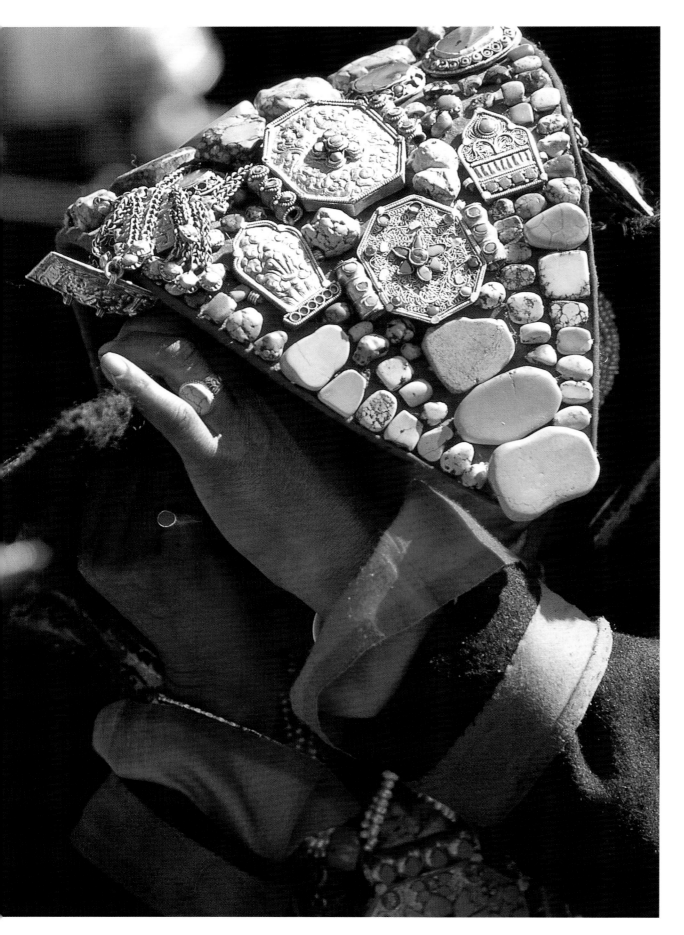

WOMAN'S PERAK (LEFT)
The traditional **perak** *or headdress worn by Ladakhi women on special occasions is their main item of jewellery. A strip of leather covered with cloth and stitched with rows of turquoise and silver covers the forehead and goes halfway down the back. The turquoise stones are passed down the generations from mother to daughter.*

IN PRAYER (OPPOSITE)
Devout Buddhists from Ladakh, Tibetan refugees and the faithful from as far away as Zanskar, Nubra, Dha-Hanu and Chang Tang congregate to celebrate the birthday of His Holiness the Dalai Lama at Jivetsal, Choglamsar. The ceremony began with a Sang offering followed by recitation of Sang Puga.

BIRTHDAY OF HIS HOLINESS
(PAGES 100-101)
In the baking sun at Jivetsal, a group of Ladakhi women prepares to perform a ritual dance. Outside the official enclosure, the birthday celebrations of the Dalai Lama had attracted by now an estimated 15,000 people. In the intense heat, they sat on the grass amongst smouldering pyres which filled the air with the perfume of incense. Vibrantly coloured prayer flags flapped against the blue sky.

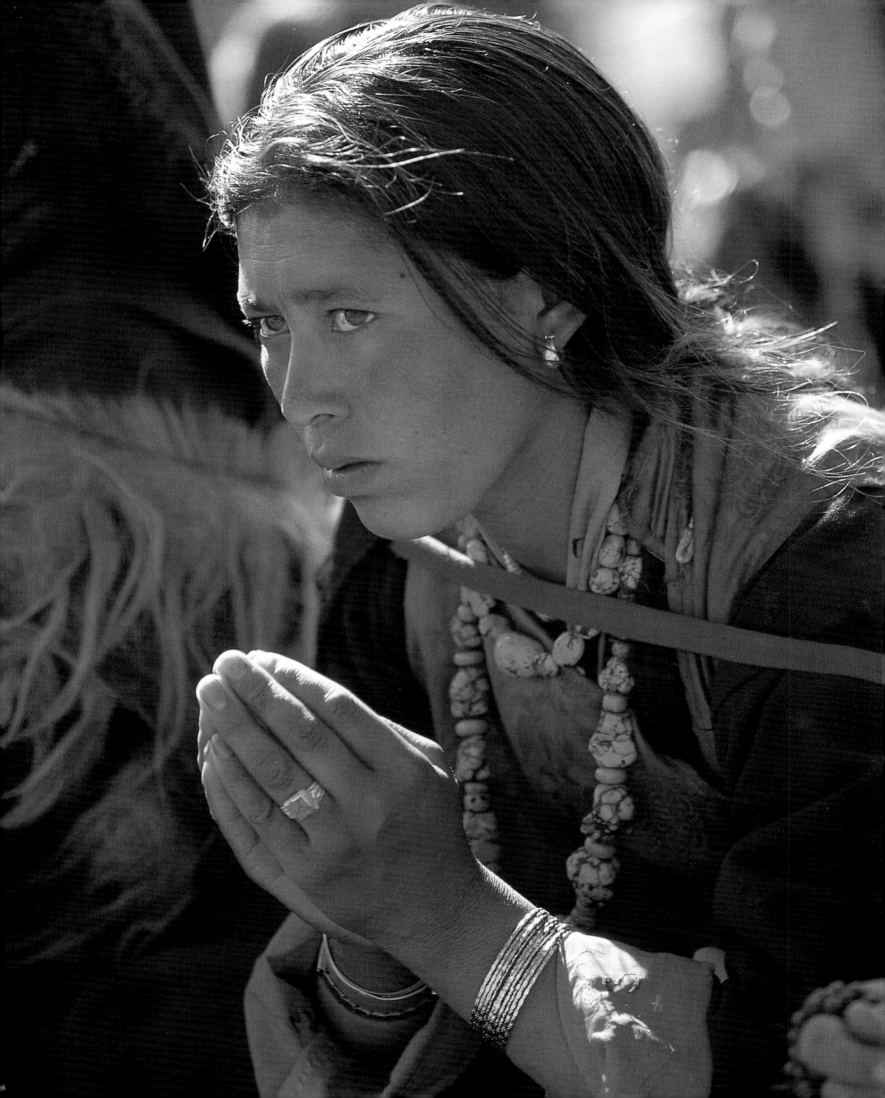

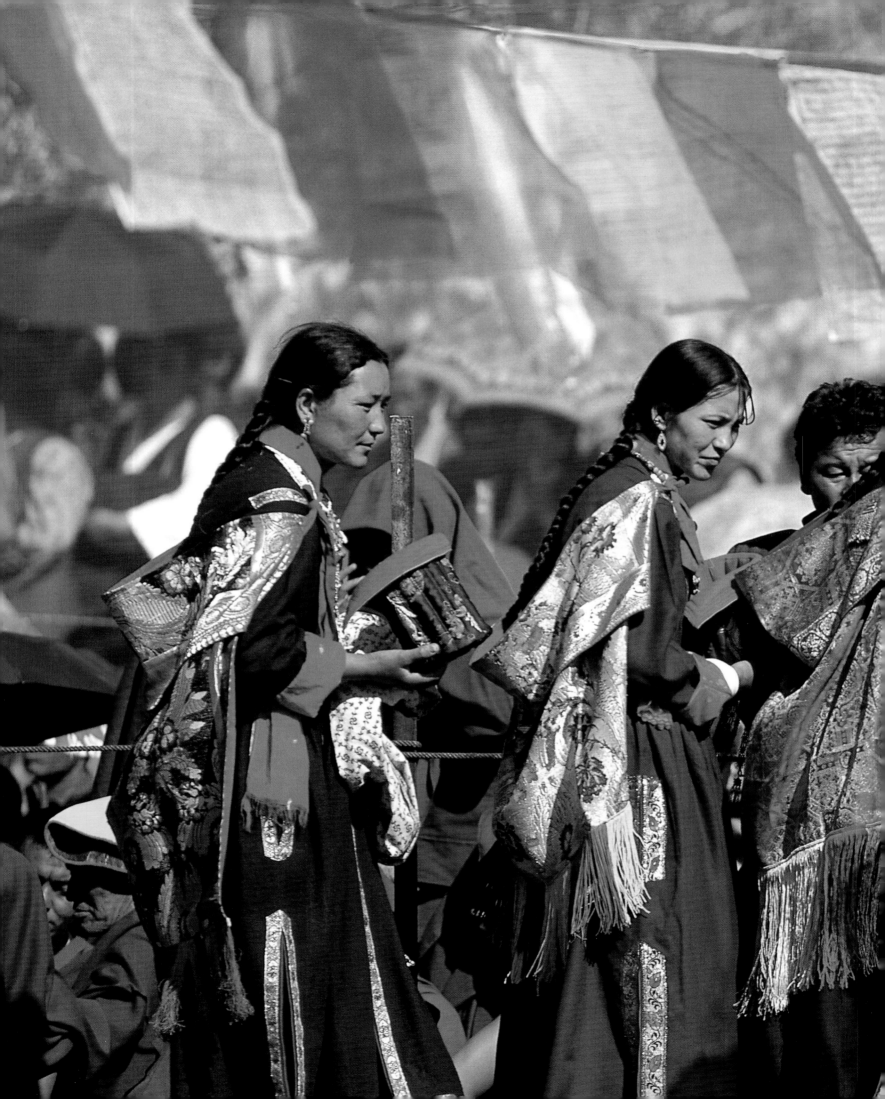

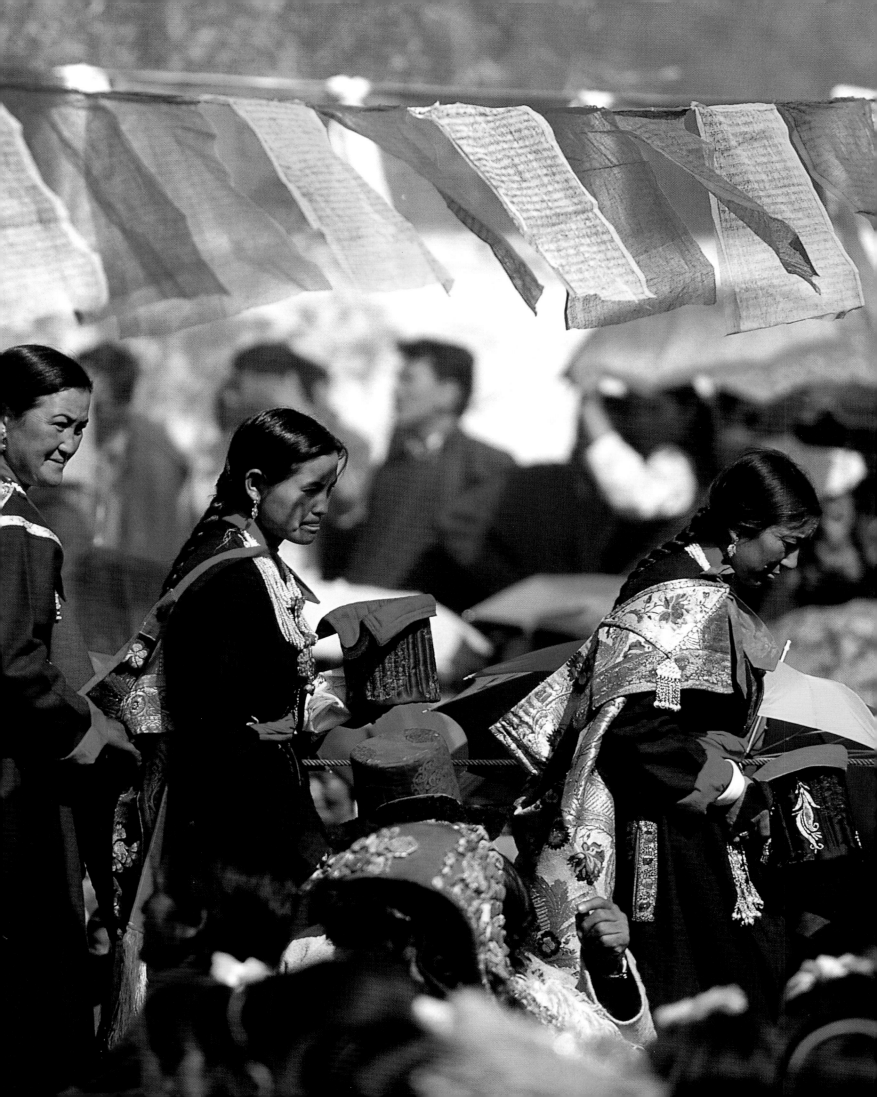

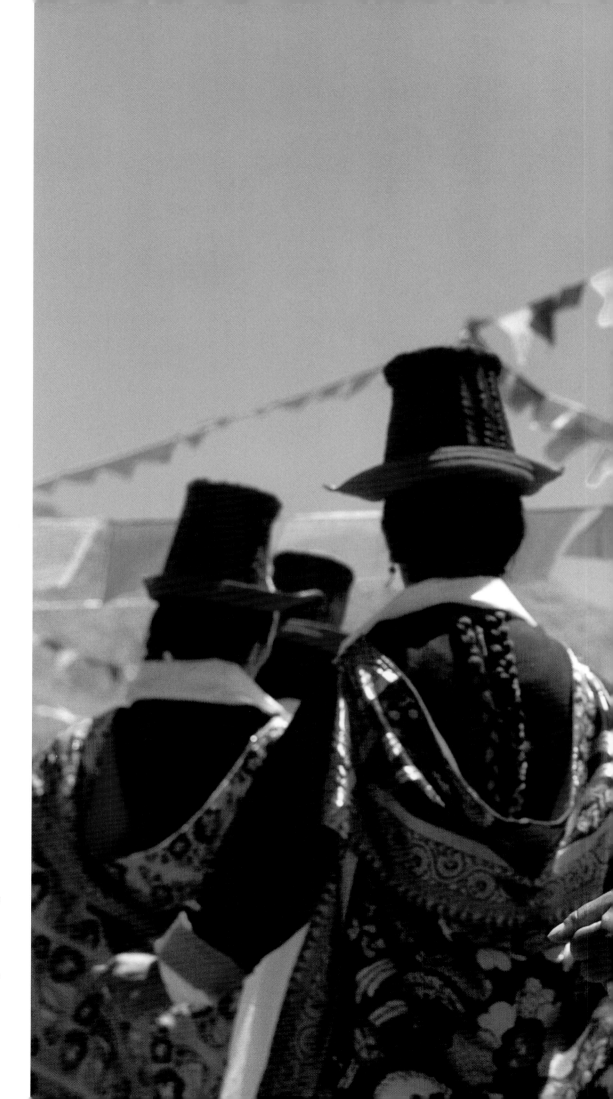

STOVE-PIPE HATS (RIGHT)
The wearing of bright brocade mantles and these jaunty quilted and embroidered stove-pipe hats is today limited to formal and ceremonial occasions. Like the **perak** *and prayer wheel, they have been abandoned by younger generations keen to embrace a modern lifestyle. Yet here, under a lattice of coloured flags, a group of young women is determined to keep the tradition alive.*

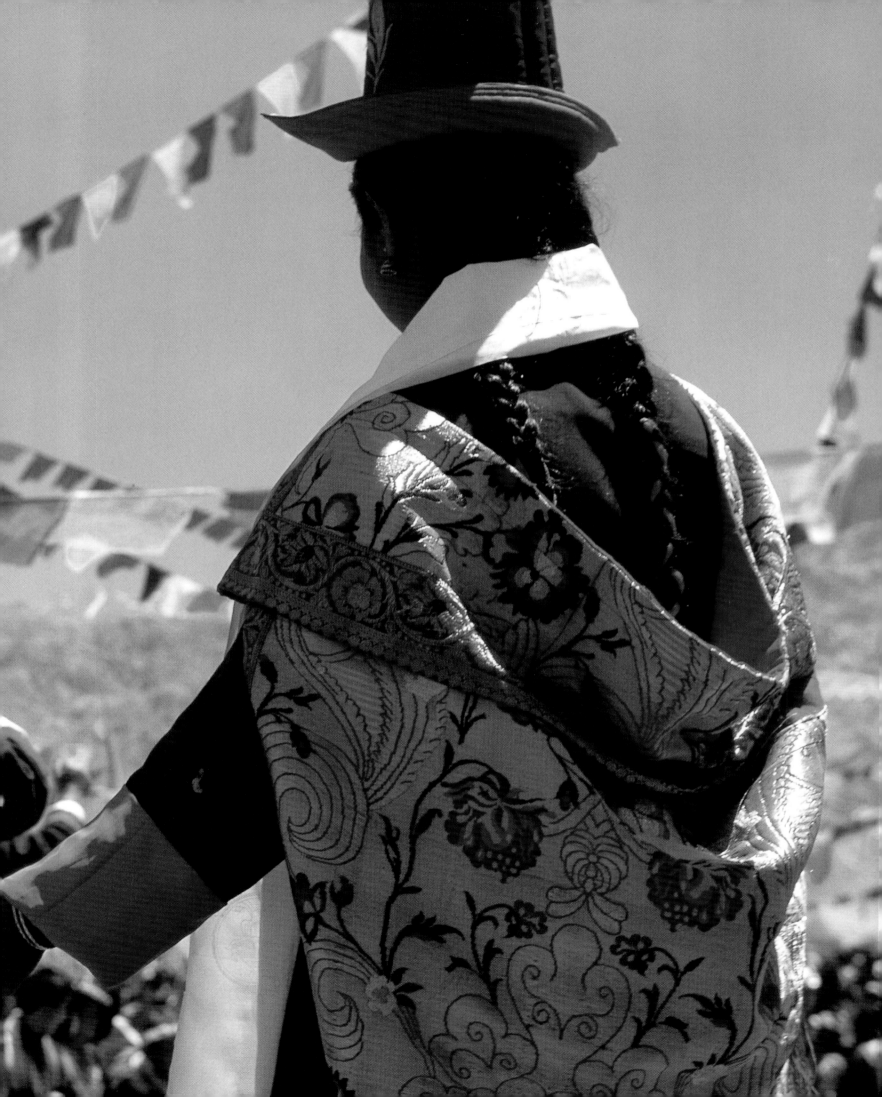

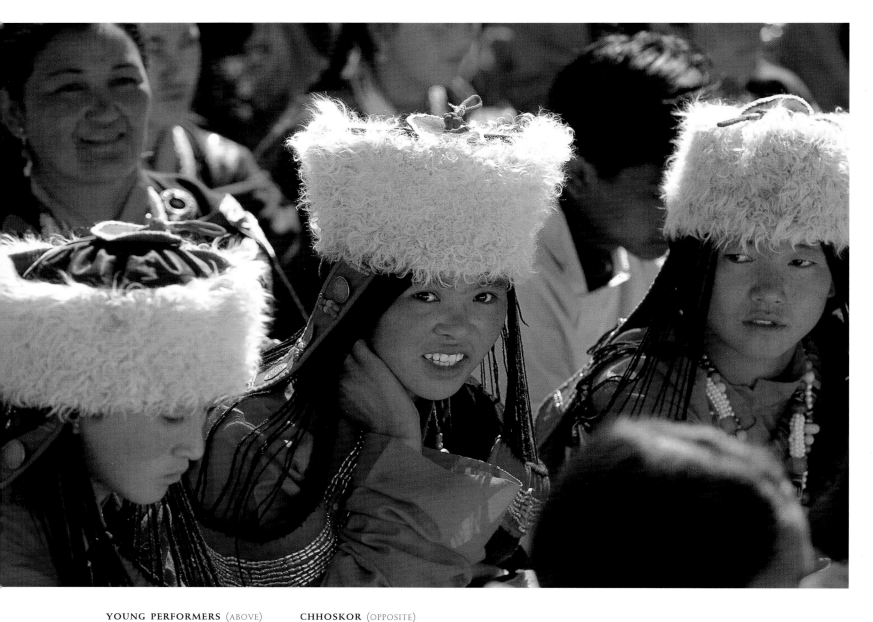

YOUNG PERFORMERS (ABOVE)
*Paying homage to His Holiness,
representatives from Ladakh's
ethnic groups wait in turns to
perform traditional dances
throughout the morning. At midday
the celebrations came to an end and
the Dalai Lama gave a final
blessing by throwing rice into the air
before departing.*

CHHOSKOR (OPPOSITE)
*Spiritual life in Ladakh centres
around the monasteries. The paths
to most monasteries, conspicuously
located on a high point, are lined
with prayer cylinders called*
chhoskor *made of metal and filled
with prayer scrolls and charms.
Before entering a monastery a
devotee sets the cylinders in motion
with gentle strokes, in the belief
that they are sending to heaven
prayers equal to the number in the
cylinder, multiplied by the number
of rotations.*

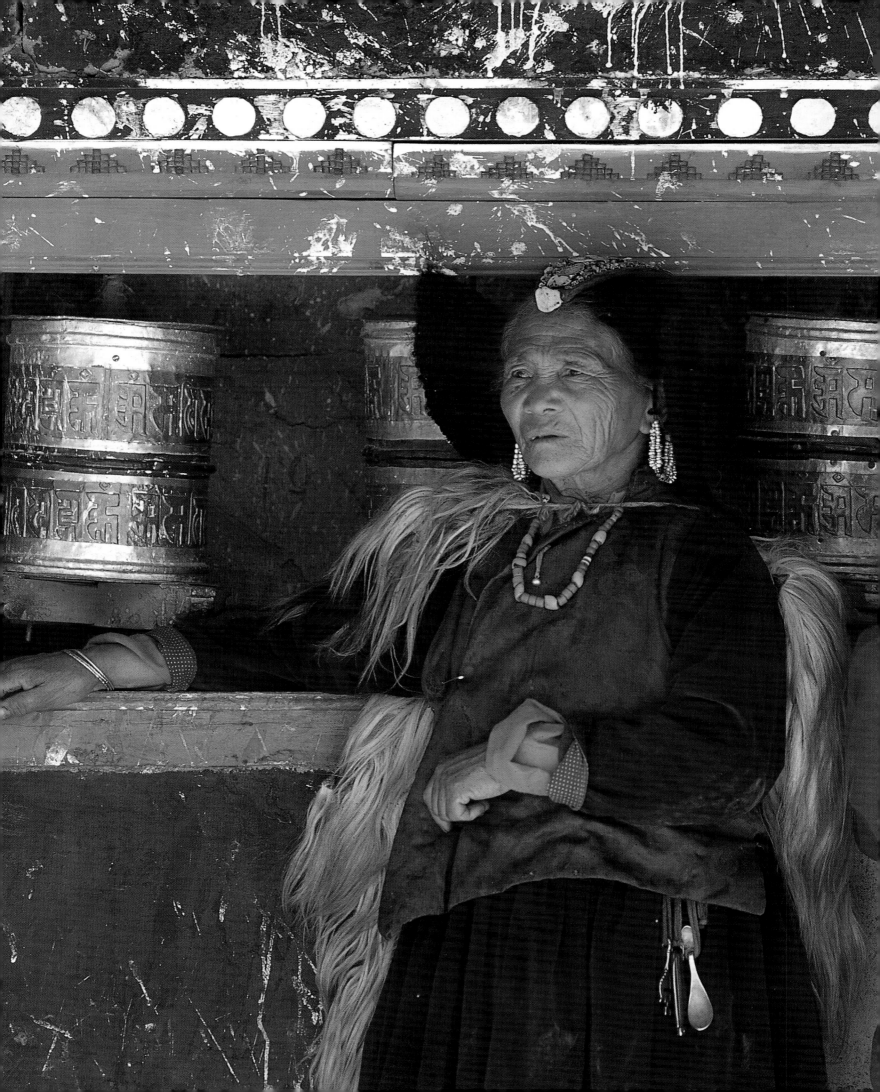

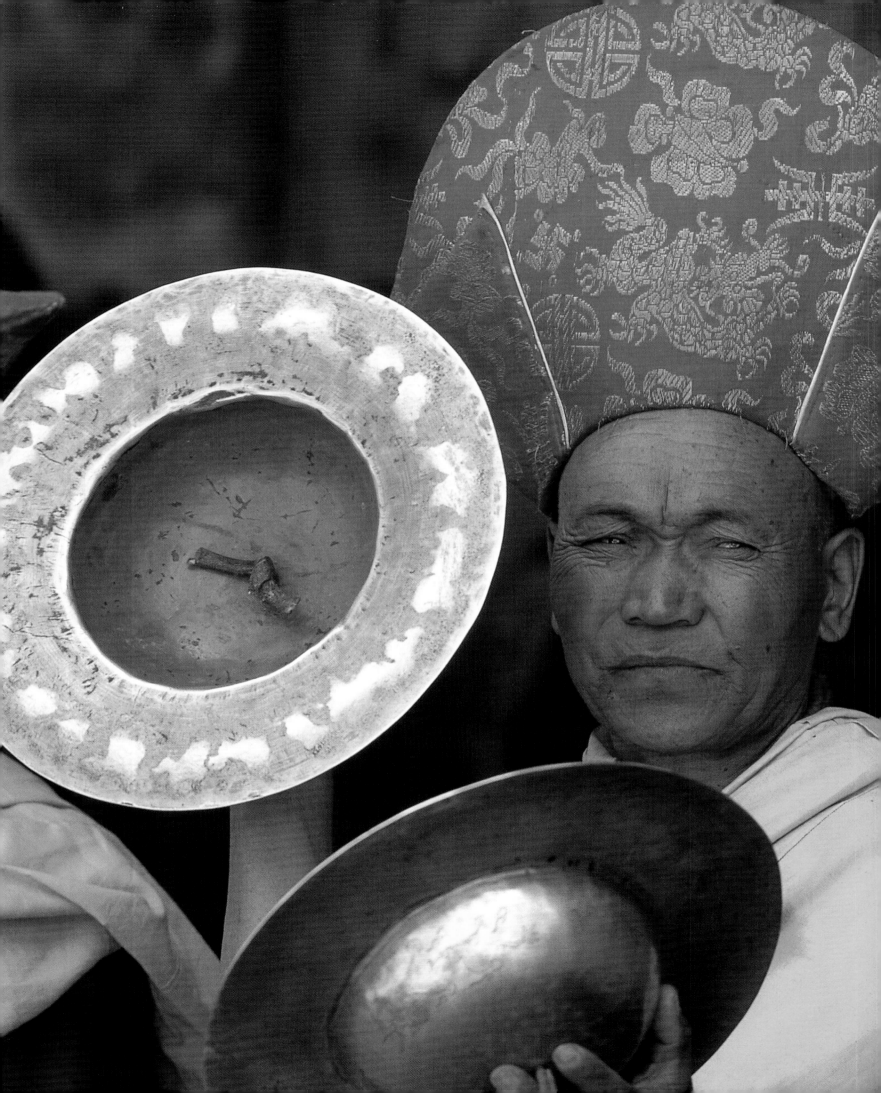

LAMA AT HEMIS (LEFT)
The distinctive metallic clash of cymbals provides the tempo for movements throughout performances at Ladakh's Hemis festival. At times the sound of symbols is sporadic, then, as the performance comes to a climax, the clash of cymbals captures the tension and excitement of the act. Masked monks wear spectacular costumes made of yellow silk and rich brocade, often decorated with ornaments of carved bone.

MASTER OF THE CREMATION GROUNDS (PAGE 108)
The Dance of the Masters of the Cremation Grounds requires some understanding of Tantric symbolism. Four skeletons guard eight cremation grounds which are situated on the edges of the cosmic diagram where Tantric deities dwell. Their mission is to protect the cosmic diagram from demonic influences. Dressed as skeletons they leap about the courtyard terrifying children and molesting onlookers.

TSOGLEN (PAGE 109, ABOVE AND BELOW)
The Dance of the Fearsome Gods depicts five wrathful deities, or Tsoglen, who are symbolic figures of all evil. They represent devils and demons that work against the Buddhist dharma *and peace. In the performance, the mortal remains of evil are turned into pure nectar and are offered by the five Tsoglen to all the Dharmapalas (the protector deities).*

The demonic masks worn by the monks during the performance are so heavy that dancers protect themselves from injury by binding their head in strips of cloth which support the mask. The dancers then see out through the opening of the mouth.

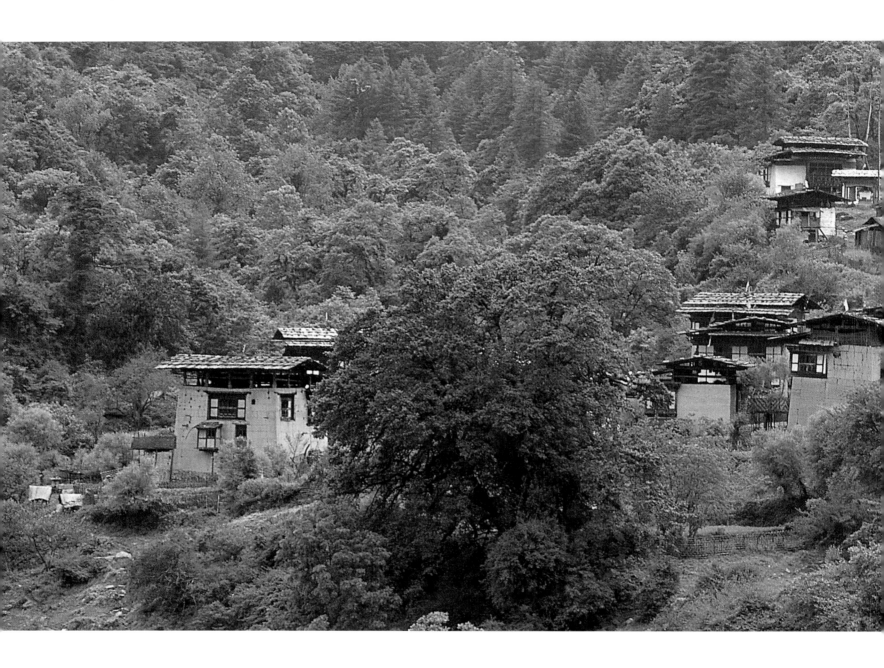

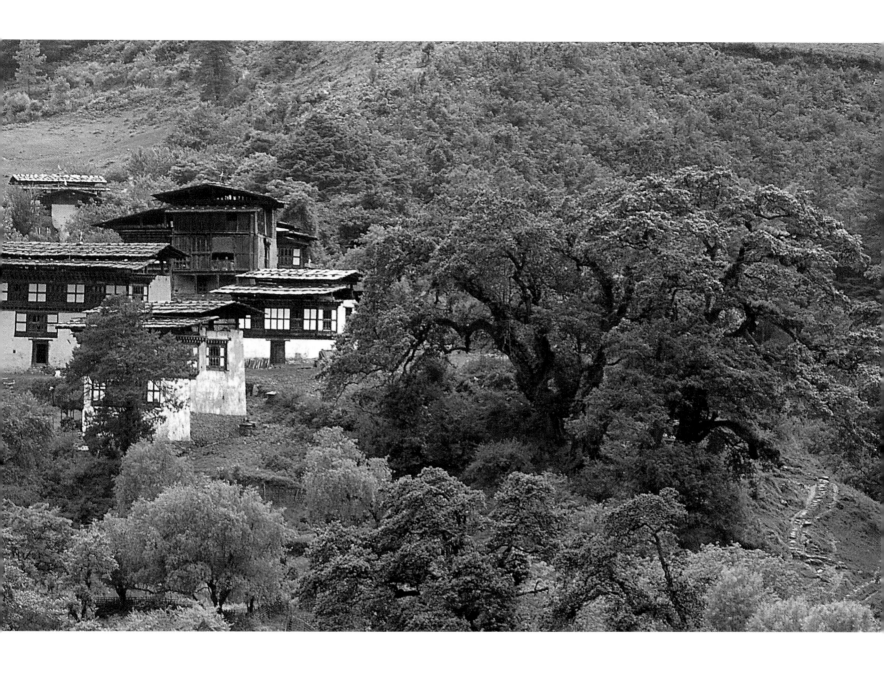

LAND OF THE THUNDER DRAGON

Bhutanese

Today's Bhutanese are descended from Mongols who arrived in the region in the seventh century AD. Initially a nomadic and pastoral society, they gradually settled in the fertile valleys and turned to agriculture. Subsistence farming and animal husbandry remain the main livelihood for 90 percent of the people today.

Introduced to Bhutan in the eighth century, Buddhism has played a fundamental role in the nation's cultural, ethical and sociological development. The country's Bhutanese name Druk Yul, or Land of the Dragon, derives from "Drukpa Kagyupa", the name of a branch of Mahayana Buddhism. This has been the official religion since the 1600s when the Tibetan statesman and religious leader Shabdrung Ngawang Namgyal first united the region's assorted peoples (Myers, 1987). Alongside study and meditation, monks and nuns perform prayer and rituals honouring *bodhisattvas*. These often involve singing and chanting, accompanied by conch-shell trumpets, thigh-bone trumpets (traditionally made from human thigh bones), drums, bells and cymbals.

Bhutan's people are made up of three main ethno-linguistic groups. The Sharchhops inhabit the east and southeast of the country and are believed to be descended from the original inhabitants. The Ngalongs, of the western and central regions, are descendants of Tibetan immigrants who arrived in the ninth century. Both of these groups are Buddhist and are collectively known as Drukpa. The third group are the Lhotsampas, Hindus of Nepalese descent, who live in the south.

By the early 1980s, Lhotsampas accounted for 30 percent of Bhutan's population. Fearing their demands for democracy, the government began protecting traditional Bhutanese culture by cancelling tuition in Nepalese, promoting the national Dzongkha language, and enforcing a code of national dress. Between 1988 and 1994, more than 100,000 refugees made their way across the mountains of northern India to southeast Nepal, seeking refuge in camps constructed under the supervision of the United Nations High Commission for Refugees (Report on Religious Liberty in Bhutan, 2000).

National dress remains obligatory for all inhabitants, with the exception of footwear. Men wear a loose, waist-length *togo* (shirt), and *go* (robe), gathered at the waist by a belt known as a *kera*. Women wear an intricately handwoven *kira* (dress) over a Tibetan-style *wonju*, a loose long-sleeved blouse of silk or other lightweight fabric. Their outfit is completed with a short wide-sleeved jacket and necklaces strung with silver amulets. Fabric weaving remains an important part of Bhutanese life (Myers, 1987).

CHENDEBJI (PAGES 110-111)
The village of Chendebji, 26 miles (42 km) from Tongsa, is built on a hillside and is reached by an ancient bridge roofed with bamboo matting. Throughout Bhutan, houses have the same characteristics: rectangular, with one or two storeys. The upper floors are constructed as an open framework with bamboo laths filling the spaces, covered with plaster. Windows traditionally had no permanent protective screening; sometimes bamboo screens were put up to shut out bad weather without excluding light, but today glass is used in most populated areas. The space between the flat roof and the two-sided sloping roof is used for drying vegetables and meat, and for storing hay.

NEMALUNG TSECHU (OPPOSITE)
A young girl is captivated by a spectacle of costume and dance at the Nemalung Tsechu. Religious dances, or cham, *can be grouped into three kinds: didactic dances which have a moral (Dance of the Princes and Princesses); dances that purify and protect a place from demonic spirits (Dance of the Black Hats); and dances that proclaim a victory for Buddhism and the Glory of Guru Rinpoche (all dances with drums; Dance of the Eight Manifestations of Guru Rinpoche).*

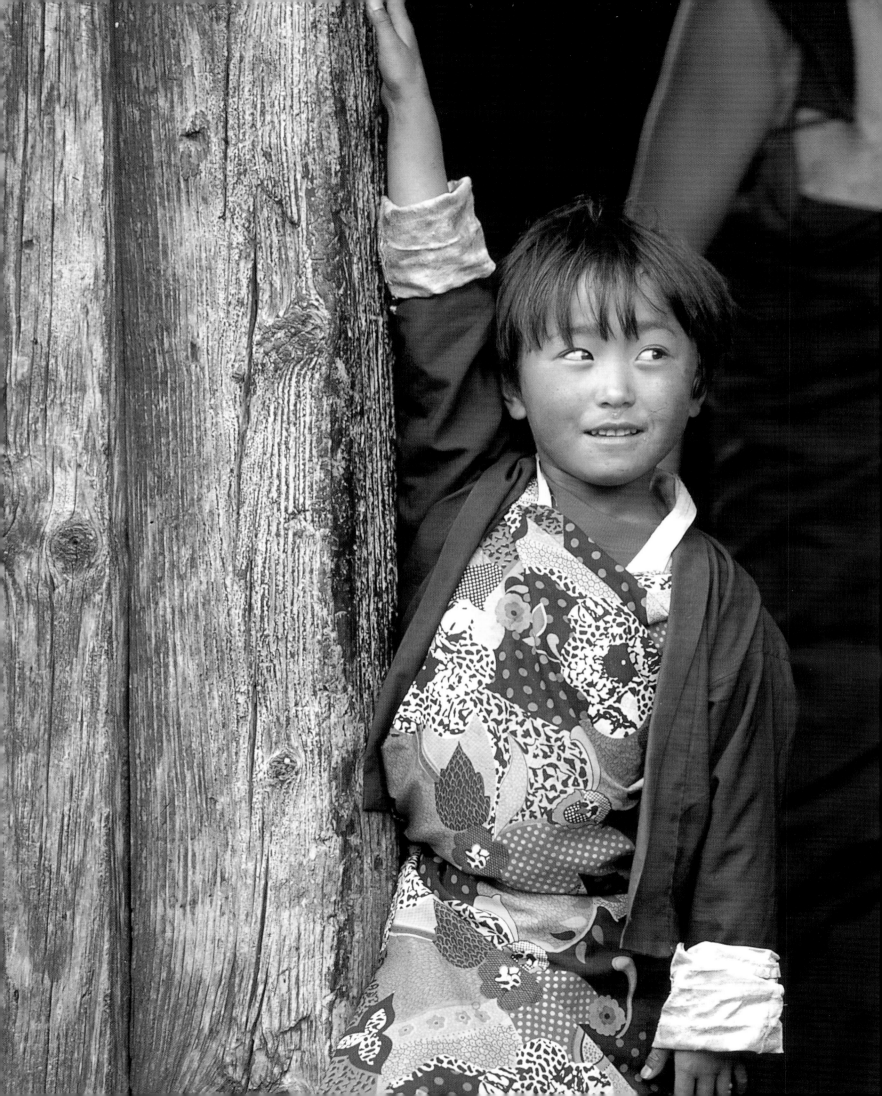

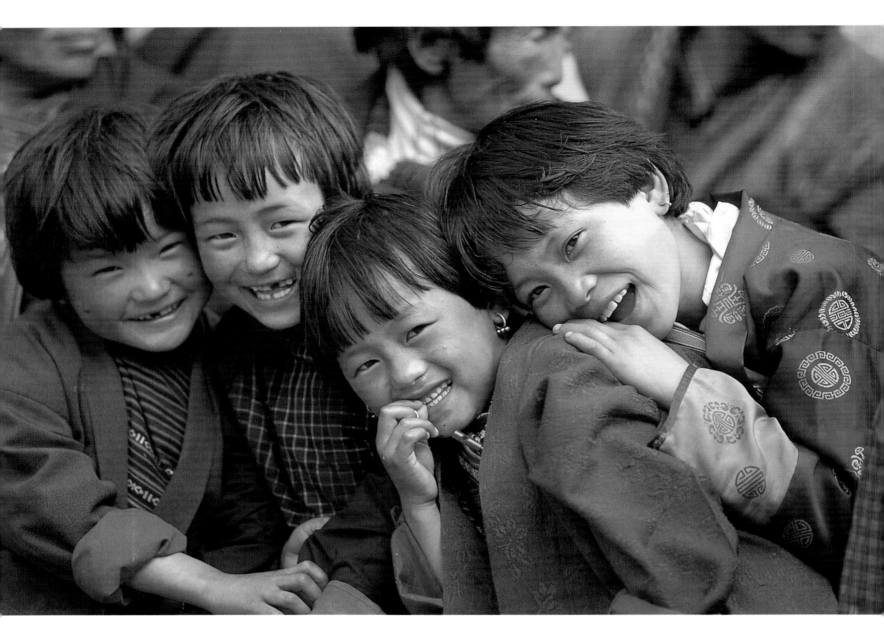

BHUTANESE CHILDREN (ABOVE)
Bemused by a stranger, children perform in front of the lens at the Nemalung Tsechu. The Nyingmapa monastery of Nemalung is hidden in the woods, half an hour's walk from Pra. Founded in 1900, the monastery has a high reputation for the quality of its teachings, its musicians and the discipline which prevails. Tsechus are festivals in honour of Guru Rinpoche, commemorating his great deeds. They are celebrated annually for between three and five days, depending on the location.

GIRL AT TSECHU (OPPOSITE)
Besides its religious significance, the tsechu is an important social event. People wear their finest clothes and most beautiful jewellery, and bring picnics with meat and abundant alcohol. Men and women joke and flirt, and an atmosphere of conviviality prevails. By their attendance at a tsechu, the devotee gains a Buddha's blessing or can reach and experience a spiritual release through a Tantric deity. In any case, one gains the goodwill of the local protective deities.

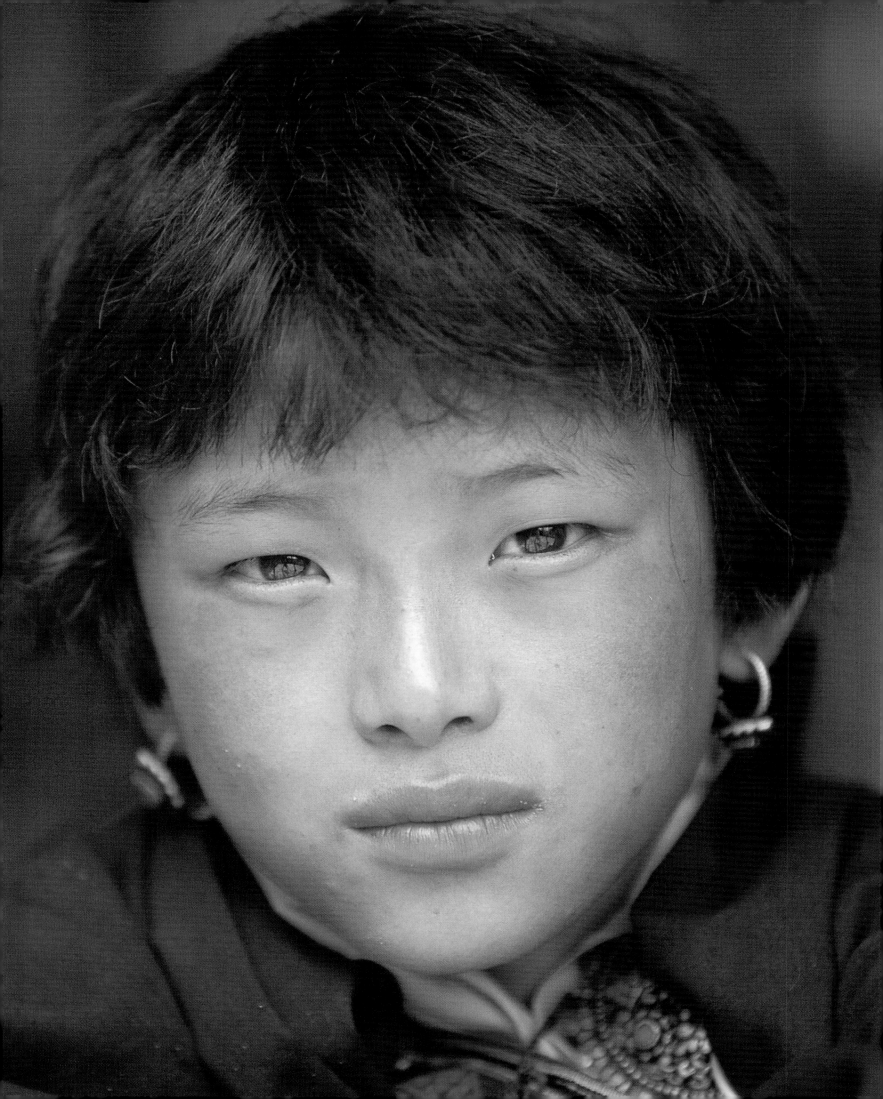

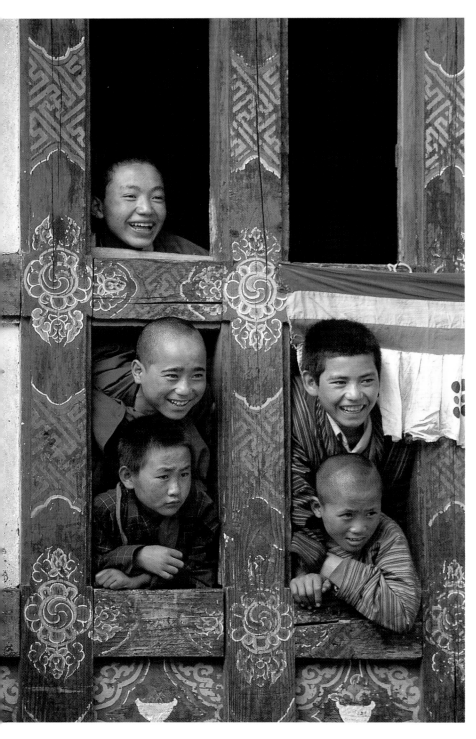

GELONG AND GOMCHENS
(ABOVE)
Boys enjoy a series of dances performed by both **gelong,** *or ordained monks, and* **gomchens,** *who are half laymen and half clergy, most of them belonging to the Nyingmapa School. Gomchens differ from ordained monks in that they live at home and have a family.*

SENGYE DRATHOK (OPPOSITE)
In the Dance of the Eight Manifestations of Guru Rinpoche, Sengye Drathok (He with the Voice of a Lion) wears a terrifying blue mask crowned with five skulls. He holds in his left hand the "diamond-thunderbolt" which represents purity and indestructibility, and hence the Buddha-spirit. In his right hand he holds the **phurpa** – *a ritual dagger.*

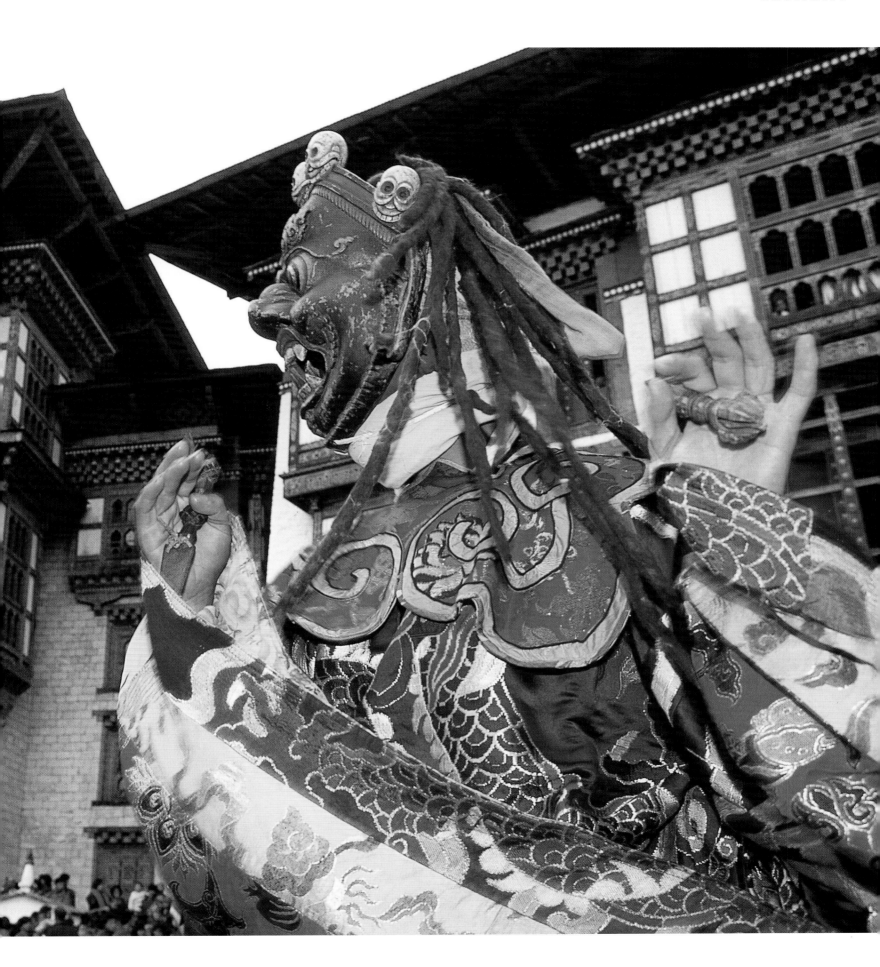

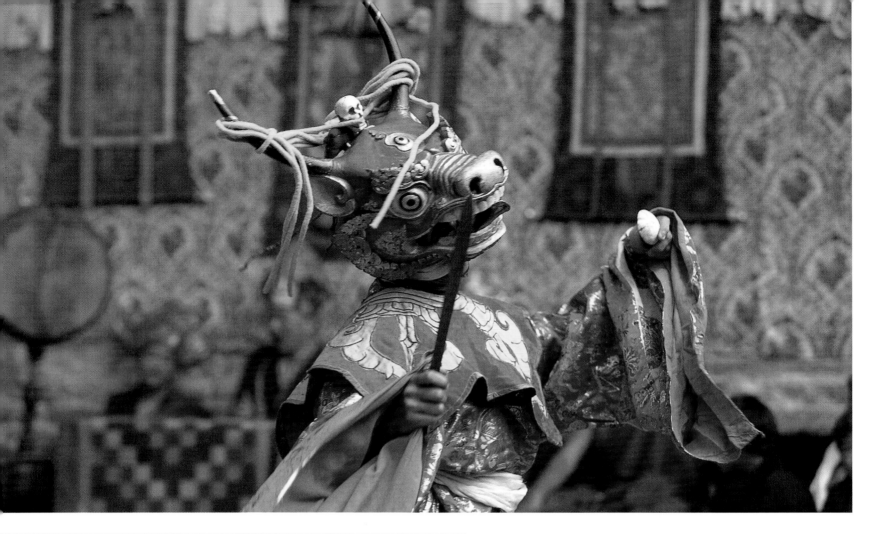

DANCE OF THE FOUR STAGS
(ABOVE)

Dancing to the clash of cymbals, a monk performs the Dance of the Four Stags. This commemorates the vanquishing of the God of the Wind by Guru Rinpoche, who commandeers the god's stag as his own mount.

KUNZANG DORJI
(LEFT)

During a lull in the performances, this five-year-old-boy and two friends found me the object of their amusement. With the use of a telephoto lens I was able to capture his mischievous expression.

THONGDEL (OPPOSITE)

To a spellbound audience, the Thongdel (a giant appliquéd thangka) is unveiled to signal the start of the annual Kurjey Tsechu. Monks lining the top of the monastery's central tower raised the massive appliqué, measuring 75 by 85 ft (23 by 26 m), from the stone cobbled courtyard. The Thongdel depicts Guru Rinpoche and his Eight Manifestations, and deliverance from samsara, or rebirth, is assured for all those who are fortunate enough to set eyes on it.

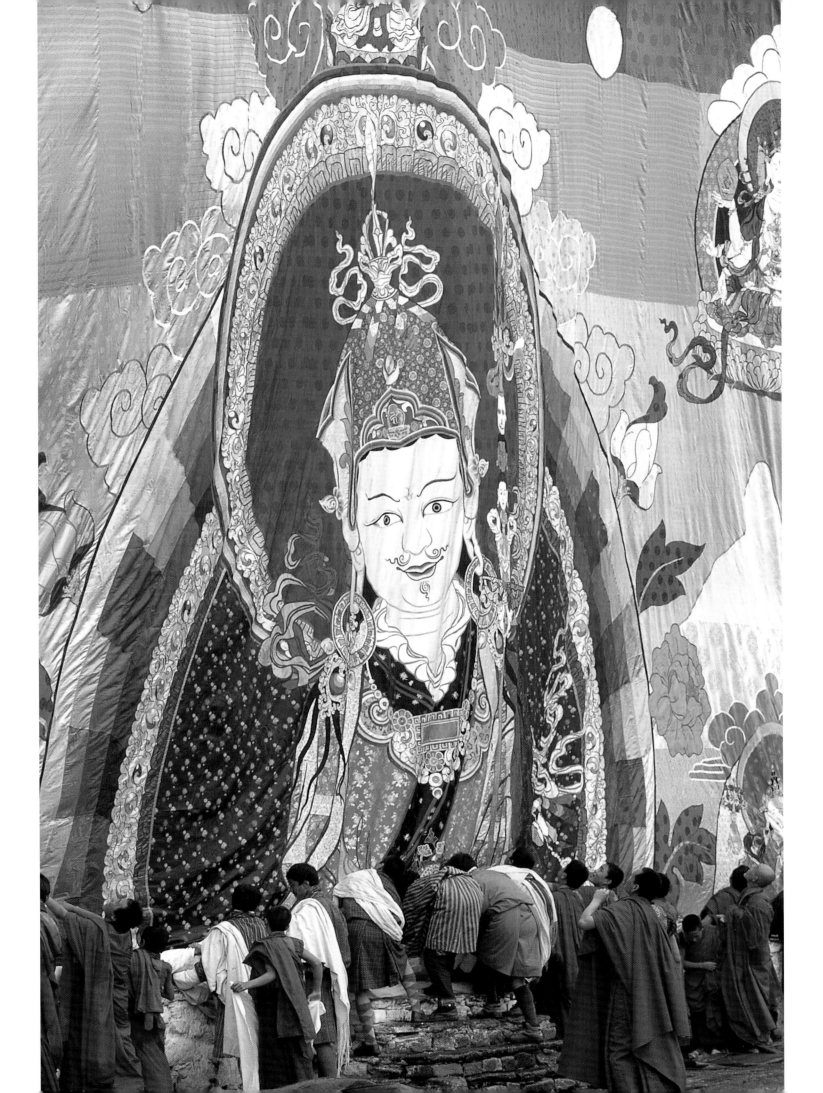

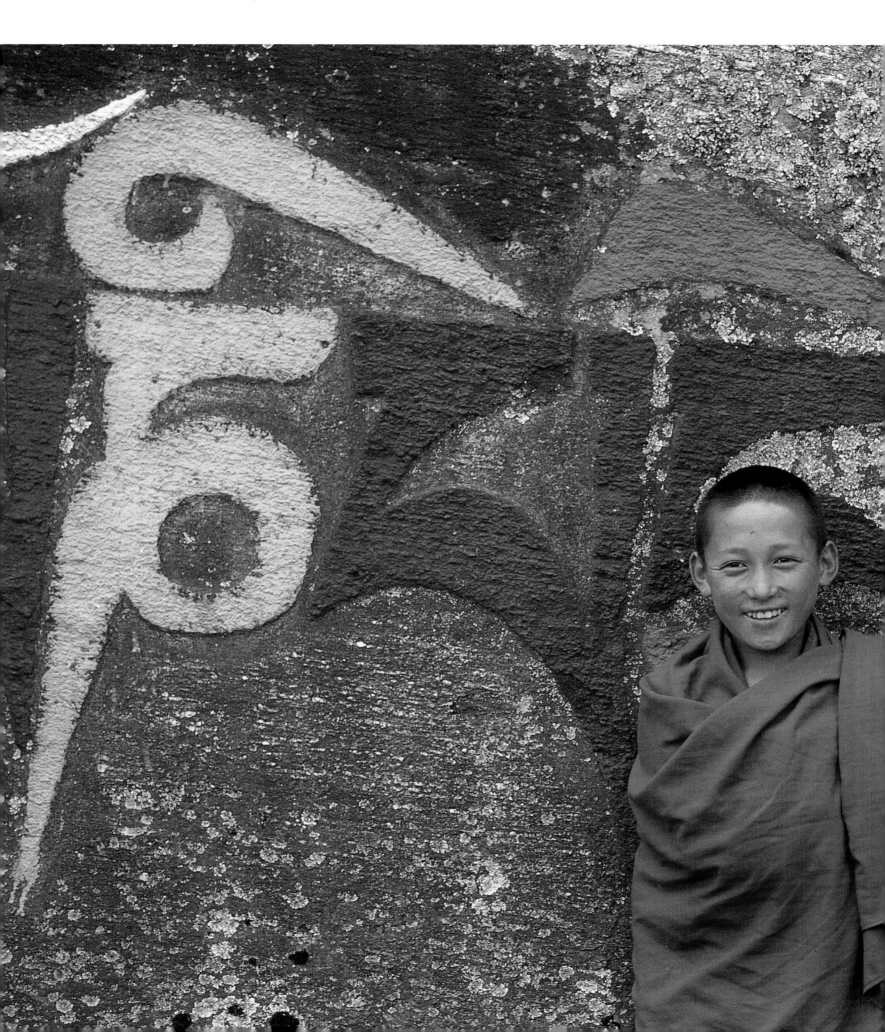

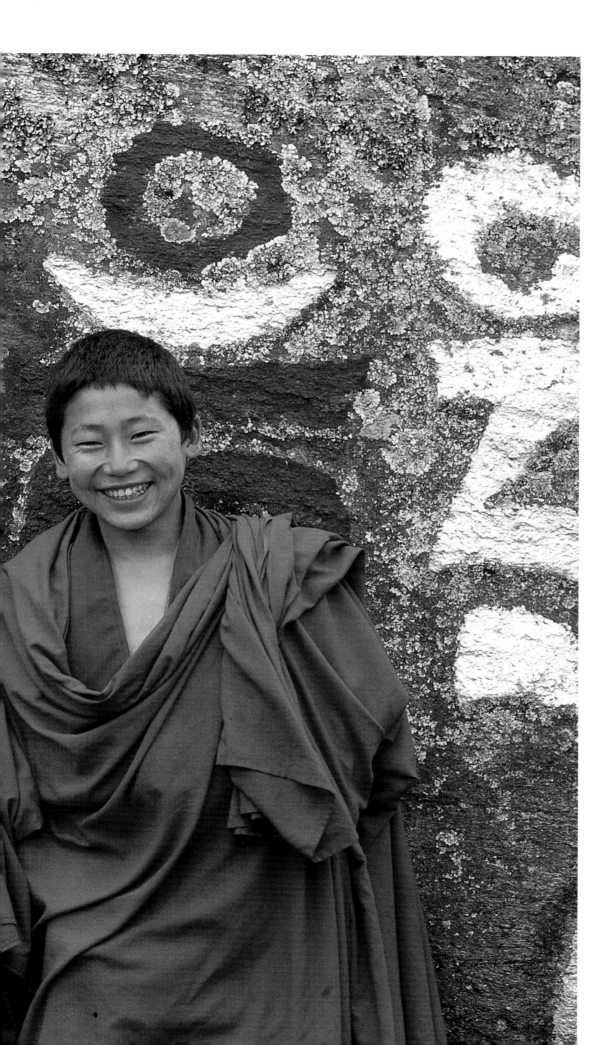

YOUNG MONKS (LEFT)
*Against the backdrop of a giant rock at Kurjey Lhakhang, two young monks pose for a photograph. Ordained monks (**gelong**) wear a characteristic red robe. They can be placed in a monastery aged as young as five or six, which brings great prestige to their families. They follow monastic academic courses and after a few years, depending on their aptitude, are then directed into purely scholastic roles or into more artistic religious pursuits (as dancers, musicians, painters or tailors).*

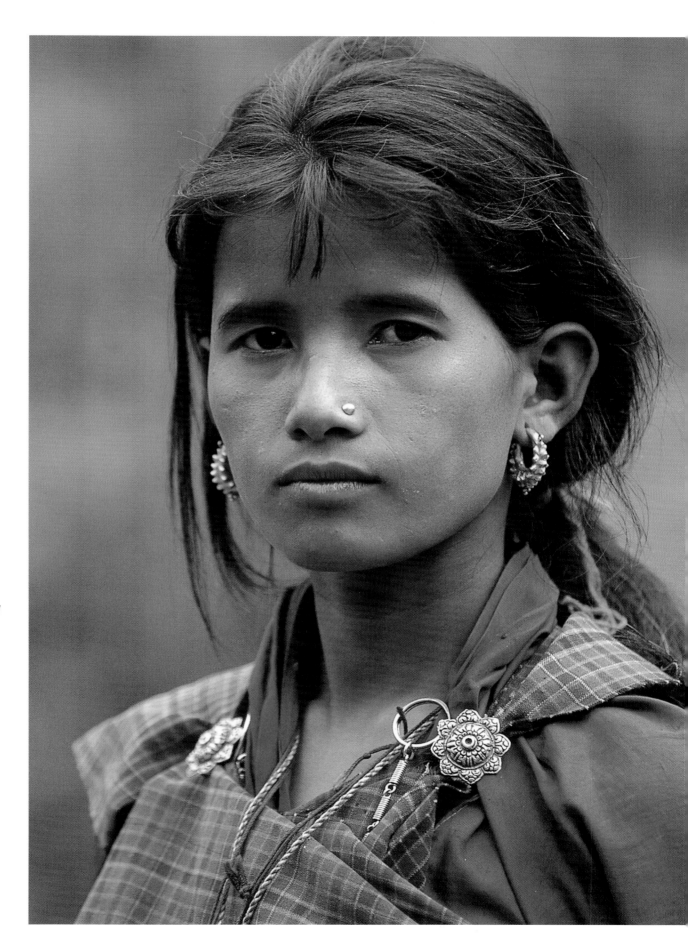

PRAYER WHEEL (OPPOSITE)

In the town of Jakar, I came across Gongze, a lady of 85 sitting outside her home. As she spun her prayer wheel, a warm smile revealed a single tooth. In most villages in Bumthang the woman is the head of the household. The land is passed on from mother to the daughter, and after marriage the man moves in with his wife. Local political opinion and decision-making processes are largely steered by the women, and at district-level political events up to 90 percent of those present may be women.

KIRA (RIGHT)

The term kira *means "dress for wrapping up". It consists of a rectangular piece of cloth, sewn together from three lengths of cloth along the warp. The cloth is wrapped around the body so as to make a big fold in front. It is then pulled up through a tight sash belt so that the cloth makes a spacious belly pocket, in which articles of daily use can be carried. Although all* kiras *are worn in the same way, the number of patterns, each of which has its own name, seems enormous.*

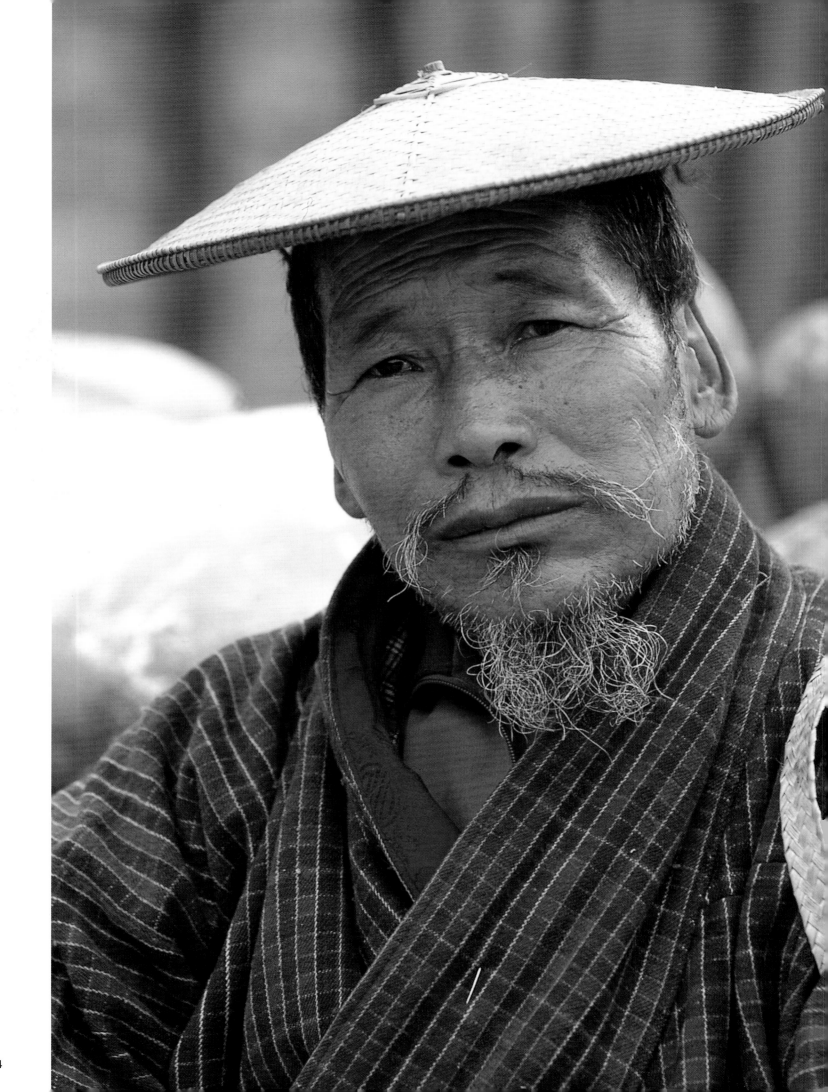

124

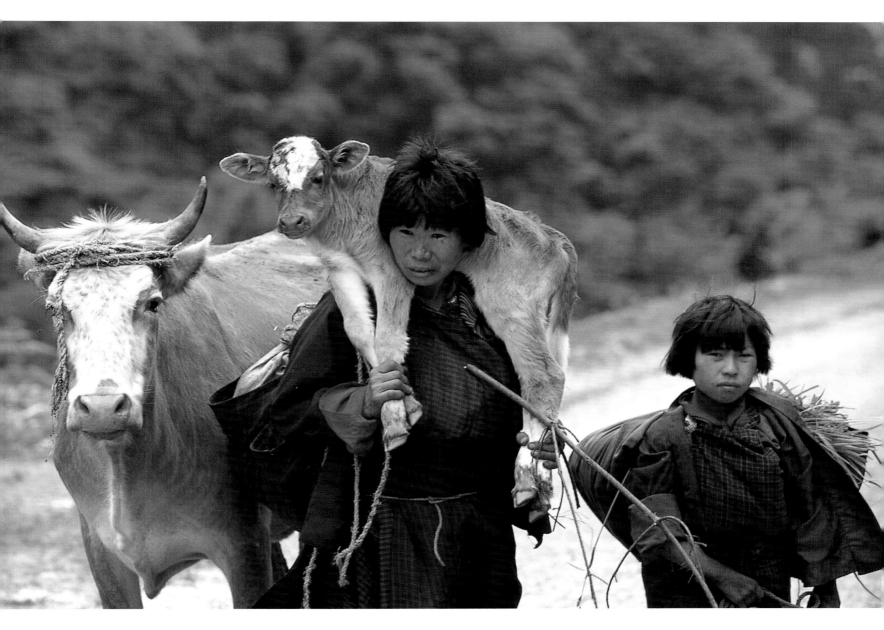

YATHRA (LEFT)

Outside a store in Jakar, a local man rests. At an elevation of 785 ft (2580 m), the village of Jakar is the principal trading centre of the region. A number of small timber-built shops line a single main street, selling a wide variety of goods, including strips of yathra – *hand-woven wool strips with geometric patterns specific to the Bumthang region. Three strips may be joined to produce a blanket or bed-cover called a* charkep. *More recently* yathras *have been used to make* togos, *a short jacket that women wear over the* kira *in cold weather.*

WOMAN WITH CALF (ABOVE)

Near the village of Chendebji a woman carries a calf to a grazing pasture. For the majority of Bhutanese people, daily life is shaped by the rhythms of subsistence farming, cultivating crops of barley, wheat, potatoes and mustard. Situated on the south side of the river Nikka Chhu, Chendebji is surrounded by stands of blue pine, spruce, oak and dwarf bamboo.

INSIDE THE GOLDEN TRIANGLE

Lisu

The Lisu live among the lush hills and valleys of the Golden Triangle, a region straddling northern Thailand, eastern Myanmar and northwestern Laos. They share the area with other tribes including the Hmong, Karen, Lahu, Mien and Akha. Anthropologists believe these people came in various migrations from China and Tibet as long as 2,000 years ago. In the 19th and 20th centuries large numbers of Lisu migrated into what are now the Kachin and Shan states of Myanmar. Moving southward along the mountain ranges either side of the Salween, they also settled in northern Thailand. In the 1990s, as many as 400,000 lived in Myanmar and 25,000 in Thailand (Dessaint and Dessaint, 1992).

Like other hilltribes, Lisu practise subsistence "slash-and-burn" agriculture, moving on when the soil has become impoverished (Larsen, 1984). They also keep goats, cows, sheep, cattle and fowl. Their needs for other foods, clothing and goods are met by growing opium poppies and selling the drug as a cash crop. Increasingly, hilltribe farmers are relinquishing food production to step up these opium operations. Some have set up field centres in the remote highlands where they produce heroin. Less bulky and harder to detect than opium, their supplies are smuggled out of the region and onto the narcotics markets of the U.S.A. and other western countries.

Although some hilltribes are Buddhist, Lisu religion is based on spirit and ancestor worship. Their spirit world is complex, comprising area hill spirits, village guardian spirits and household ancestor spirits. Each village maintains a fenced compound with an altar for its guardian spirit, while each household keeps an altar for worshipping ancestor and lineage spirits. Shamans are the intermediaries through which the Lisu communicate with the spirit world. They call down spirits to possess their bodies so villagers can ask for guidance on issues such as illness and other misfortunes (Durrenberger, 1980). Soul-loss is a typical diagnosis of symptoms such as general malaise, anorexia and insomnia. To counteract it, the Lisu hold soul-calling ceremonies to persuade the spirits to return runaway souls to their owners.

The Lisu also differ from other hilltribes in their music. Lisu men make musical instruments such as mouth organs, flutes, lutes and jews' harps from wood, bamboo and rattan. Only men play instruments, although both sexes sing; and, unlike in other cultures, instruments and song are never used together. At the New Year ceremony, musicians take turns through the night while people dance around the "spirit tree". The Lisu believe that music and dancing please the spirits, and that dancers stamping on the ground hold back bad spirits to stop them making the transition to the new year (Larsen, 1984).

MAE HONG SON
(PAGES 126-127)
Lisu settlements are located in the highlands at an average altitude of 3,300 ft (1000 m). Here they cultivate buckwheat, millet, mountain rice and a range of vegetables, plus opium for sale. They set aside part of the rice for producing alcohol. Additional income may be drawn from the sale of domesticated animals such as pigs and cattle.

GIRL AT LISUMAETHO
(OPPOSITE)
Nowhere is the determination to be "number one" more evident than in Lisu clothing. The coloured strips on the yokes and sleeves of the young women's tunics, the multiplication of strands in the long tassels that hang from their sashes, and the copious amounts of silver with which they adorn themselves, are all vivid symbols of their consuming desire to outdo one another.

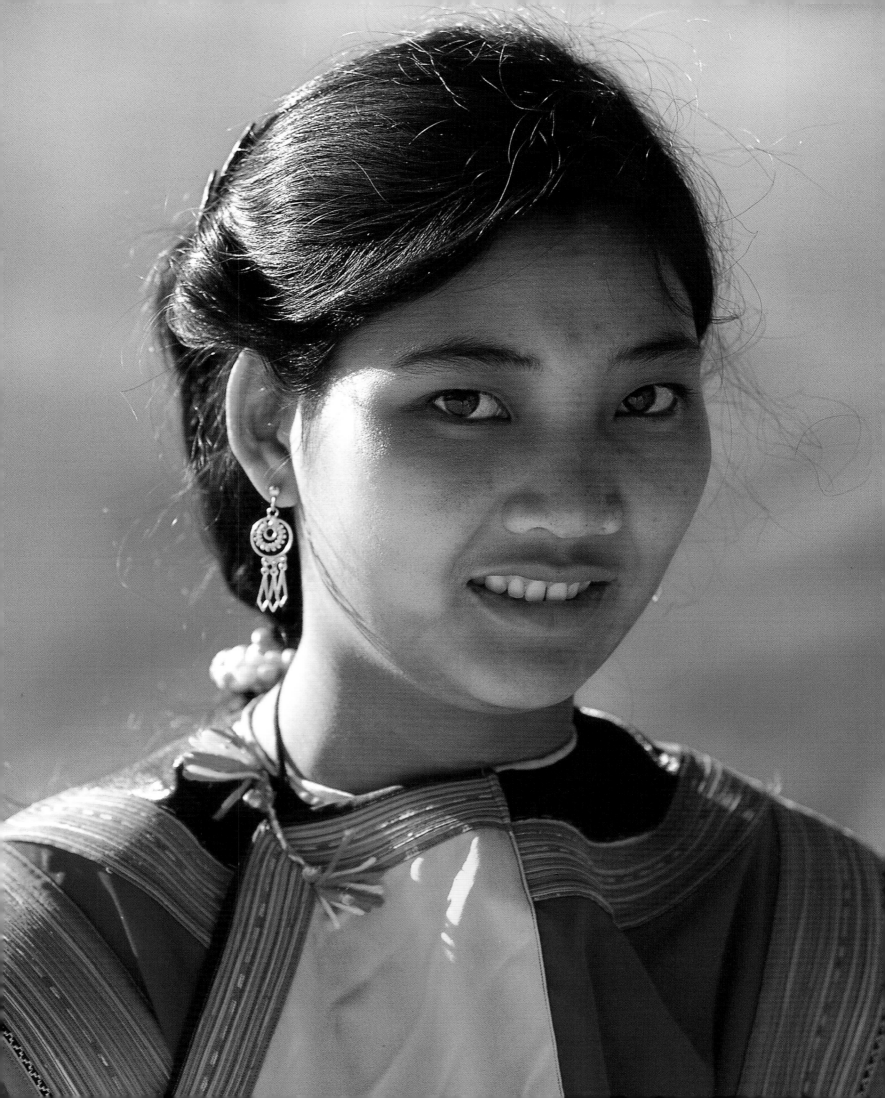

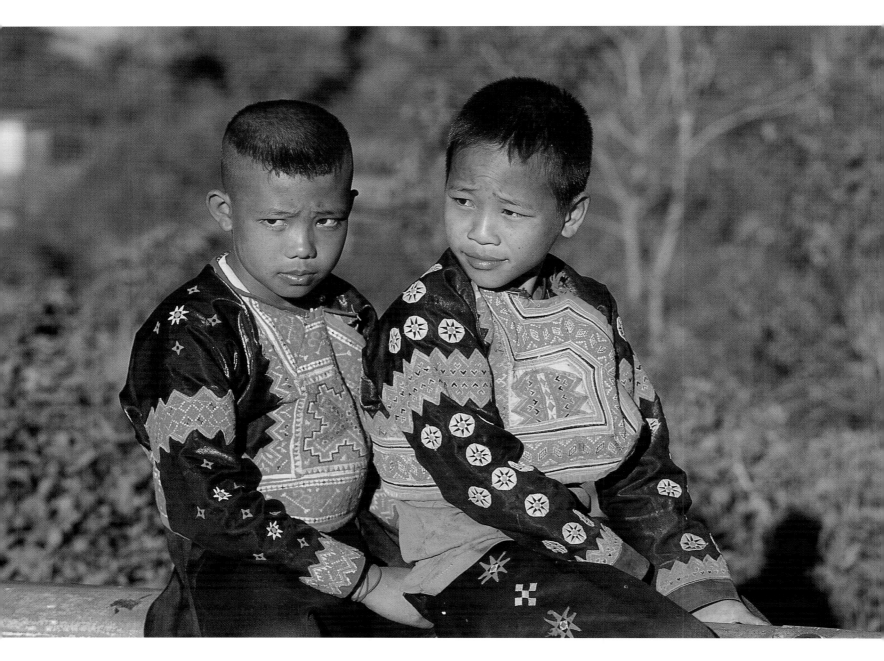

NEW GENERATION (ABOVE)
The Lisu tribe is made up of several patrilineal clans. The clan is important because it stands as the chief determinant of kinship relations and marriage rules. Monogamy and clan exogamy (where the man is compelled to marry outside his clan) are the ideal practices which, when followed, strengthen familiarities and provide a cohesive force in Lisu society. Without a political secular leader at village level, Lisu solidarity depends on this in a way that differentiates them from other tribes.

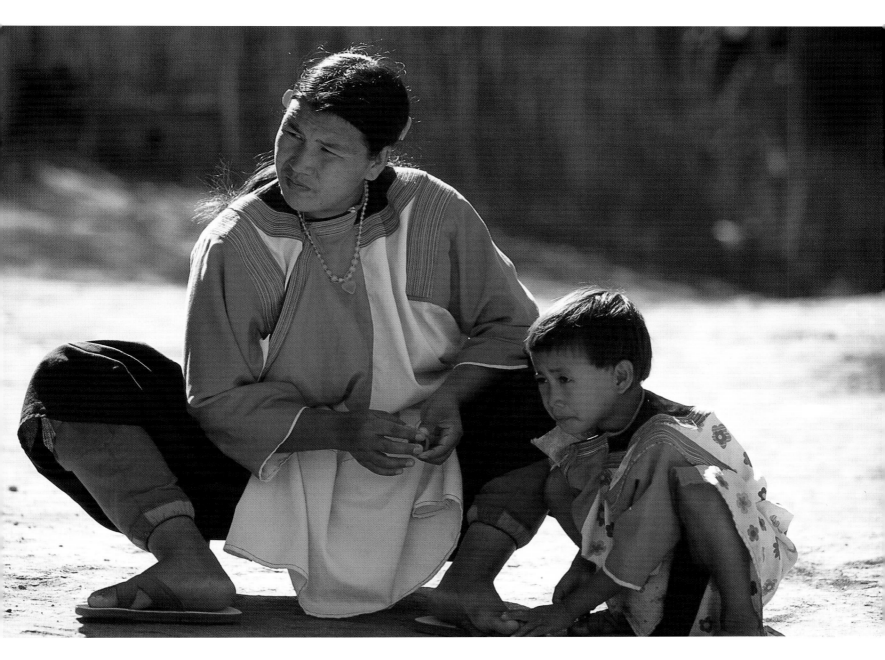

NUCLEAR FAMILY (ABOVE)
*Whilst extended family households
are common among some hilltribes
such as the Meo and Yao, the
nuclear family is characteristic of the
Lisu and other tribes like the Lahu,
Akha, Karen, Lua, H'tin and
Khamu. The nuclear family
household consists of just two
generations, a husband and his
wife, and their children. It forms the
basic socio-economic unit, charged
with the responsibility of providing
food, shelter, welfare, education,
religious training and socialization.*

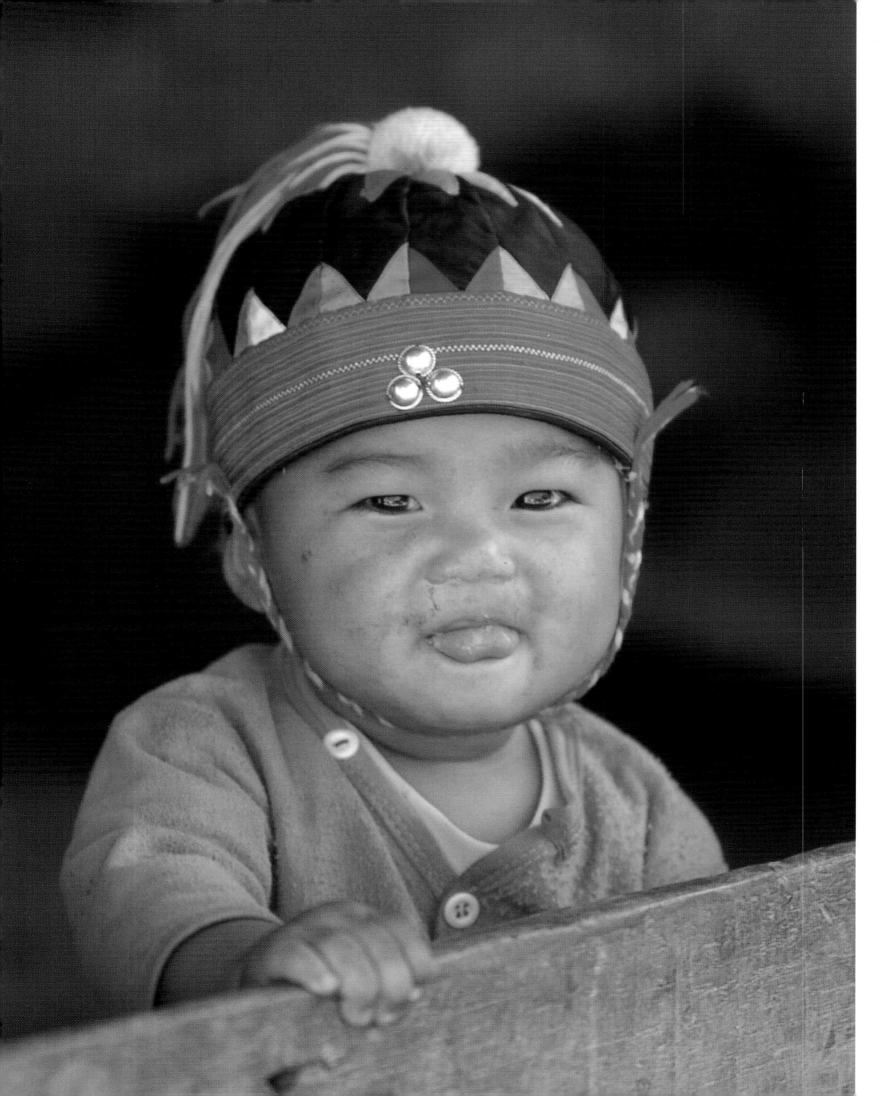

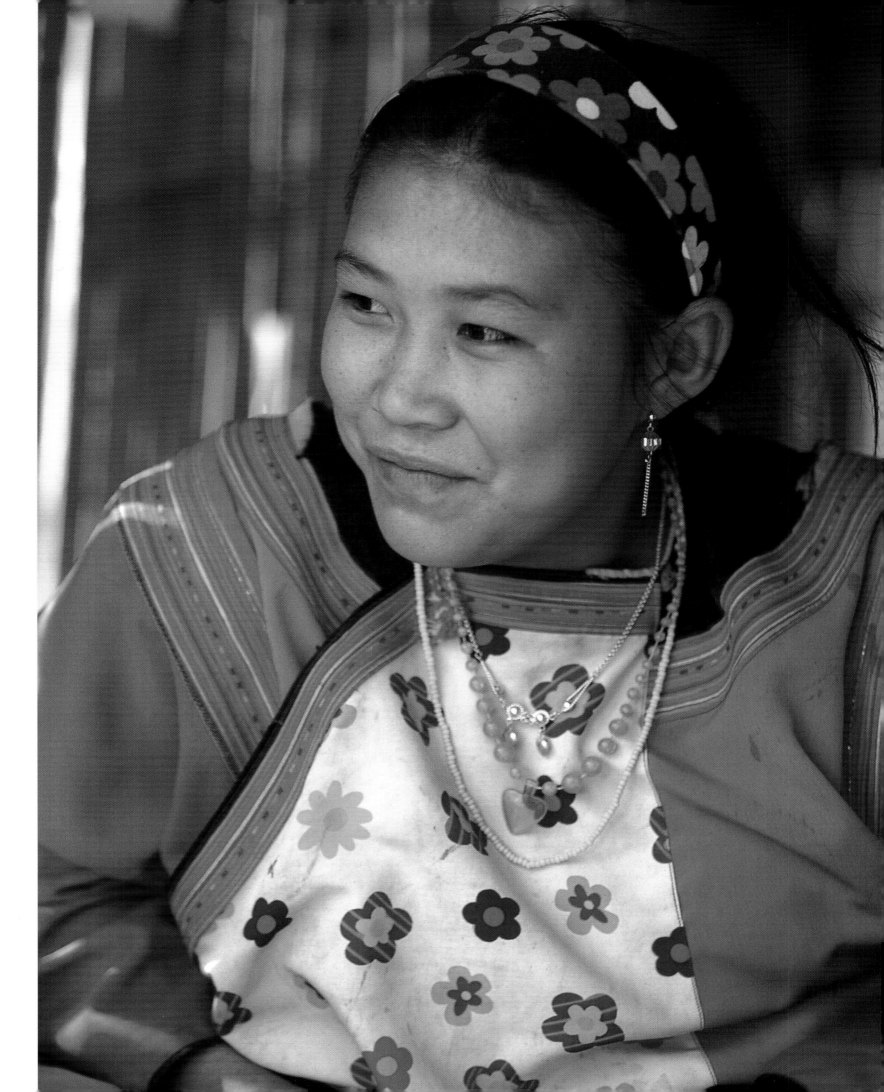

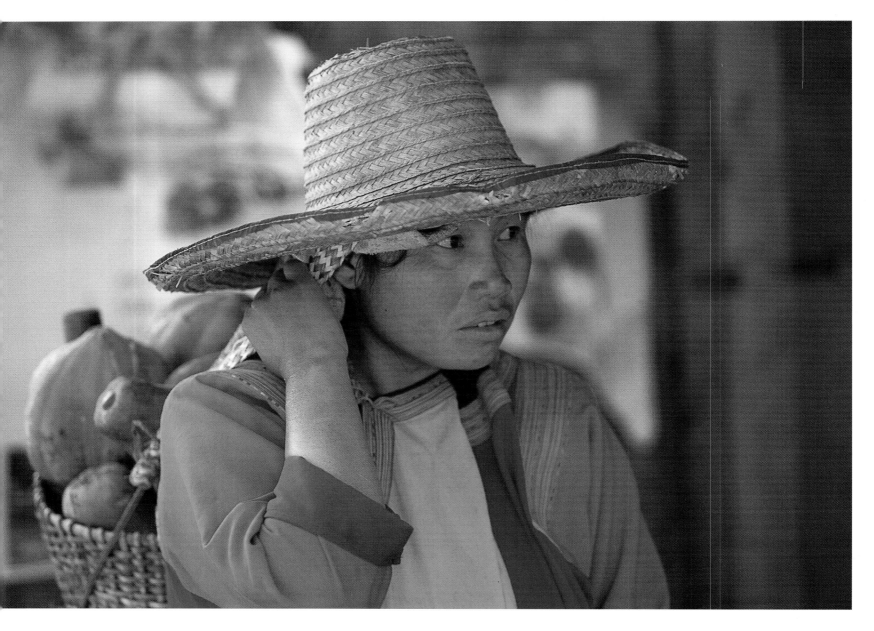

PATCHWORK HAT (PAGE 132)

Children's clothing is similar to that of the adults, except that boys to the age of three or four wear triangular-shaped rompers which tie around the neck. Snug-fitting caps adorned with exquisite bands of patchwork are made for babies by their mothers. However, western-style clothing for children is increasingly worn as a cheaper alternative to traditional dress.

TRYST (PAGE 133)

Courtship centres around the rice pounders in the evenings. Girls gather to pound rice for the next day's meals, while young men come to tease and flirt. As the girls take turns resting, a boy may venture to sit with one he likes. They eventually exchange bracelets or some other token of their affection, kept hidden in a pocket. The Lisu view the men of the clan as being the "tree" and the women as the "leaves". When the men detect the threat of a leaf being "stolen" from their tree, they feel compelled to try to prevent it.

FRUIT SELLER (ABOVE)

Lisu try to locate their villages where they can have political independence and freedom from harassment. Proximity to other northern Thai villages is desirable, as the Karen and Lahu villages provide cheap labour, security and companionship, and over the Chinese border in neighbouring Yunnan province there is a ready market for their opium.

MINOR ALTERATION (OPPOSITE)

The Thai Lisu woman's outfit is made from machine-made cotton or synthetic material. A blue or green tunic, split up the sides to the waist, is knee-length in front and hangs to mid calf at the back. It crosses over the chest and fastens under the right arm. The piece across the chest is often made of a different colour from the rest – green or light blue, for example, if the tunic is otherwise royal blue.

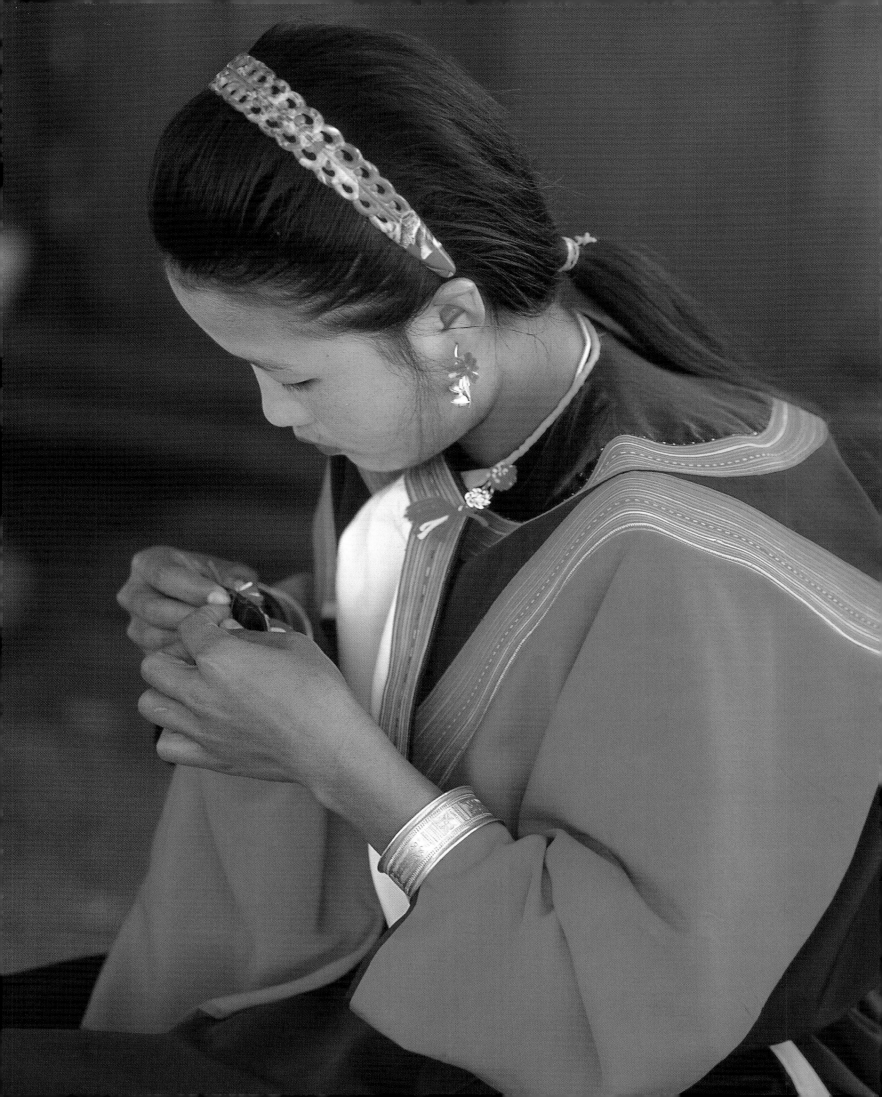

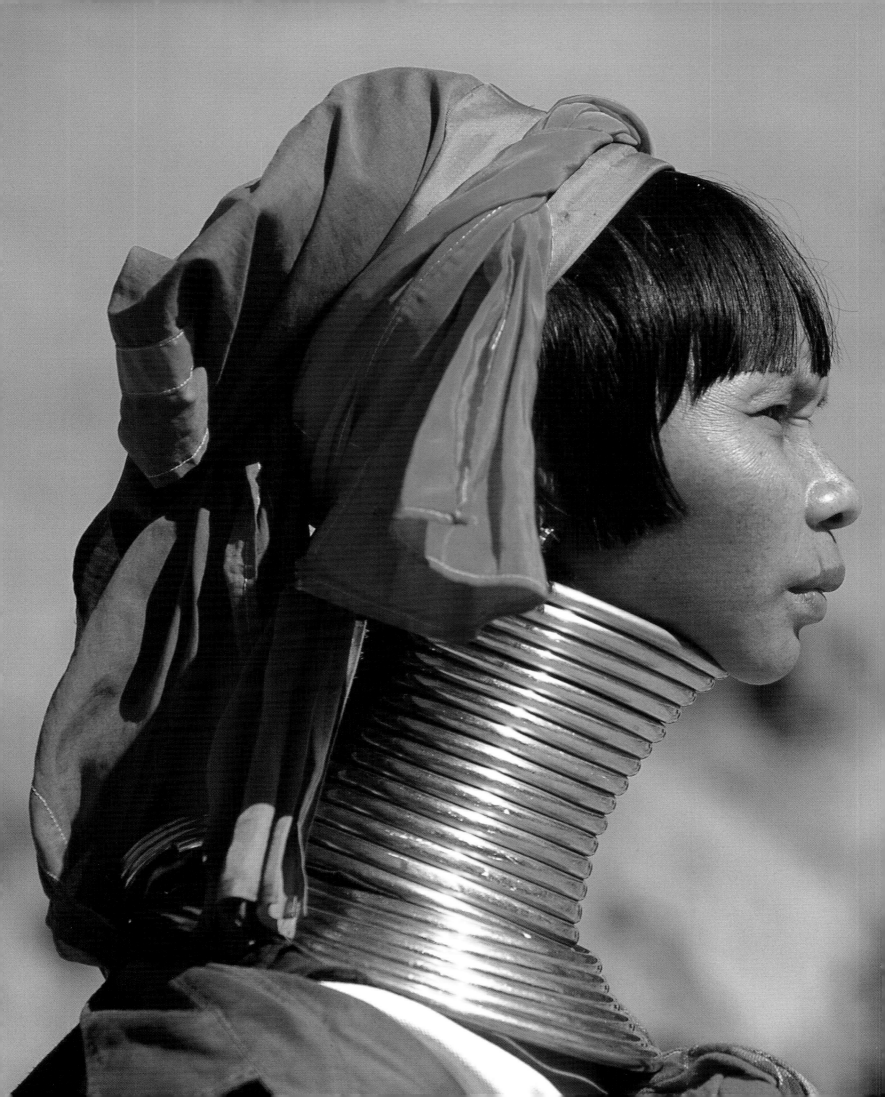

Padaung

Among the hilltribes of Thailand and Myanmar are the Karen, a loose confederation of heterogeneous but closely related tribes. They number around four million in Myanmar and 300,000 in Thailand. They are primarily farmers, eking a living growing rice in paddy fields in the nutrient-rich valley floors. Families live in houses built on stilts, fashioned from teak or bamboo and roofed with palm leaves. Adult children usually leave home when they marry; Karen society is matrilineal, so two married women do not generally live in one house.

The Padaung form a small sub-group of the Karen. Padaung people occupied central Myanmar before the Burmese arrived from the north and, together with ancient Mon, farmed the Irrawaddy and Salween river valleys. The majority still live in Myanmar but since 1962 many have crossed the border into Thailand to escape the oppression of Myanmar's military dictatorship.

The Padaung are best known for their practice of wearing metal rings on the neck, arms and legs. Girls would traditionally gain their first ring, weighing around two pounds (1 kg) at the age of five or six. A new ring would then be added every two or three years – one woman in Plam Piang Din Village in Thailand came to wear 37 coils. A Padaung woman of marriageable age is likely to have had her neck extended by about 10 in (25 cm).

There are several tales as to how the practice of wearing rings came about. One legend says that in the distant past, in the Padaung's ancient homeland of northern China, the rings were worn to protect against tiger bites. Other stories suggest the rings were placed on women to prevent them from being desirable to slave traders.

These days, older women still wear them but in Myanmar many women have stopped fitting them to their children. Although the rings give the appearance of elongating the neck, they actually depress the collarbone. They can be removed – a procedure that is becoming more frequent as the tradition wanes – but afterwards the neck muscles are often too weak to support the head.

Across the border in Thailand, though, there have been reports that the practice is being revived, purely for the benefit of foreign visitors. While the Thai government has been a reluctant host to other refugees, it has welcomed the long-necked people for their ability to lure wealthy tourists. In some villages, children are once again being fitted with rings, in exchange for cash from unscrupulous tour operators.

ELONGATED NECK (OPPOSITE)
A Padaung woman's rings are added to regularly from girlhood. The stack of rings not only gradually pushes down on the collarbone and ribs, but also prevents her from catching a glimpse of their own feet or watching her own baby as she nurses. The practical reasoning for this is not clear.

DECORATIVE RINGS (PAGE 138)
A mature woman sports a brass rod spiralling 20 times around her throat and collarbone. Despite many hypotheses, the most likely explanation for the wearing of rings is simply that they are decorative and have aesthetic value as well as representing wealth and status. This is the case with many African tribes and the Iban, who have similar traditions, although the bodily distortions are usually not as extreme.

COILED FOR LIFE (PAGE 139)
Rings were traditionally fitted on a day prescribed by the horoscopic findings of the village shaman. The neck would be carefully smeared with a salve and massaged for several hours, after which a priest would fit small cushions under the first ring – usually made of bronze – to prevent soreness. The cushions were removed later on. The process would continue with successive rings being added over the years.

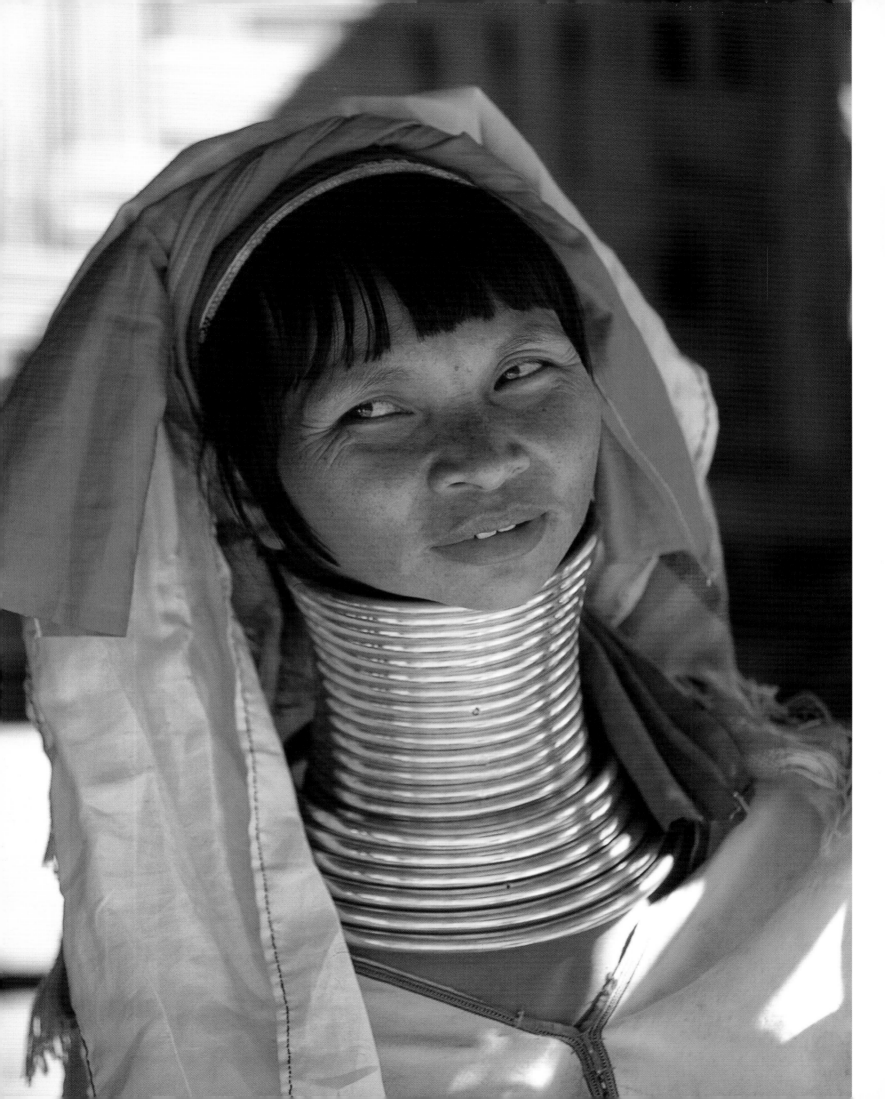

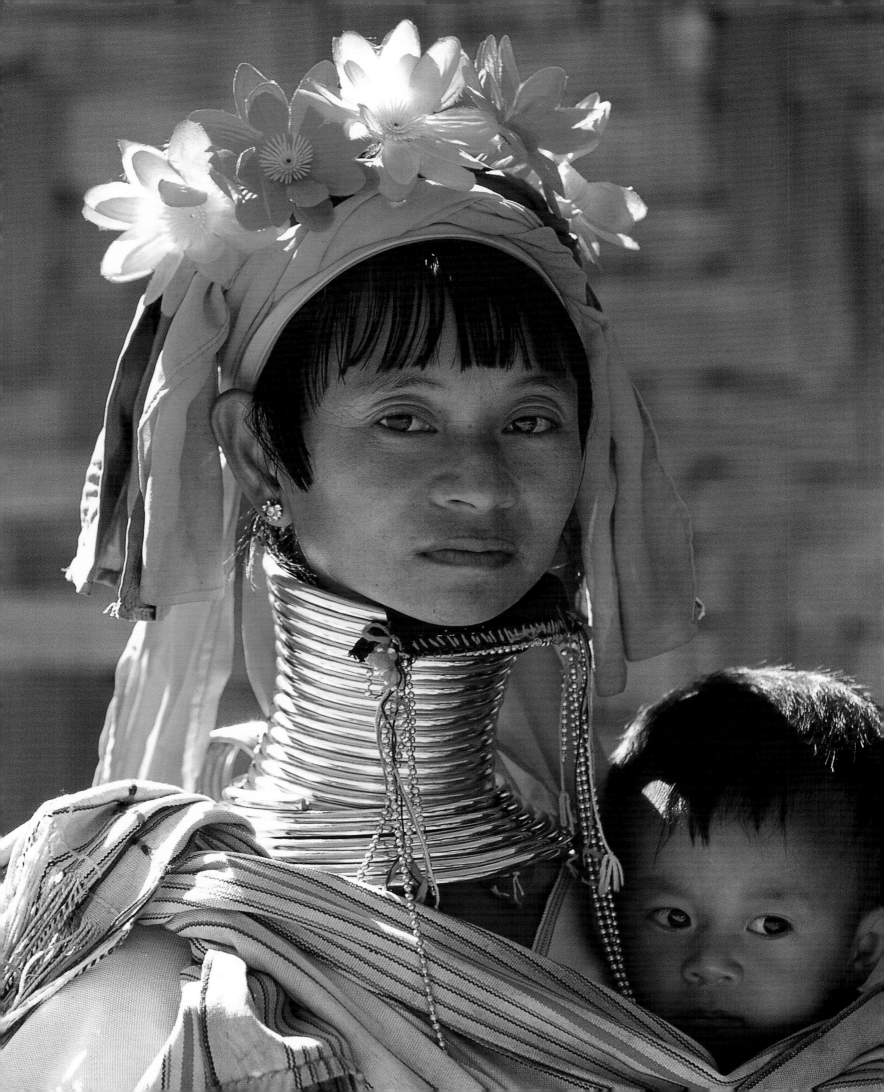

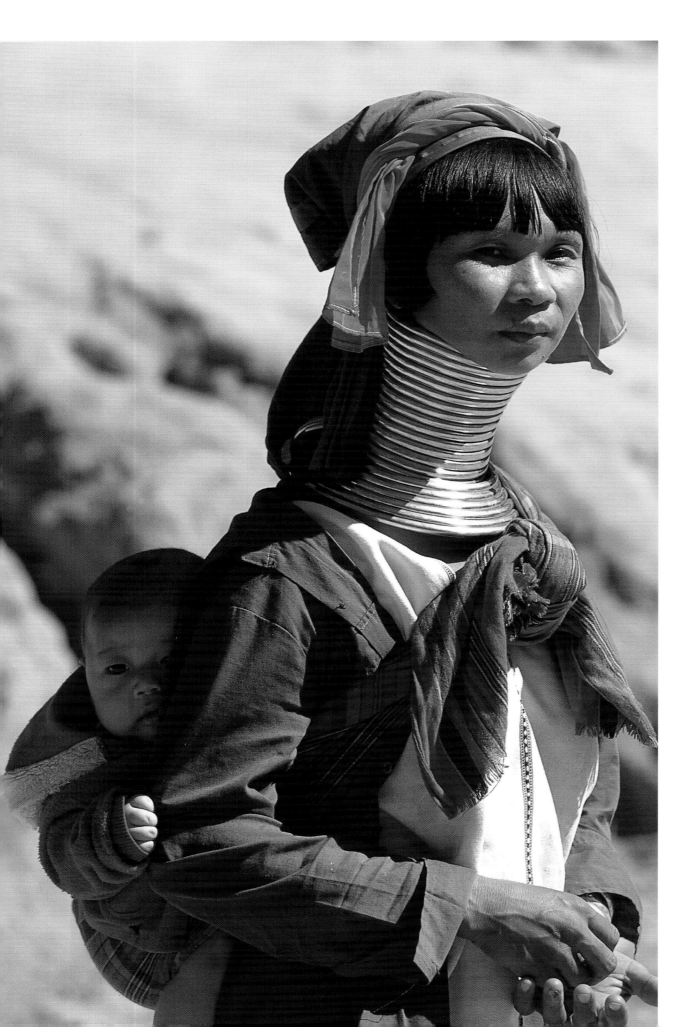

REMOVAL (LEFT)
Unlike normal accessories, these rings are for life and may only be removed with the direst of results. Adultery among Padaung women has always been punished by the removal of the rings, a fate almost literally worse than death as the cervical vertebrae become deformed after years of wearing the rings, and the neck muscles atrophy. Unless wishing to risk suffocation, the unfortunate wife must pay for the infidelity by spending the rest of her life lying down or try to find some other artificial support for her neck.

TIGER'S BITE (OPPOSITE)
These severe decorations express the Padaung women's own concept of beauty and social ranking but there are other theories concerning the origins of these rings. It has been claimed that rings were first placed around the women's necks in order to make them undesirable to slave traders. Another Padaung legend explains that the rings were protection against tiger bites, a constant hazard in their homeland in the north of China.

DAILY LIVING (PAGE 142)
The famous brass rings are actually made of a long coil of wire of approximately 1/2 in (1.5 cm) in diameter. There are various modifications necessary for living with them, such as a high bamboo pillow on which the 11–22 lb (5–10 kg) of brass rings can rest during sleep, and the extra time used to wash and dress.

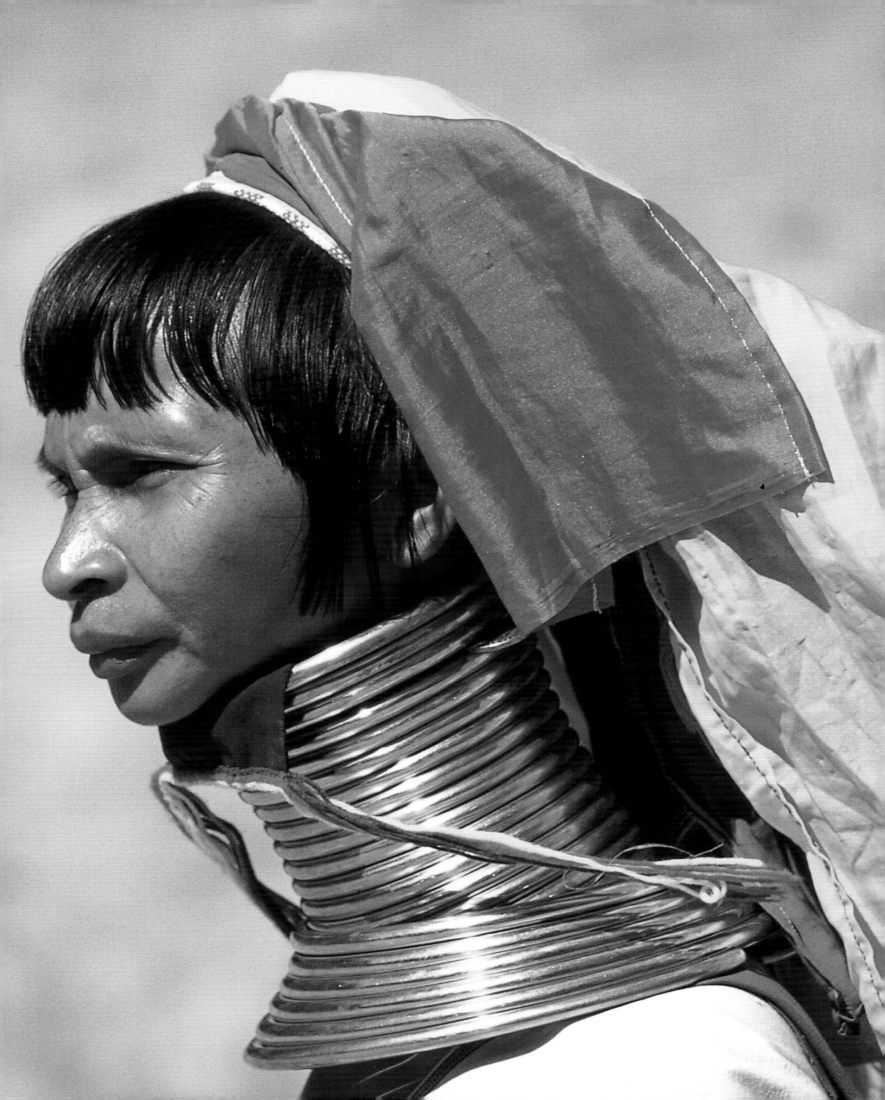

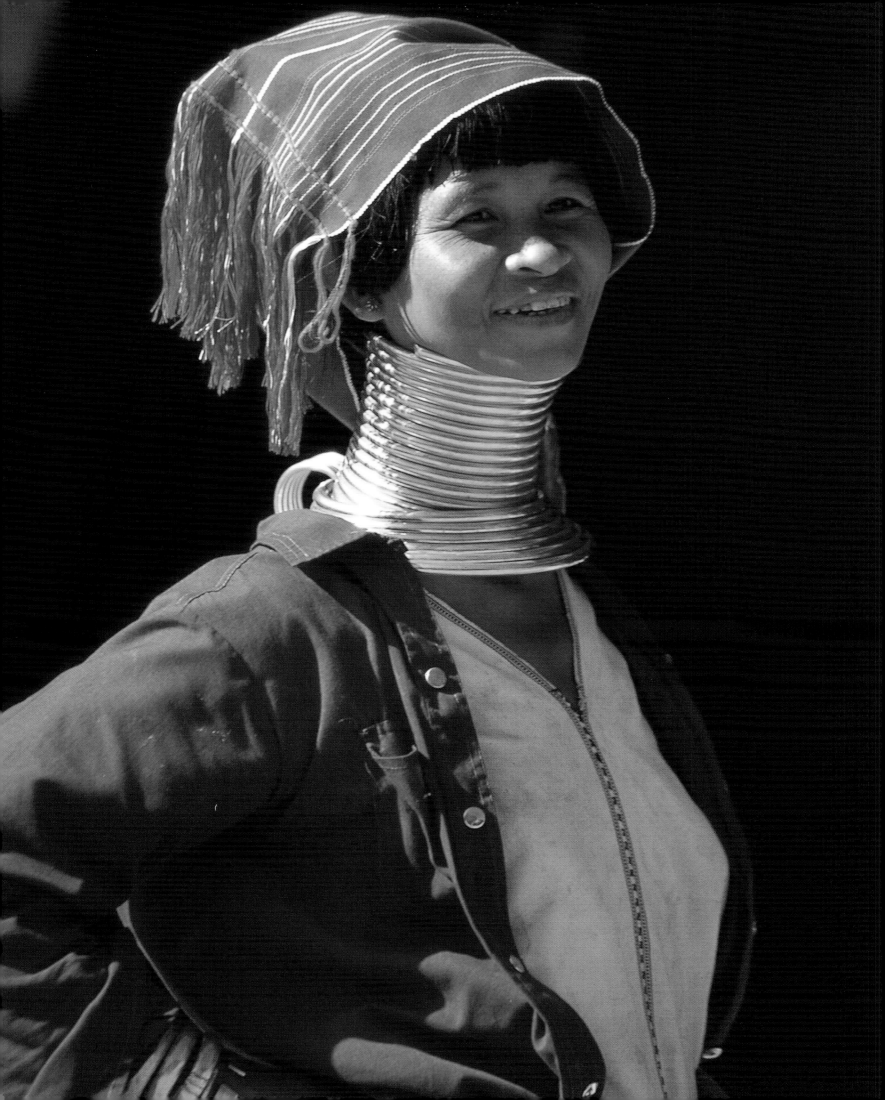

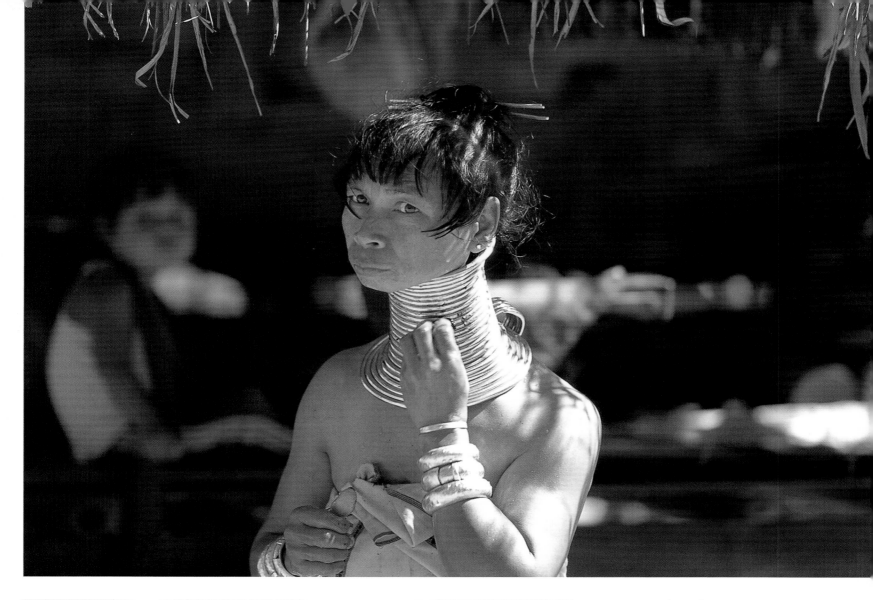

POLISHING (ABOVE)
Polishing the coils requires as much effort as polishing chrome on a car. "To make the coils shiny, we use this brown fruit from the trees here," my conversant explained as she squeezed dark brown tamarind in her fingers into paste. "We rub it on the coils, and then use straw to polish it off," she added, working the paste into the coils and vigorously rubbing their brass. Eventually she bent over, splashed water from a plastic bucket onto her coils and upper torso, and picked up a handful of straw to wipe away tamarind residue. The entire operation took about 20 minutes.

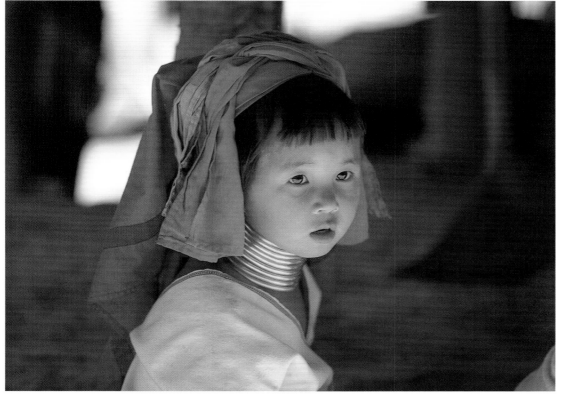

RINGING A DAUGHTER (LEFT)
According to Padaung tradition only girls born on a Wednesday of a full moon are destined to have their necks fitted with metal rings. But the rings, which had almost disappeared 20 years ago, are experiencing a revival in Thailand.

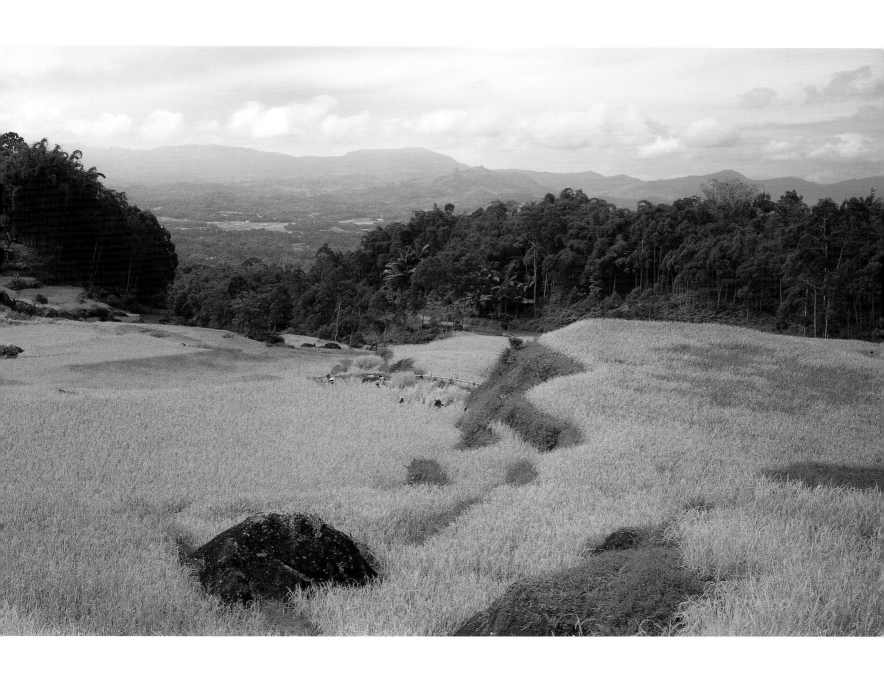

BETWEEN EMERALD FIELDS

Toraja

Legend has it that the Toraja came to the island of Sulawesi, Indonesia, by boat from mainland Southeast Asia, possibly Cambodia. They settled in the central highlands, building *tongkonan*, carved wooden buildings with dramatically swept-up gables. These great halls were the focus of community life, the place where families met to dicuss affairs and take part in ceremonies. Craftsmen decorated them with chicken and buffalo motifs – of mythical and economic importance to Torajans.

Traditionally, Toraja society comprised three classes of people: the highest class were the nobles or *to parengnge*; below them were the commoners or *makaka*, and the lowest class were the slaves or *kaunan*. Status was determined by birth, but economic aptitude or failure allowed a degree of social mobilization (Adams, 1997). Dutch colonists arriving in the early 1900s then abolished slavery and pacified the Toraja. They persuaded them to relocate their houses from the highlands to the valleys, and introduced missionaries to the area.

The native religion of the Toraja is now known as Aluk To Dolo, or "rituals of the ancestors". It is based around opposites: life and death, east and west, sunrise and sunset. The Dutch missionaries, realizing that wholesale condemnation of Aluk would not yield many converts, separated harmless customary ritual elements from offensive pagan rites (Volkman, 1984). Thus they banned life rituals revolving around the taboo topic of fertility, while encouraging death rituals. Subsequently, the lavish *aluk rambe matampu* or death ceremony has become the major event in the life cycle of a Torajan.

Although contemporary Toraja are predominantly Christian (Adams, 1997), they continue to hold lavish funerals to pay homage to their deceased elders. When someone dies, a three-stage rite takes place: the wrapping of the corpse and lamentation; the funerary ritual and animal slaughter; and the placing of the corpse in a rock tomb. The higher the social status of the deceased, the larger and more drawn-out the ceremony is likely to be. The ten-day funeral of one aristocrat in 1987 attracted 30,000 guests (Adams, 1997).

Not surprisingly, Toraja land is no longer the isolated enclave it once was. Many young Toraja have left and now hold well paid positions as teachers, professors, lawyers, architects and politicians. The money coming in from outside is blurring the boundaries of the traditional social hierarchy. Families of former slaves can now afford to sponsor death rituals far in excess of what would have been allowed through Aluk (Volkman, 1984). Tourism, too, is redefining Toraja culture. In 1973 only 422 foreigners visited the highlands but by 1994, over 53,000 foreign tourists were visiting the region annually (Adams, 1997).

RICE TERRACES (PAGES 144-45)
In the highlands of Tana Toraja, intense cultivation of rice terraces accounts for high yields. Typically, rice-growing villages are perched on a hilltop, surrounded by stone walls, and are lived in by extended families who inhabit a series of houses, or tongkonan, *arranged in a circular row around an open field.*

RICE HARVESTER (OPPOSITE)
A teenager pauses to rest from harvesting black rice at Lokomata. Individual rice stalks are gathered by hand into bundles of 12 and secured with a rice-tie from her headscarf. As 90 percent of Toraja are farmers with rice as their principle product, the size of the family's rice barn, or lumbung, *is indicative of its social status.*

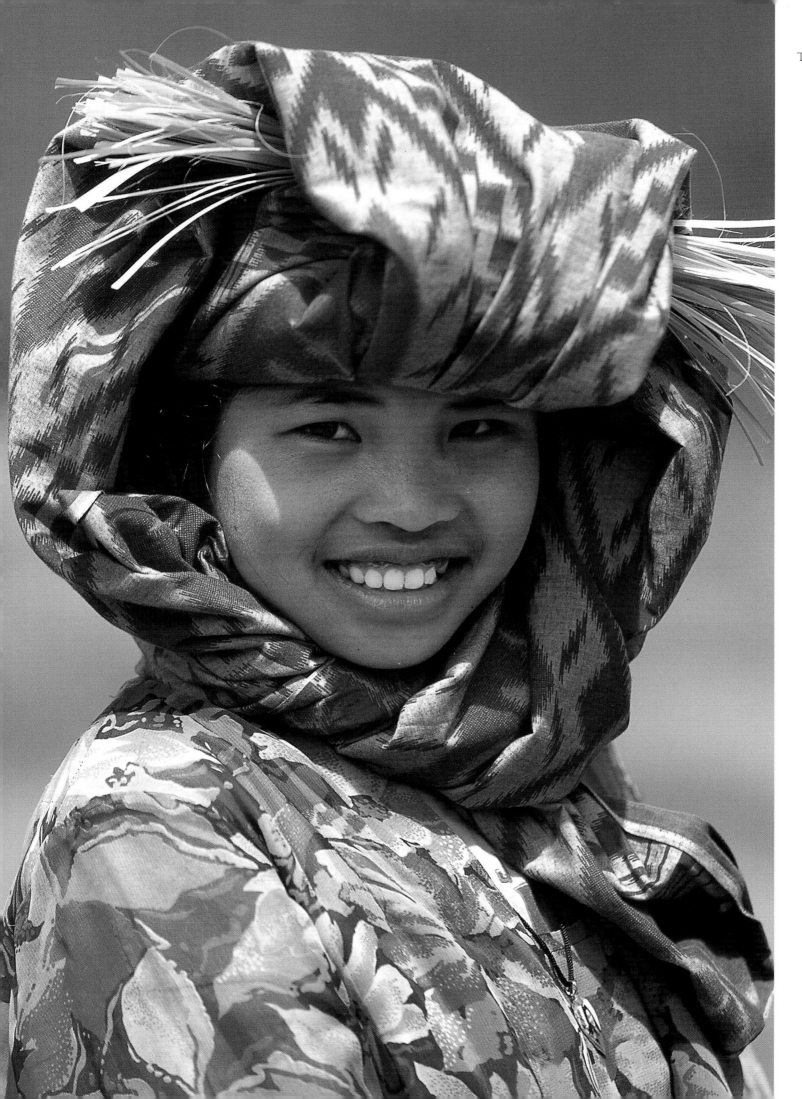

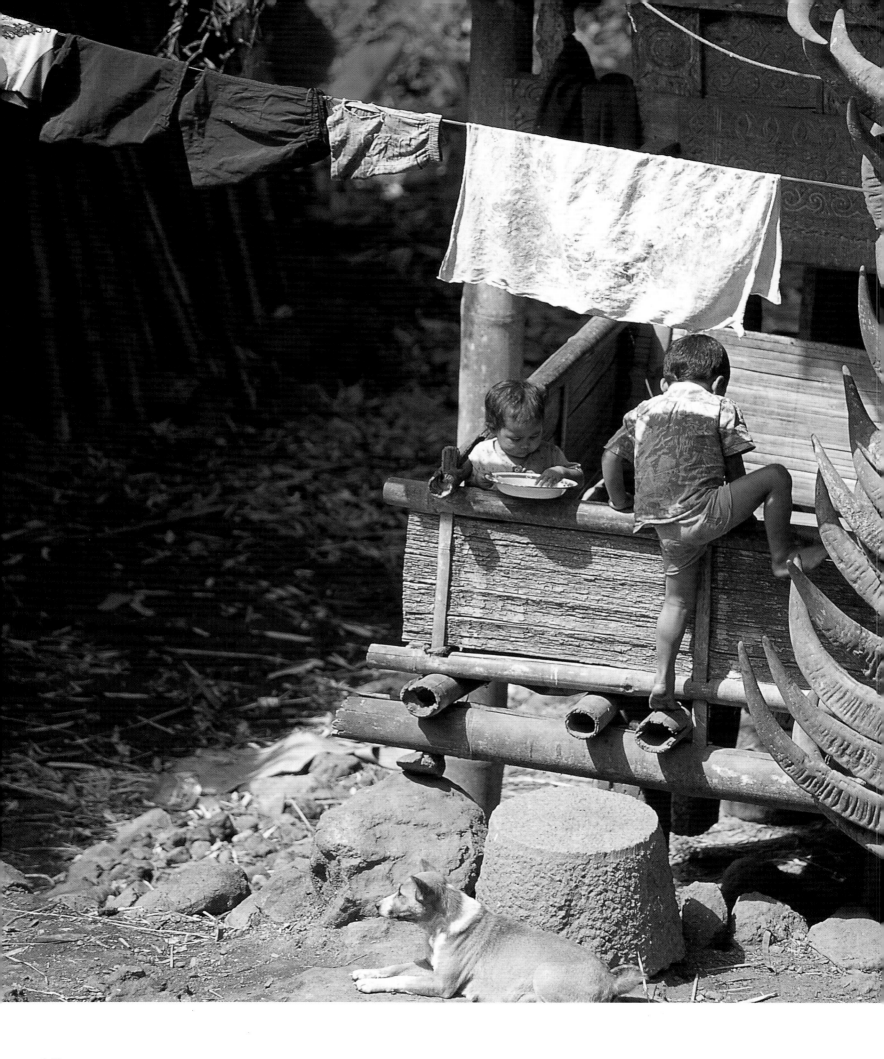

CHILDREN PLAYING

(LEFT)

Beside the horns of sacrificed buffalo, a young boy joins his younger brother in the tongkonan. *Contrary to its classic appearance, the* tongkonan *of today is the result of a continually changing building tradition, and as such has evolved in innovation and spirit. The modern version incorporates new materials and structural techniques to express old concepts of cosmology, ancestry, kinship, ranking and society.*

TONGKONAN (PAGE 150)

Architecture is perhaps the most striking aspect of the Toraja culture of Indonesia. Building is by no means a mere provision of shelter from the elements, but a creation of symbolic space, which mirrors the perceptions of its people. So integral is the home to their way of thinking, that the Toraja are commonly characterized as a "house society". Each part has a name, with the front post for example being known as the tulak somba.

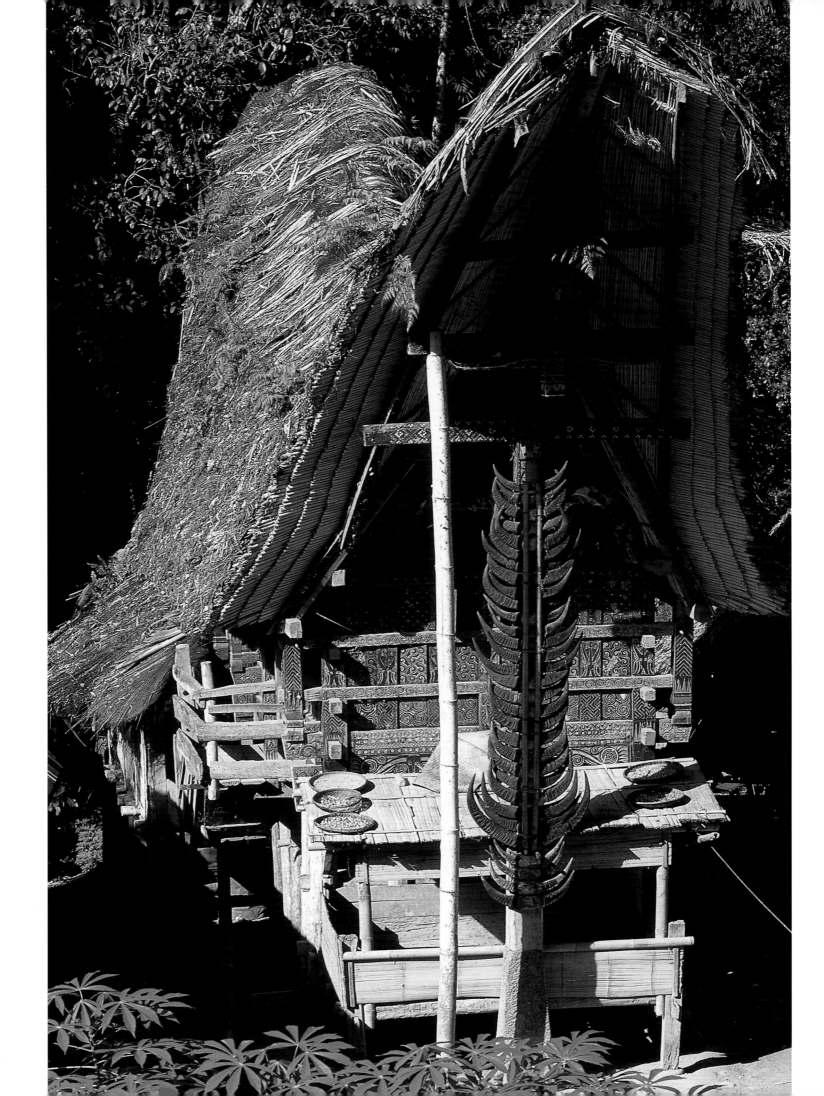

BUFFALO FIGHTING (ABOVE)
Buffalo fighting at a funeral attracts cheering from onlookers. The buffaloes are later slaughtered, and their meat distributed to the funeral visitors in accordance with their position in the community. The spirit of the deceased is also entitled to a portion of meat, known locally as aluk todolo. *The heads of the buffaloes are returned to what is known as* puya *(a site for the spirit of the dead person) and their horns are placed in front of the house of the kin. The more horns that decorate the front of the house, the higher the status of the deceased.*

ROCK TOMB (LEFT)
Crypts carved with prodigious labour into the rock house the mortal remains of the deceased. Funerals in Toraja are so extravagant that they say it costs more to die here than to live.

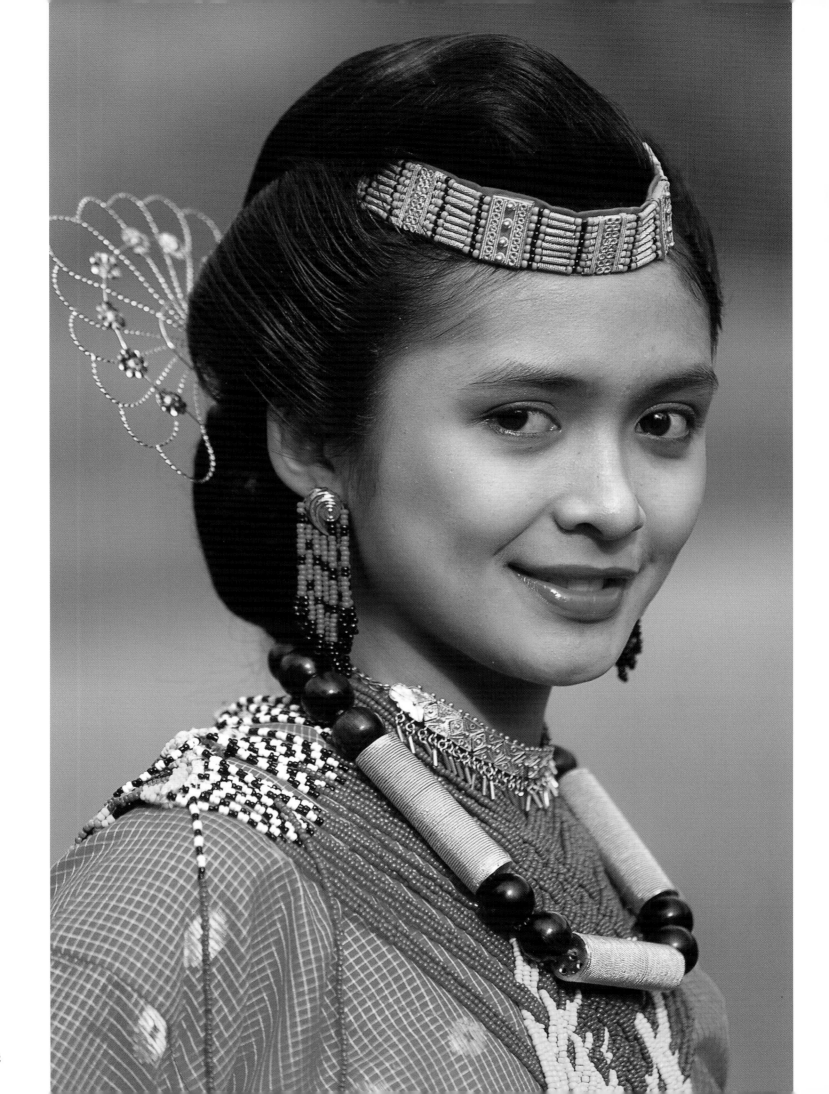

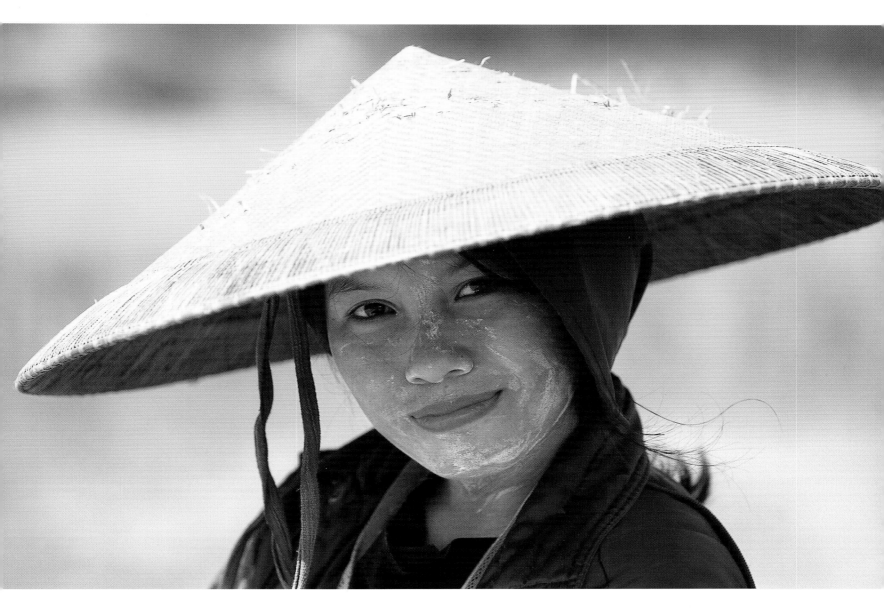

TORAJA BEAUTY (OPPOSITE)
*In traditional dress, a young girl
attends a feast at Makale. To
conduct the souls of the deceased
safely into the next world, the
Toraja mount elaborate ceremonies,
which serve also to cement bonds of
obligation between the traditionally
suspicious clan groups. Observing
intricate cycles of ritual punctuated
with marvellous pageantry, the
Toraja devote huge time and effort
to the care of their ancestors. They
believe their forebears participate
directly in the welfare of the material
world through their blessing.*

NATURAL SUNSCREEN (ABOVE)
*Working in irrigated nursery beds
for rice plants, a young woman
smears a mustard-based sunscreen
on her face to prevent burning.
Exposure to the sun's reflections in
the water is intense and can be
minimized by this natural remedy.
The flooded rice field is an artificial,
almost self-contained ecosystem.
Rice is the only staple crop produced
in the semi-submerged conditions,
which help to account for the
usually high and sustained yields.*

LAND OF RIVERS AND GORGES

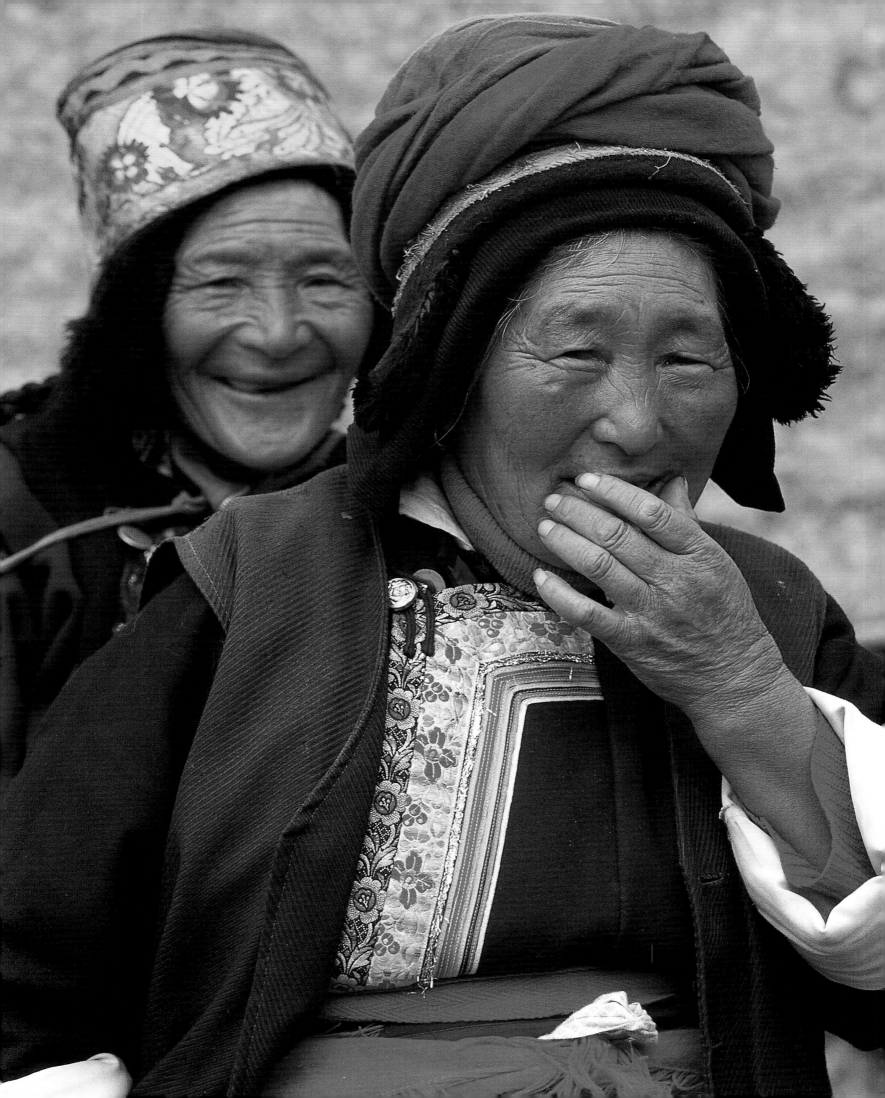

Khampa

The Khampa inhabit the grassy plateaus and deep valleys of Kham, a region of Tibet now officially part of Sichuan, Qinghai, Tibetan Autonomous Region and Yunnan provinces of China. The Salween, Mekong, Yalong and Yangtze rivers and their numerous tributaries have incised gorges through the rugged mountains, giving the region its traditional name of Chuzhi Gangdruk, "four rivers and six ranges".

The earliest known records of Khampa people date back to the seventh century AD when the Tibetan king Songsten Gampo set out on a horseback mission to pacify the tribes of central Asia. Finding allies among the natural-born warriors of Kham, he gathered an army strong enough to threaten the emperor of China. He remains a legendary hero to the Khampa today (Baldizzone and Baldizzone, 1995).

More than 800,000 Tibetans live in Kham, one eighth of them in northwest Yunnan (Hongladarom, 2001). Two main dialects distinguish the lowland population from the few pastoral nomads who live at around 13,000 ft (4,000 m). Both dialects are vastly different from Lhasan, the official Tibetan language. The Khampa speak quickly, loudly and bluntly, while Lhasans speak softly and politely. Around 70 percent of Khampa are farmers, growing barley, wheat, potatoes and corn, while tending yaks, sheep and goats. They also dig mushrooms and herbal roots, transporting them by yak to market in the towns.

Khampa men are tall and muscular, and many wear their hair braided with yarn and tied around their heads. Proud of their warrior history, they remain avid horse-riders and carry traditional daggers in ornate silver sheaths. When the Chinese invaded Tibet in the 1950s, the Khampa were among the first to fight. During the 1960s, the U.S. Central Intelligence Agency brought Khampa Tibetans to Colorado, armed them and trained them as anti-Chinese rebels before returning them to their homeland to resist the communist takeover. The multi-million dollar guerrilla war was largely unsuccessful and was eventually brought to a close by U.S. President Richard Nixon in the 1970s.

Secular and religious festivals have long been an important part of Khampa history. Each region has its own horse-riding festival, a great social occasion at which inhabitants compete against each other in athletic events. As recently as 1998 the area was opened up to tourism but Kham's minimal transport links and remoteness keep visitor numbers relatively low.

XIAO ZHONGDIAN HE
(PAGES 154-55)
Embracing the gorges of various rivers which rush down from Tibet, Dechen Tibetan Autonomous Prefecture lies at the heart of the Hengduan mountain range. The region ranges in elevation from a 22,200-ft (6,740-m) mountain on the border with Tibet to 4,880 ft (1480 m) in the valleys of the south. The plant hunters and naturalists that journeyed here during the first half of the 20th century prized the area.

TASHI DELEK (OPPOSITE)
"Tashi delek" (good luck) calls a Khampa Tibetan woman as she leaves for her daughter's house. Tibetans in the Khampa area are largely nomadic, and their clothing is adapted to such a lifestyle. This is a high-altitude, bitterly cold area, with a long winter, short summer and huge temperature difference between day and night. The robes worn by the Khampa people are baggier and looser than those worn in the Tsang area, making it easier for them to slip their arms in and out of their sleeves.

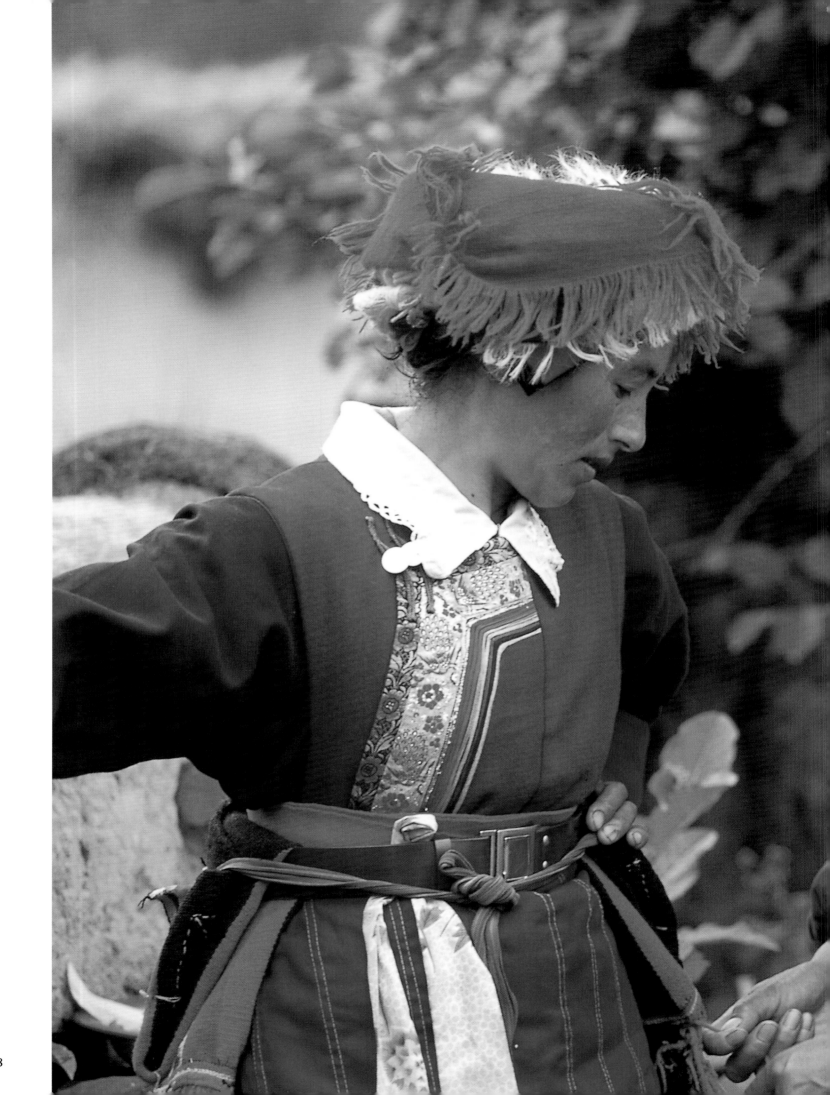

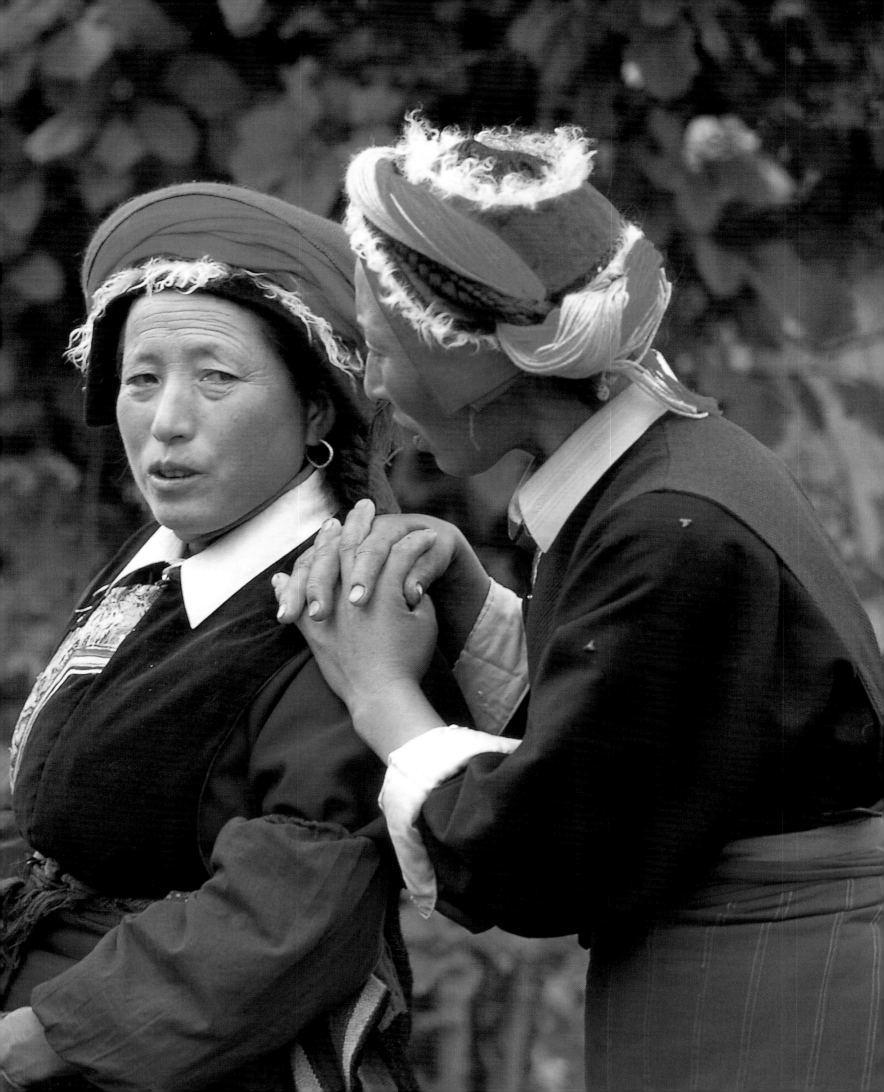

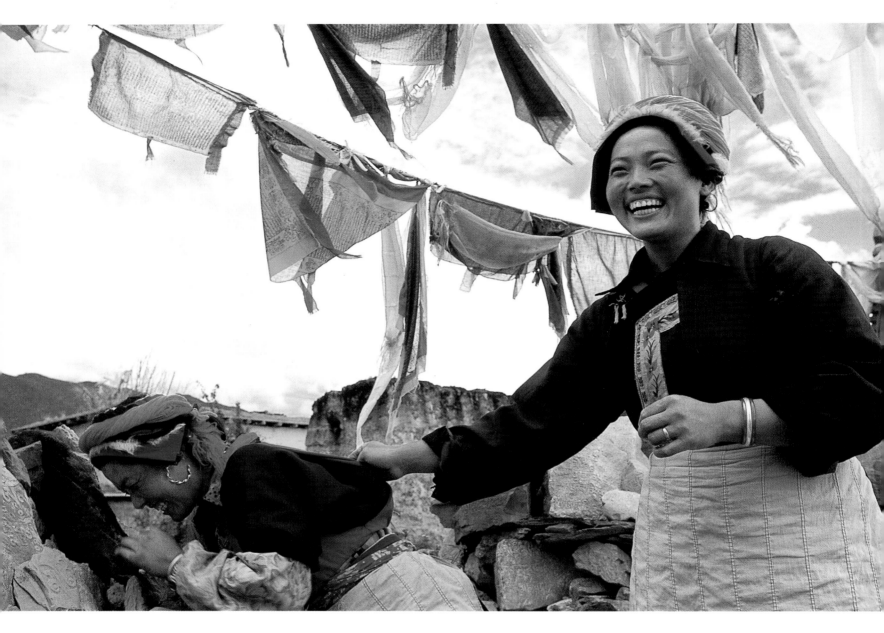

HOUSE WARMING
(PAGES 158-59)
In the garden at a house-warming party women gossip about the events of the day. In keeping with custom I was presented with tsampa – *flour of roasted barley, the mainstay of the Tibetan diet. A bowl filled with butter tea, rich and salty, is covered with a handful of* tsampa, *which is kneaded into dough. Whilst fortifying, this is definitely an acquired taste.*

FESTIVITIES (ABOVE)
In the spirit of celebration, two women enjoy a joke. Secular and religious festivals have long been an important part of Khampa history. Each region has its own horse-riding festival, a great social occasion when inhabitants compete against each other in athletic events. The two-day festival in the town of Gyalthang in the Dechen Tibetan Autonomous Prefecture attracts around 25,000 people and the hillsides surrounding the racetrack and stadium become dotted with the blue-and-white embroidered tents of visiting Khampa.

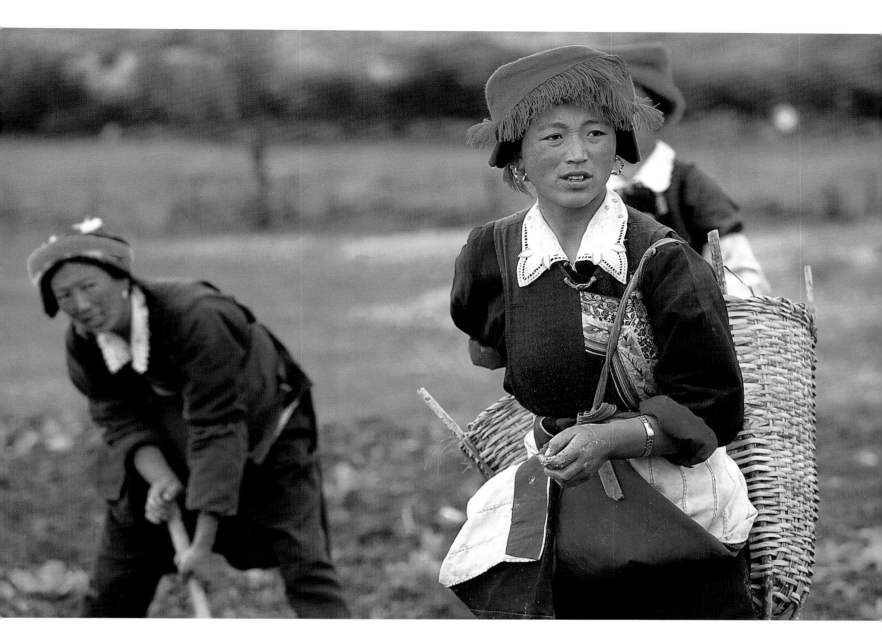

GRASS WARS (ABOVE)

Around 70 percent of the Khampa are farmers, growing barley, wheat, potatoes and corn, while tending yaks, sheep and goats. They also pick mushrooms and dig herbal roots, transporting them by yak to markets in towns. The nomadic people have increasingly seen competition for land turn violent. As the population continues to expand, a combination of policy changes and an influx of Chinese settlers has led to growing tensions over land ownership which has led to a series of "grass wars".

MAKING DRAGONS

(PAGES 162-63)

Beneath the Ganden Sumtseling monastery in Gyalthang, a coppersmith fashions the heads of dragons from sheet copper. With little more than a hammer, the craftsmanship he displays is astonishing. The heads were commissioned to embellish the monastery's architecture, which resembles the Potala Palace in Lhasa. The monastery once had as many as 1200 monks but now claims only a few hundred, though most of these stay at home with their families, only coming together as a single body on rare festivals.

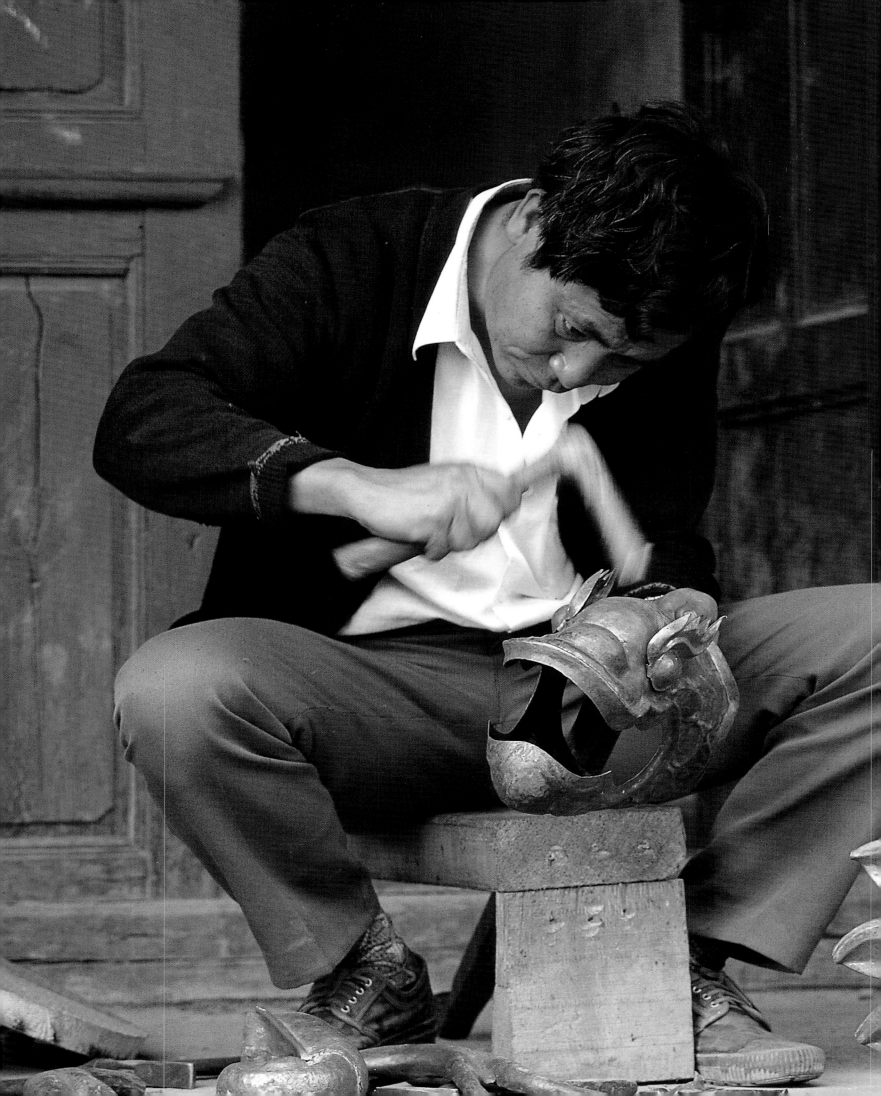

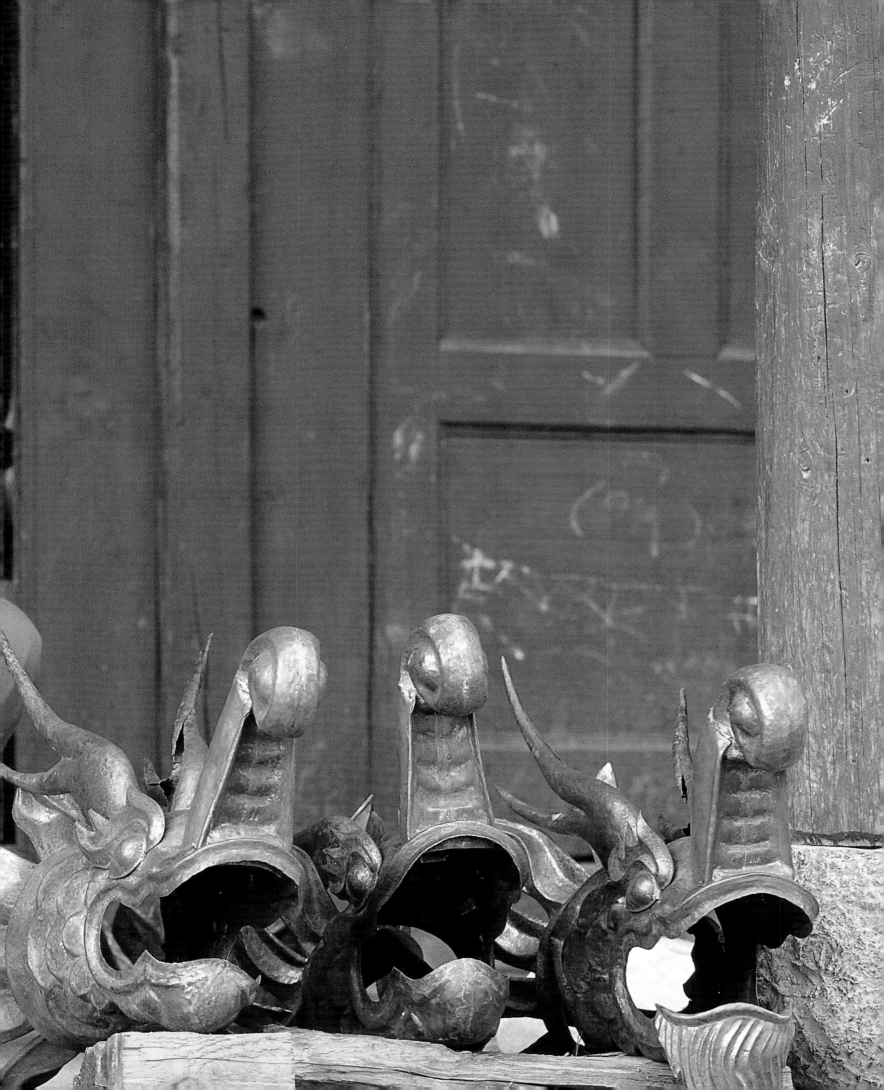

AFTER THE DREAMING

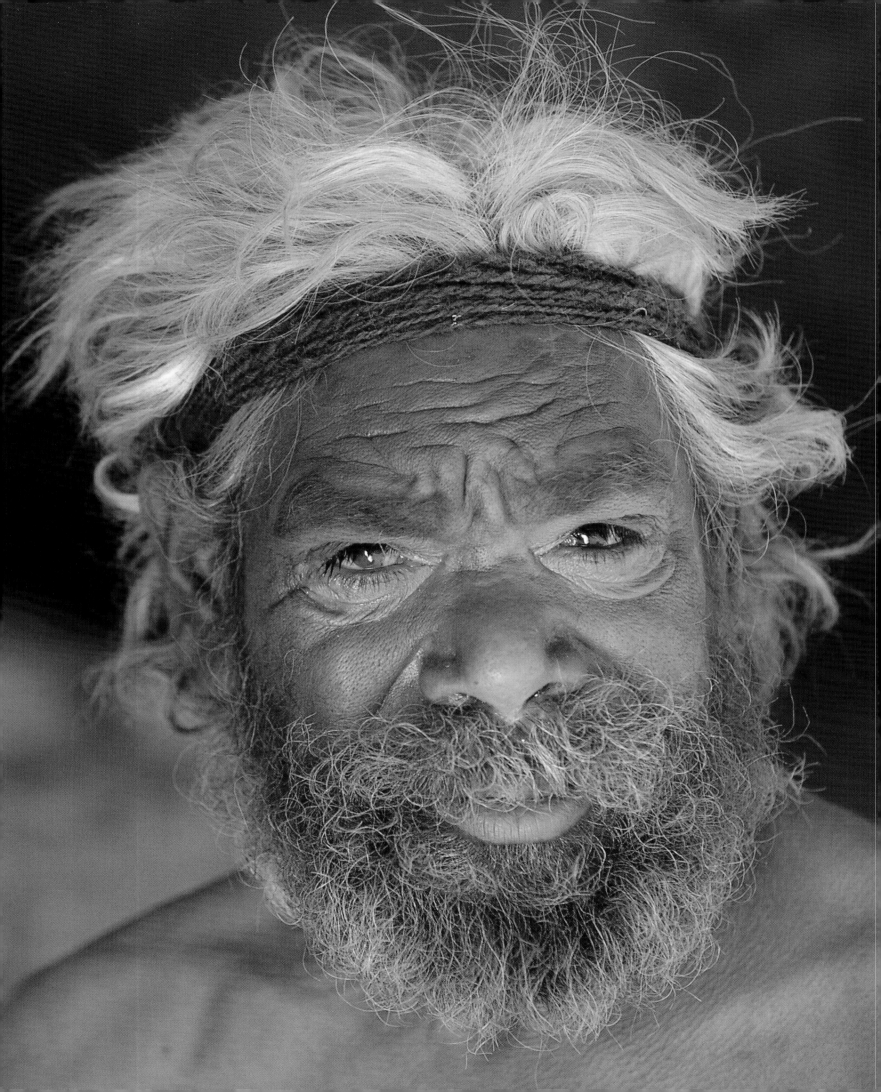

Aborigine

The Aborigines, Australia's indigenous people, arrived on the continent at least 50,000 years ago – and possibly as far back as 100,000 years ago. The name Aborigine derives from the Latin for "from the beginning" and was used by European explorers who arrived in Australia from 1770 onwards. However, individual Aboriginal groups use different words to describe themselves. Kuri, Koori, Murri, Nanga, Yura, Nyungar, Piyirn, Tiwi, Yolngu and Yapa are all words meaning "people", highlighting the complex nature of Aboriginal anthropology (Price and Price, 1998).

These early people were hunter-gatherers who tracked kangaroo, wallabies, goannas and fish using spears, boomerang, nets, hooks and a spear-thrower called a *woomera*. Before the arrival of Captain James Cook in 1770 and subsequent European colonization, there were numerous groups of Aborigines, speaking 300 different languages. Today, there are still around 100 languages spoken by discrete groups such as the Warlpiri. Central to all is "Dreamtime", the belief that land, people and animals are spiritually connected. In Dreamtime, animal spirits exist in human form, and landforms represent the places where Dreamtime spirits once lived. The myths have been perpetuated through stories, rituals and paintings. Cave paintings – older than those in Europe – tell tales of how the great spirits made the land and taught people to find food, perform ceremonies and keep the laws.

The experience of the Aborigines at the hands of the European explorers is a sorry one. Like the Inuit of the Arctic, Aborigines have been displaced from their traditional lands, had their hunter-gatherer economy destroyed and been forced to adopt European culture or be perceived as failures (Young, 1987). Today, Aboriginal life expectancy is 57 for a man and 62 for a woman, compared with the national averages of 77 and 82. At the age of 19, only 12 percent of Aborigines are in full-time education, one-third of the national average (Brace, 2001).

Central to the Aborigines' plight is the fact that for many years the Australian government declared the continent *Terra nullus* (i.e. inhabited by no one) prior to 1778. This thwarted attempts by indigenous people to make court claims on land they felt was theirs historically. However, various land rights acts have since granted land to Aboriginal communities, though generally to plots of peripheral land with no commercial value. Much of Australia's indigenous population continues to feel deprived of land that they are spiritually connected to. Groups such as the Warlpiri have begun developing their own websites and generating films to tell their story to the world.

PICCANINNY CREEK (PAGES 164-65)
The Bungle Bungle Range in Purnululu National Park is one of the most fascinating geological landmarks of Western Australia. The orange-and-black stripes across the beehive-like mounds are composed of sandstones and conglomerates encased in a skin of silica and algae. Although the Bungle Bungle Range was extensively used by Aboriginal people during the wet season, when plant and animal life was abundant, few Europeans knew of its existence until the mid 1980s.

DREAMTIME (OPPOSITE)
"I love this land. This land and this rock are in my blood." Aboriginal societies are strongly attached to the land, because they believe that every tree, rock, animal and mountain was created by their ancestors in the Dreamtime. Aboriginal tribes in the past respected each other's territories and rarely encroached upon the territory of another, fearful that they would only find hostile spirits there.

KUYUNBA (PAGES 168-69)
Kuyunba is an area of special significance to the Arrente people and has been a traditional meeting and ceremonial site for thousands of years. Rich in Aboriginal rock art, Kuyunba means "place of uninitiated men". With ceremonial ochre applied to his body and hair, Dick Marshall Japangardi performs a chant to the rhythmic clap of instruments.

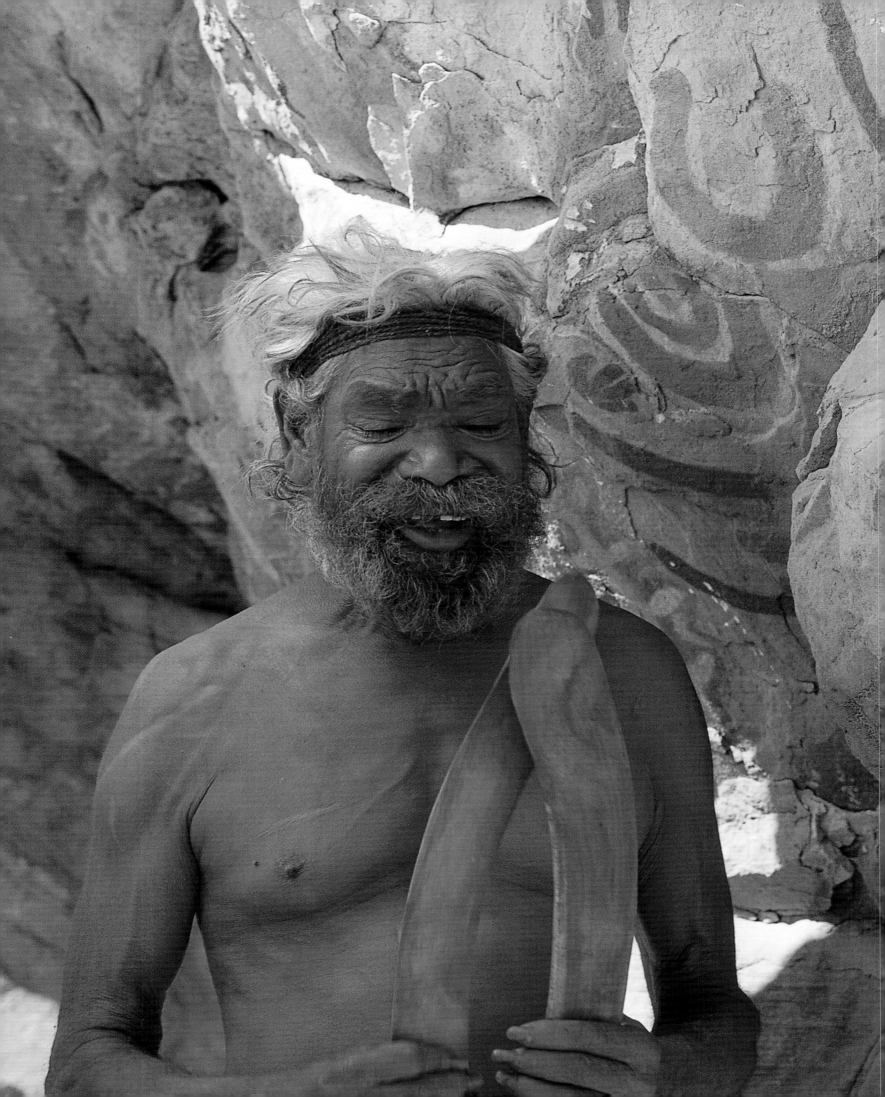

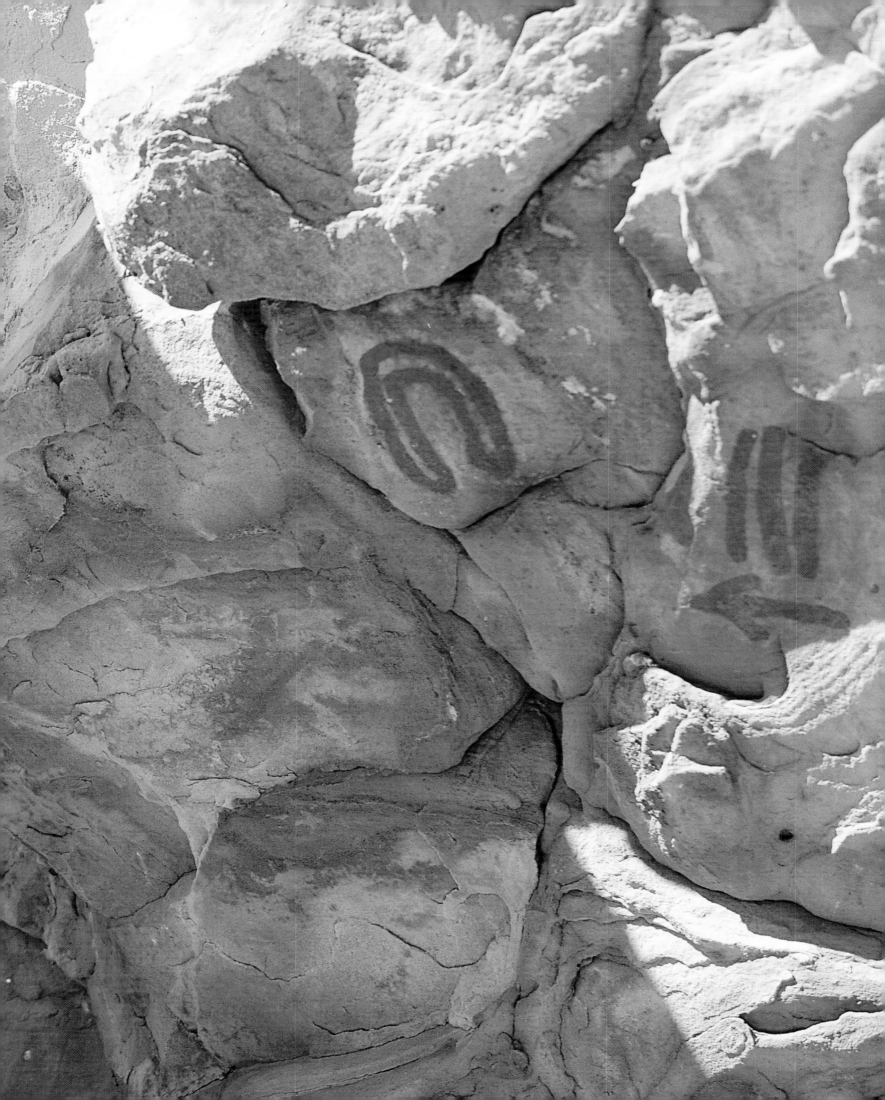

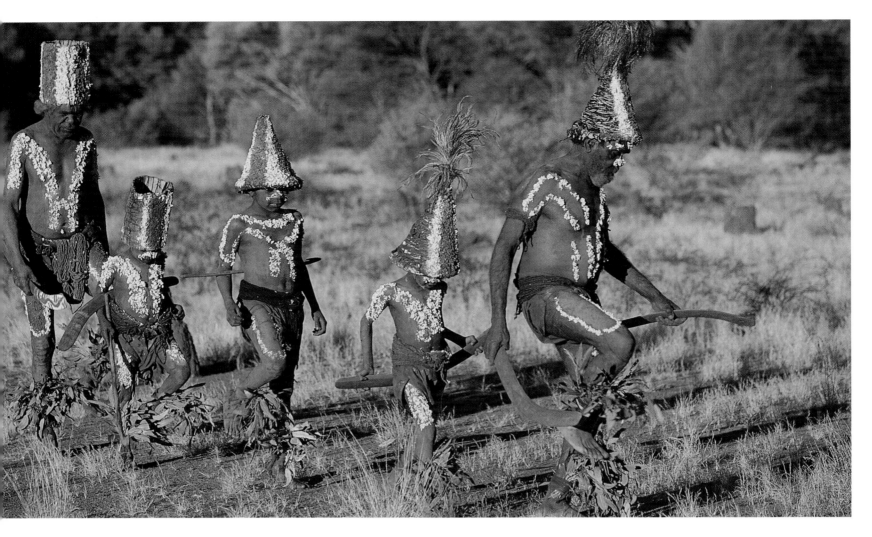

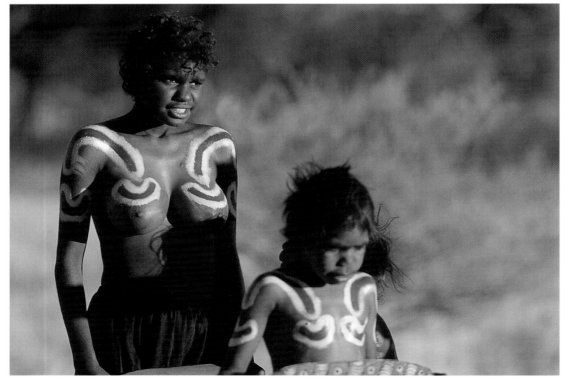

POSSUM DANCE (ABOVE)
In the evening light, members of an Aboriginal group perform the Possum Dance. They wear headdresses crowned with emu plumes and attach leaves around their ankles. Later that night by the fire Ted Egan Jungala relates the story. "Long ago, way long ago, some little possums ran away from home, so the Possum Man had to go looking for them. He came down to Alice Springs from up north to collect the little possums. He came all the way down to take them back to Nappaby, to bring them back to their country, the place where they belonged."

DREAMING (LEFT)
Many Aboriginal rituals connect the present to the mysterious Dreamtime of the past. After a person dies the soul returns to the Dreamtime, where it resided before birth.

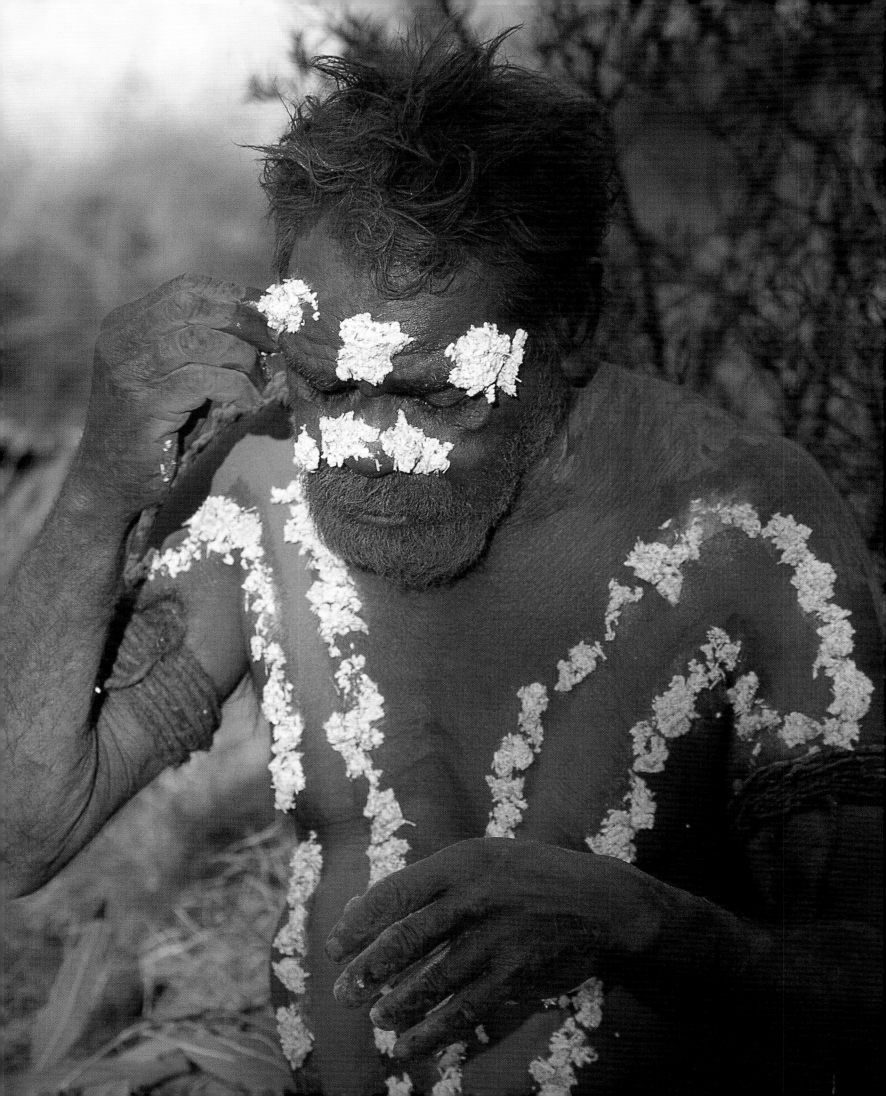

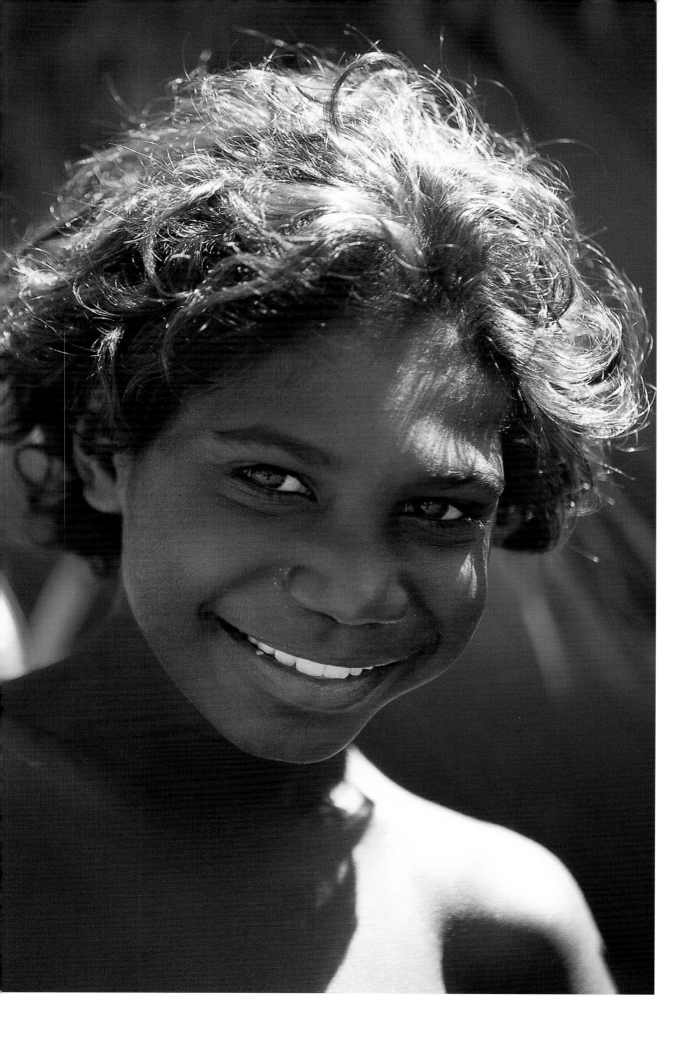

ORNAMENTATION (PAGE 171)

The vibrant ceremonial and religious life of Northern Territory people in the past generated a spectacular array of art forms, including body painting and personal ornamentation, wood carving, rock painting and engraving. Designs and motifs embodied multiple sets of meanings about group ownership of lands and relationships to particular ancestral beings. These expressions, along with the rich oral traditions, elaborate song and dance styles, were all regarded as manifestations of the original ancestral creative power.

KINSHIP (LEFT)

As in other kinship systems, Aborigines recognize relations by blood and by marriage. They also regard themselves as being related to all the people within a cultural or linguistic group.

YERRAMPE (OPPOSITE)

Decorated with a mixture of plant fibre and clay, Clinton Wayne Jungarrayi awaits his turn in the Possum Dance. One hour earlier I watched him and his brother, with the use of a digging stick, excavate a tree root to expose the nest of the yerrampe (honey ant). The worker ants have distended abdomens in which they store honey. As a guest, I was given the opportunity of sampling the sacred delicacy, which entails bursting the honey sack in one's mouth.

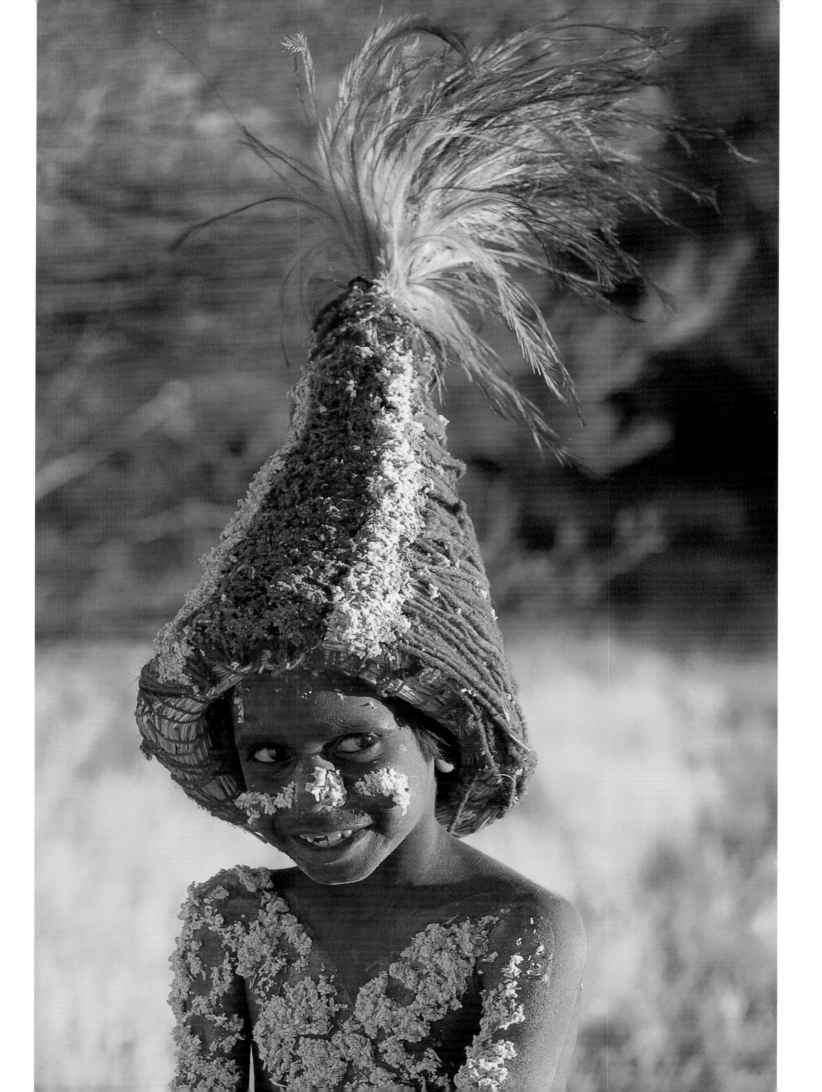

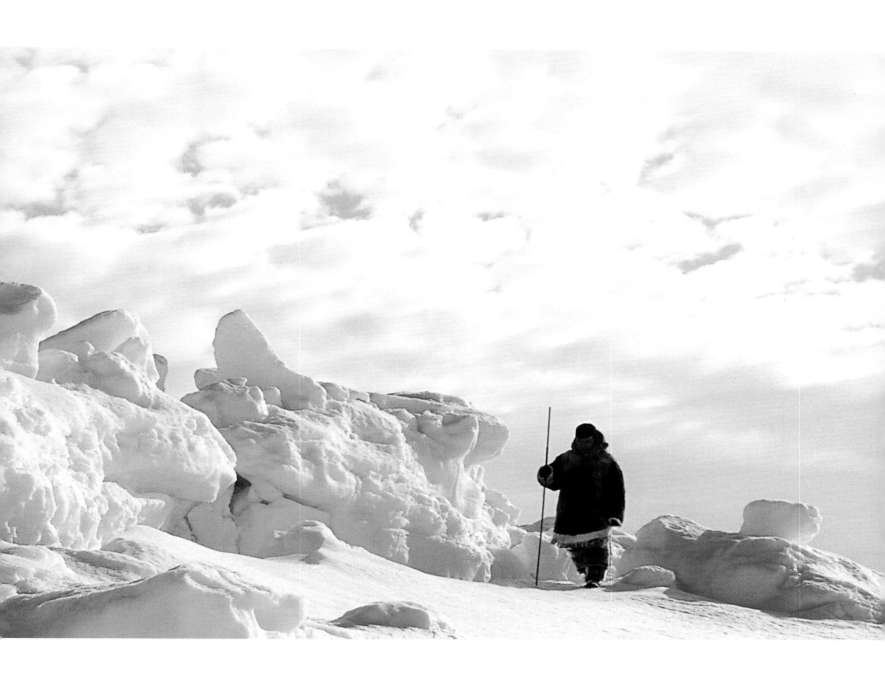

NUNAVUT OUR LAND

Inuit

The term Inuit, meaning "the people", is used loosely to describe the various indigenous peoples of the American Arctic including Inuit and Inuvialuit in Canada, and Inupiat, Yup'ik and Alutiiq in Alaska. The total population is now around 125,000, extending along the coast and sometimes inland from east Greenland, across north Canada to Alaska and the far Russian east. Archaeologists believe these people derive from a semi-nomadic culture that entered Alaska from Siberia about 6,000 BC.

Originally, Inuit life revolved around fishing, and hunting seals, whales and caribou. In 1576 Englishman Martin Frobisher led a search for a "northwest passage" trade route from America to the far east, the first of many European forays into the Arctic. In North Alaska and Baffin Island, a major turning point came in the 1860s, when American and Scottish whalers set up the first shore stations. Whaling had a major impact on these Inuit, changing settlement patterns and providing them with metal, tools, guns and whaleboats. Researchers soon followed: in 1884, geographer and ethnographer Franz Boas published the first major ethnographic study of the Canadian Inuit, *The Central Eskimo*.

Early in the 20th century, Canadian Inuit began to rely on trading fox fur with the Hudson's Bay Trading Company. In the 1960s, encouraged by government settlement policies, almost all Canadian Inuit moved into communities, with permanent heated wooden housing. Missionaries moved in to spread the Christian gospel among the newly settled populations and children were obliged to attend school. Many young Inuit have since lost their traditional hunting skills but are unable to find paid work. High levels of depression and alcoholism have affected many Inuit communities.

Since the early 1970s, however, the Inuit have been successful in various land claim actions. The 1971 Alaska Native Claims Settlement Act amounted to U.S.$925 million; this was followed two years later by the James Bay Treaty in Quebec, and the Home Rule in Greenland agreement in 1979. In 1999, the Canadian government addressed Inuit land claims and harvesting rights by inaugurating Nunavut, 770,000 sq miles (two million sq km) of northern Canada. It is not an ethnic Inuit state, but it has given the Canadian Inuit a greater degree of autonomy and self-government. While snowmobiles replaced dogsleds in the 1960s and hi-tech ski wear competes with caribou-skin clothing, moves continue to keep Inuit culture alive through singing, carving, drawing, writing and documentary film-making. Since the 1980s, the Inuit Broadcasting Corporation has aired hours of programming each week. And in 2002, Zacharias Kunuk directed the first mainstream film to be written and acted by an entirely Inuit cast (Alexander, 2002).

SEAL HUNT (PAGES 174-75)
Searching for the telltale signs of a blowhole, an Inuit studies ice formations in Cumberland Sound. Seal holes are normally found on the east side of ice ridges sheltered from the prevailing westerly winds. For over a thousand years, Inuit survival depended on the ringed seals, walruses and beluga whales that populate the waters of the sound, and on the magnificent bowhead whales that were once abundant.

SUN-SHADES (OPPOSITE)
Traditional Inuit technology was based on locally available materials, principally bone, horn, antler, ivory, stone and animal skins. In some areas grass or baleen was used for basketry, wood substituted for bone, native copper for antler or bone, and bird or fish skins for animal skins. Many Inuit inventions such as the domed igloo or toggling harpoon head are now considered technological masterpieces.

CONTINUING THAW (PAGES 178-79)
Scanning the ice, my guide Joavee Alivaktuk makes use of a high-point for any signs of life. In recent years, many Inuit have observed that in places where the ice is usually thick, it is now too thin for a snowmobile. During this trip down Pangnirtung Fjord and into Cumberland Sound, Joavee was concerned about the extent of the thaw for the time of year and suggested global warming as the agent for this change.

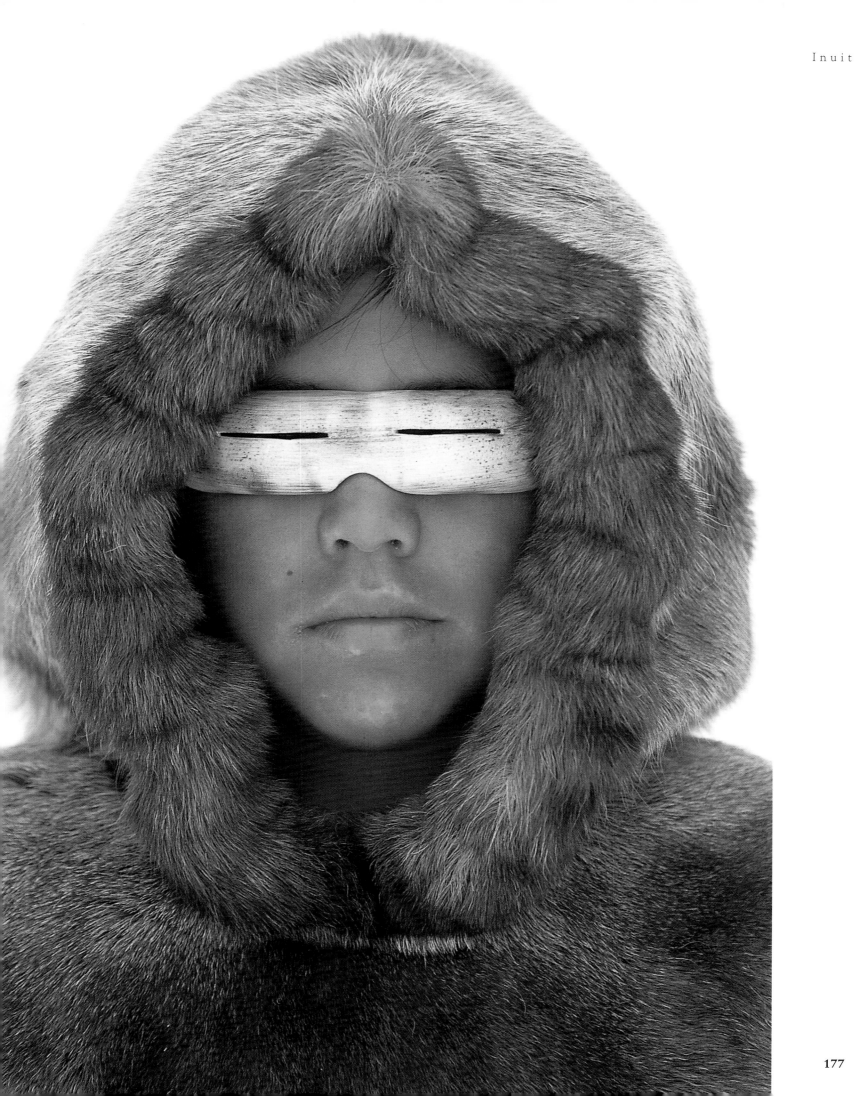

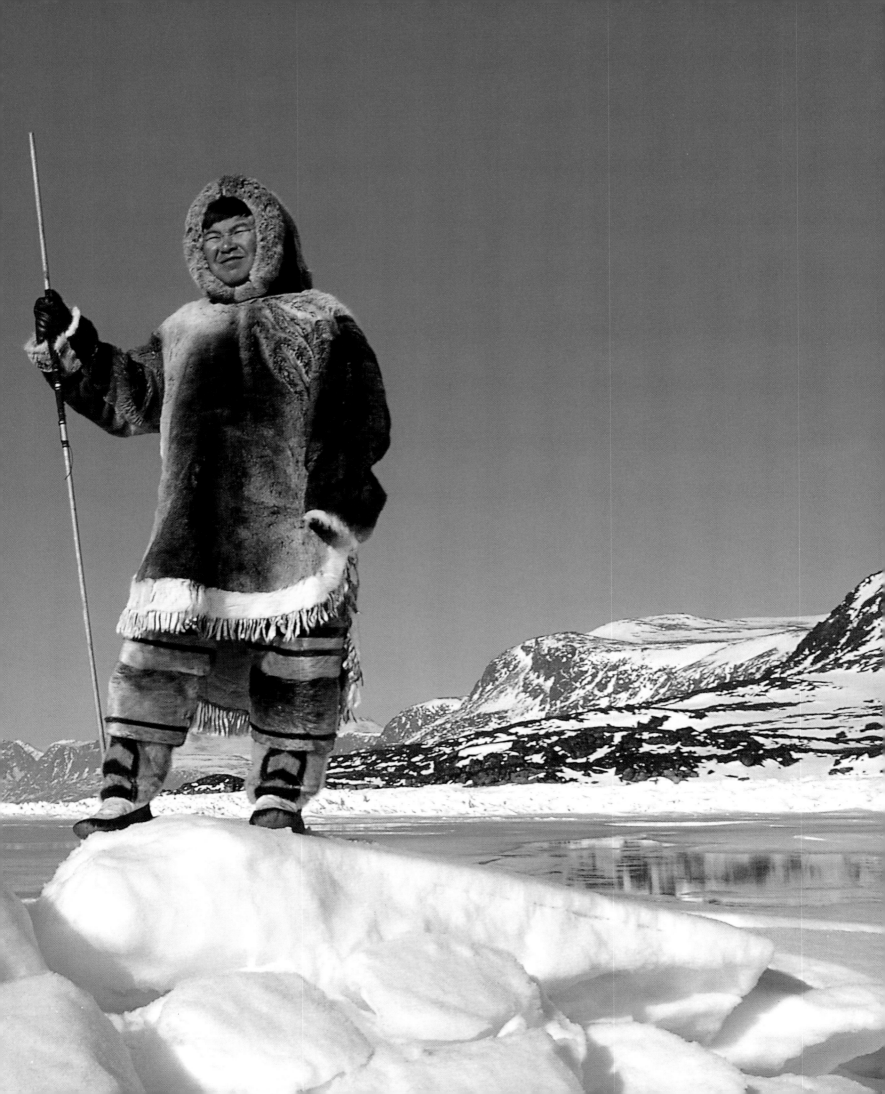

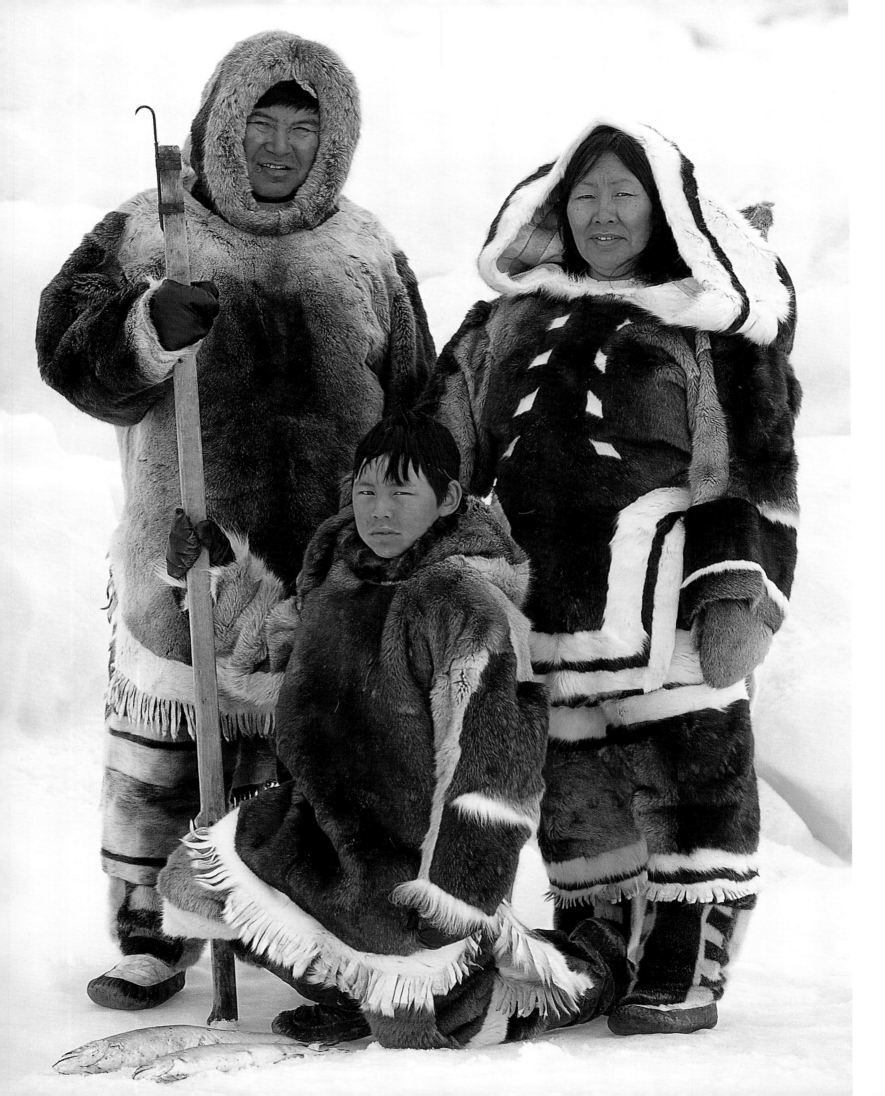

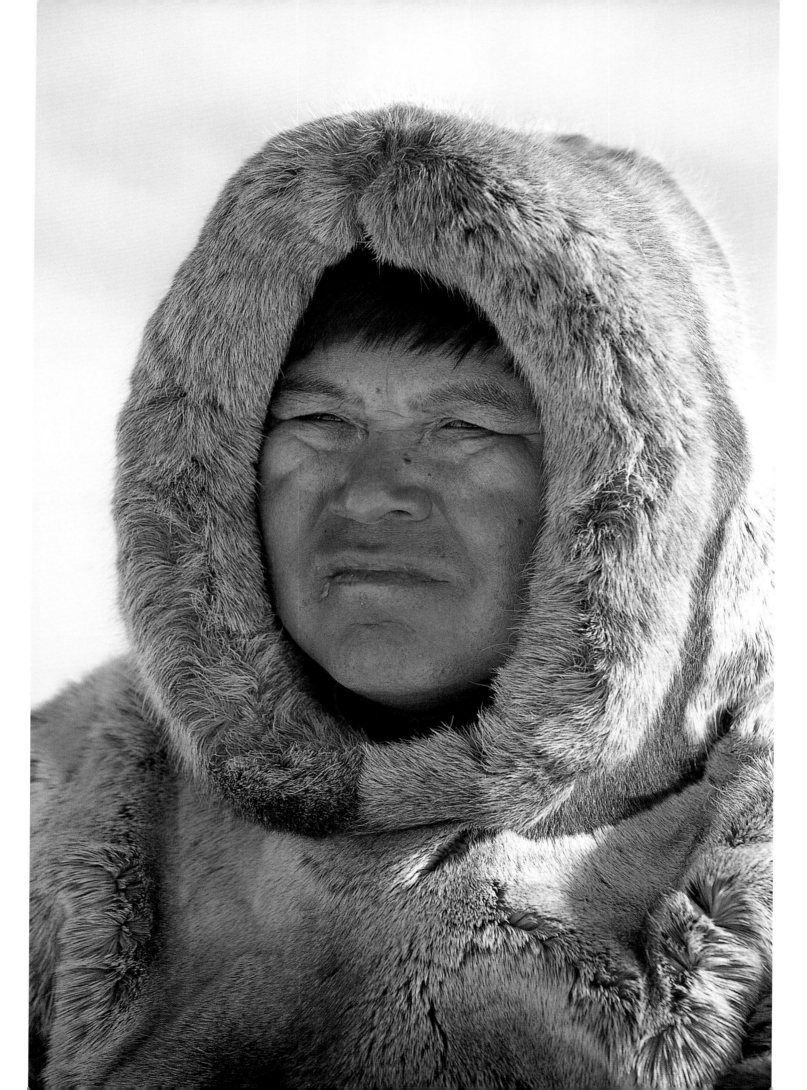

FISHING FOR ARCTIC CHAR
(PAGE 180)

Most Inuit groups used to base their economy on seasonal hunting for polar bear and whales. In summer and autumn many groups hunted caribou or moved to favoured coastal locations to hunt and fish. Whilst high value was placed on fresh food, quantities were also stored for future use. Drying, and caching in cool places, were common, although special techniques such as storing in oil were also used.

CARIBOU PARKA (PAGE 181)

The parka traditionally consisted of an inner and outer jacket, usually of caribou skin though sometimes sealskin. Women's clothing was often more elaborate than men's, with a voluminous hood on the tailed and aproned parka. The caribou parka is still worn during winter months, but Gore-Tex and fleece clothing is otherwise the norm. "When you're out on the ice there is nothing warmer than the natural fibres of caribou skin," Joavee tells me.

IN THE FAST LANE (RIGHT)

Snowmobiles have completely replaced traditional dog-sledding. Canadian Inuit no longer know how to raise dog teams and are dependent on their expensive machines. A reliance on snowmobiles and GPS systems may bring a false sense of security that can be dangerous – unpredictable conditions require an ability to read the land carefully and, at the speed of a snowmobile, subtle changes are often missed. Also, because the noisy vehicles scare off wildlife, hunters have to travel further to procure game.

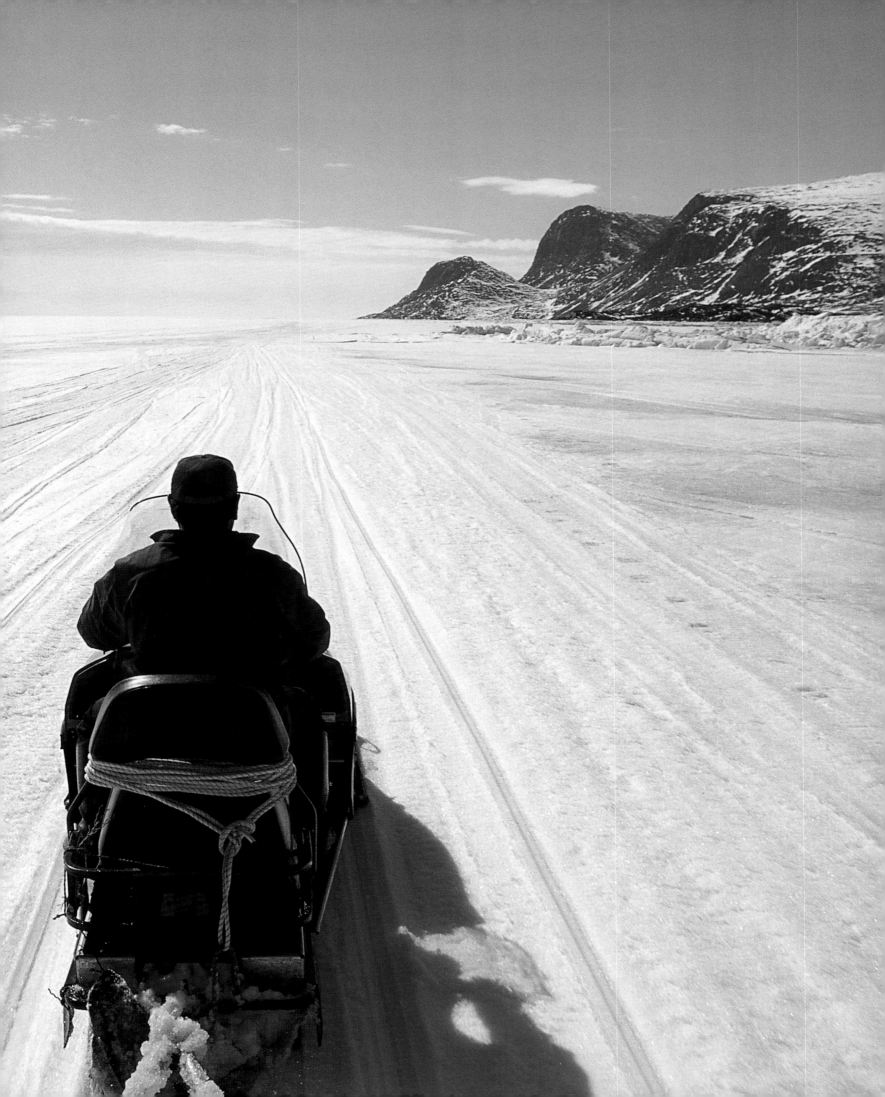

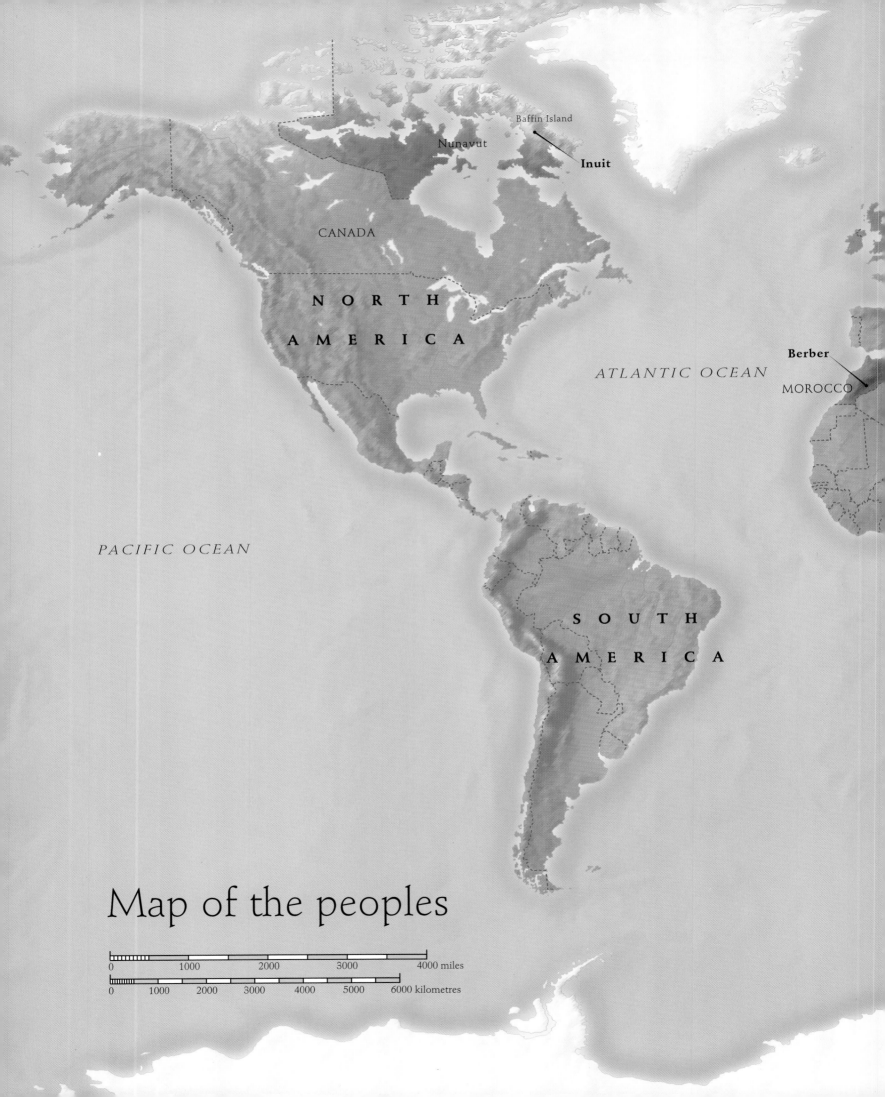

Baffin Island

Nunavut

Inuit

CANADA

N O R T H

A M E R I C A

ATLANTIC OCEAN

Berber

MOROCCO

PACIFIC OCEAN

S O U T H

A M E R I C A

Map of the peoples

| 0 | 1000 | 2000 | 3000 | 4000 miles |

| 0 | 1000 | 2000 | 3000 | 4000 | 5000 | 6000 kilometres |

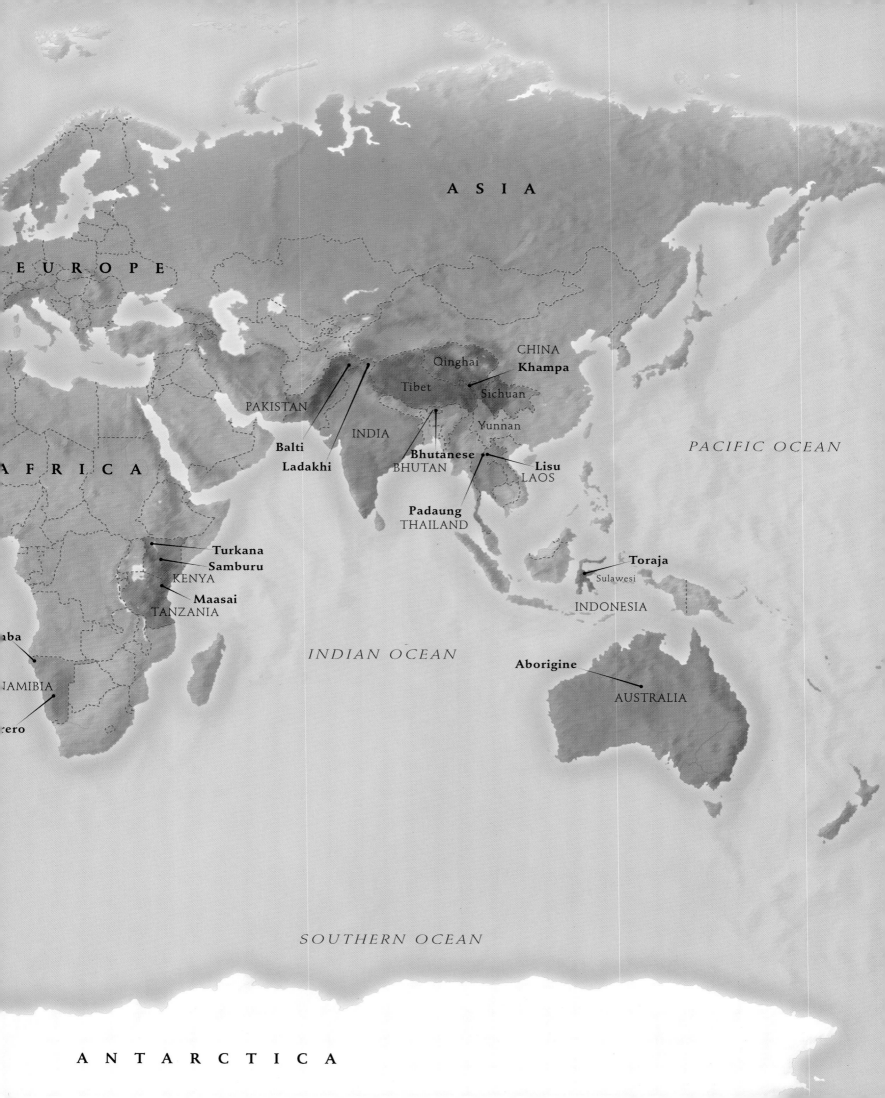

ASIA

EUROPE

CHINA

Qinghai

Khampa

Tibet

Sichuan

PAKISTAN

Yunnan

INDIA

AFRICA

Balti
Ladakhi

Bhutanese
BHUTAN

Lisu
LAOS

Padaung
THAILAND

PACIFIC OCEAN

Turkana
Samburu
KENYA
Maasai
TANZANIA

Toraja
Sulawesi

INDONESIA

aba

Aborigine

NAMIBIA

INDIAN OCEAN

AUSTRALIA

ero

SOUTHERN OCEAN

ANTARCTICA

Note on the Photography

With the exception of the panoramas, all the images in this book were shot on 35mm Canon equipment. I've always been an advocate of the 35mm format: its 2/3 format is distinctive, delivering both landscape and upright images depending on the subject matter; and the old argument that 35mm is too small a format to carry discernible quality is simply no longer true. The combination of the Canon EOS system and L Series lenses, coupled with Fuji transparency emulsions, high-end drum scanning and CTP screening technologies makes possible reproductions of extremely high quality.

When travelling overseas, the size of a camera system is particularly important, as airlines increasingly restrict the weight of cabin baggage. The development of L Series high-speed zooms has been pivotal in the reduction of lenses of a single focal length, with no compromise on quality. After upgrading my Canon system I now travel with the following equipment: EOS1V and PB-E2 motor drive (x 2), Canon EF16-35mm f2.8L USM, EF28-70 f2.8L USM, EF70-200 f2.8L IS USM, EF300mm f2.8L IS USM, EF1.4x Extender, EF100 f2.8 USM, TS-E24m f3.5L and Speedlite 550EX (x 2). It's a significant amount of camera equipment, but I need to know on assignment that I am covered for all eventualities. When working from a base or a vehicle it is possible to extrapolate from this equipment.

The importance of the use of a tripod cannot be overstated – over 95 percent of the images in this collection were shot using a lightweight carbon-fibre Gitzo Mountaineer Model G1349 tripod. Image sharpness has as much to do with camera shake as it has with optical performance. Portraits shot with the EF70-200 f2.8L USM, typically at 125th or 60th at f4 or f5.6, would not yield sharp images without the lens being tripod-mounted. Although many photographers approaching similar subjects might opt for a monopod, my experience of shooting portraits with a monopod was a compelling lesson in the benefits of a tripod. The portraits in this book are testimony to this lesson and might appear to have been shot on a larger format.

Film stock was predominantly Fuji Provia 100F and Fuji Velvia, which yielded highly saturated colour transparencies. Provia was my first choice for photographing people. I would choose the higher saturation of Velvia to record the vibrancy of festivals or landscapes, whenever there was sufficient light.

The panoramic images were shot on the Fuji GX617 with the SWD90mm f5.6 and the W180mm f6.7 on Fuji Velvia.

LAST LAUGH (PAGES 188-9)
During a lull in performances in Bhutan, I became the unfortunate victim of the satire of the atsaras, *much to the amusement of the crowd. These clowns, whose expressive masks and postures are an indispensable element of any religious festival, play the part of confronting monks, tossing out salacious jokes and generally distracting the crowd with their antics when the dances become tedious. Believed to represent* acaryas, *or religious masters of India,* atsaras *are the only people permitted to mock religion in a society where sacred matters are treated with the highest respect.*

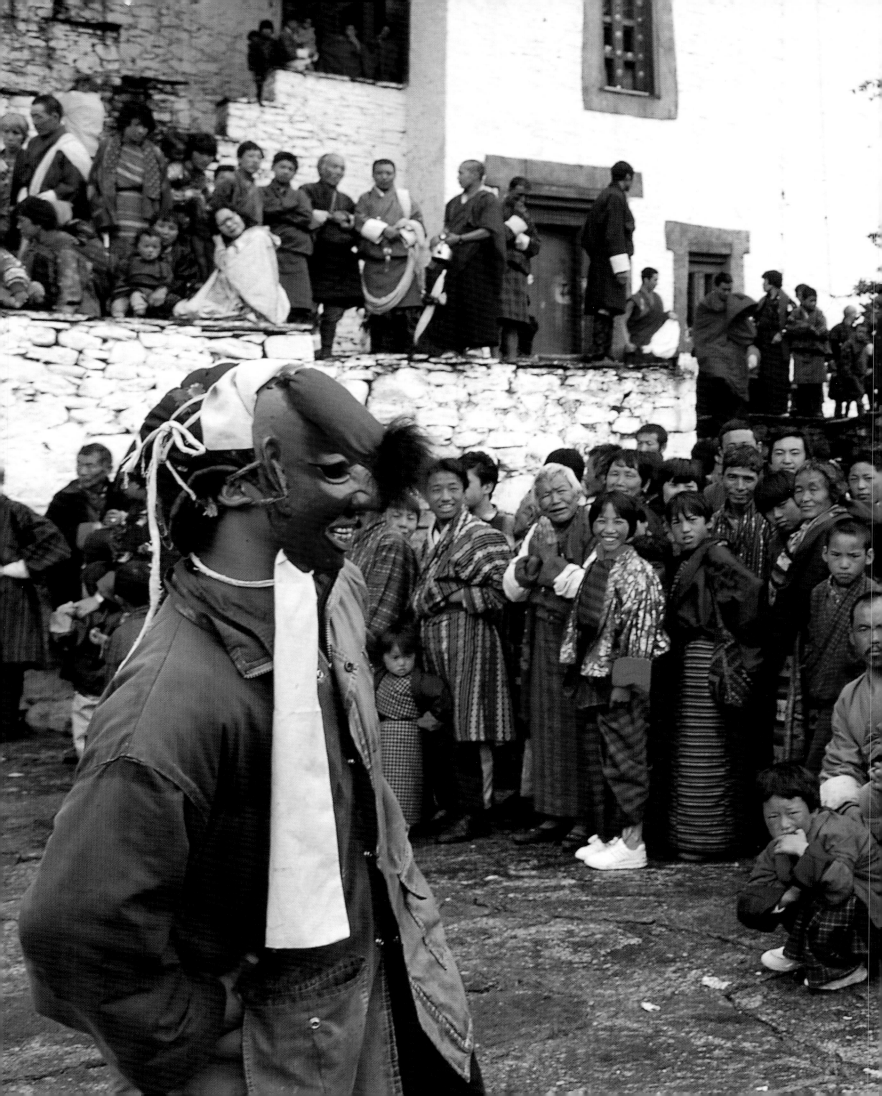

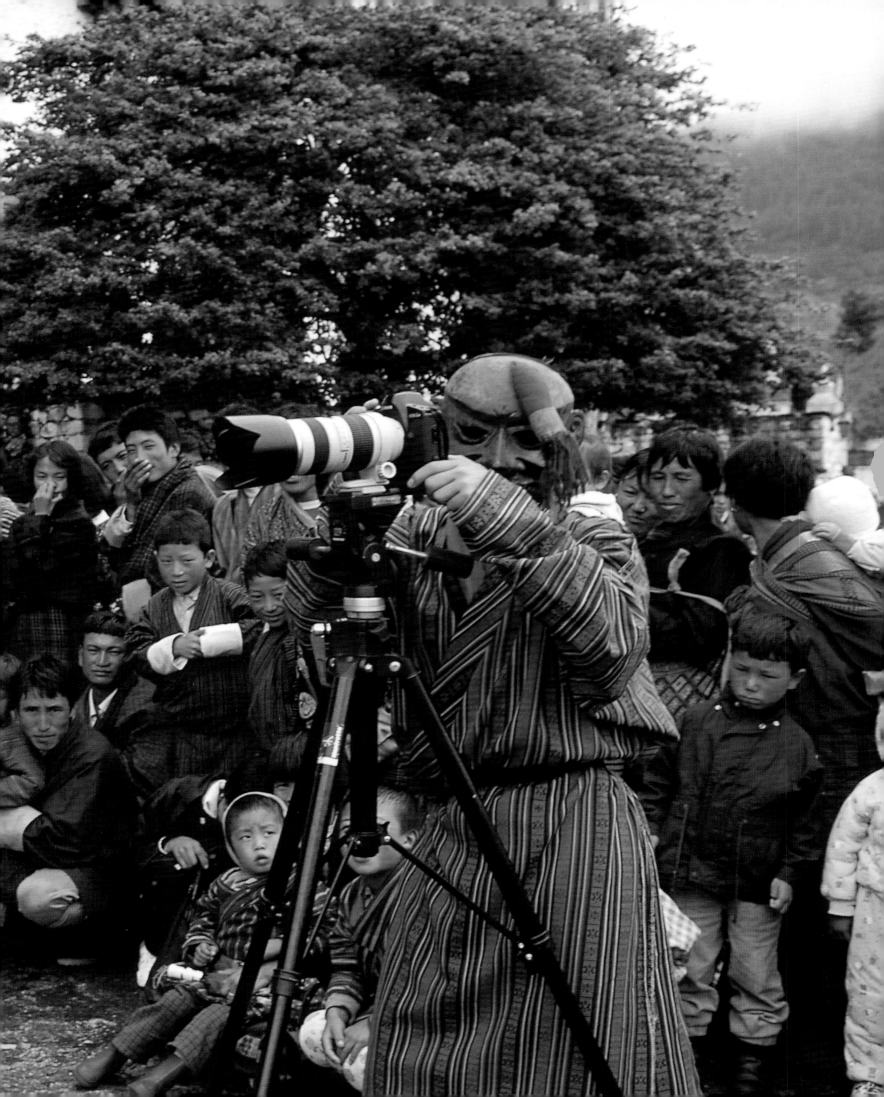

Bibliography

Kathleen M. Adams, 'Ethnic tourism and the renegotiation of tradition in Tana Toraja (Sulawesi, Indonesia)', *Ethnology* 36:4, pp 309-20 (1997)

Doug Alexander, In conversation with Zacharias Kunuk, *Geographical* 74:4 (2002)

Kaj Arhem, 'Two sides of development: Maasai pastoralism and wildlife conservation in Ngorongoro, Tanzania', *Ethnos* 3/4, pp 186-210 (1984)

Tiziana and Gianni Baldizzone, *Tibet, on the Paths of the Gentleman Brigands: Retracing the steps of Alexandra David-Neel*, London: Thames and Hudson (1995)

Peter Bellwood, 'Ancient seafarers: new evidence of early southeast Asian sea voyages', *Archaeology* 50:2, pp 20-2, 82 (1997)

Gebhart Blazek, 'Tabrdouhte and tabbnoute: indigo-dyed Berber shawls of the middle Atlas', *Hali* 113:94-100 (2000)

Helmut Bley, *South West Africa under German rule, 1894–1914*, London: Heinemann (1971)

Michael Bollig, 'Risk and risk minimisation among Himba pastoralists in northwestern Namibia', *Nomadic Peoples* 1:1, pp 66-89 (1997)

Matthew Brace, 'A nation divided', *Geographical* 73:11 (2001)

B. Chakravarti, 'Bhutan – the land, people and polity', *Journal of the Asiatic Society* Calcutta 19:1/2, pp 33-43 (1977)

Margaret Courtney-Clarke and Geraldine Brooks, *Imazighen: The vanishing traditions of Berber women*, London: Thames and Hudson (1996)

David P. Crandall, 'The strength of the OvaHimba patrilineage', *Cimbebasia* 13:45-51 1012-4926 (1991)

Matt Currington, 'Keeper of the holy fire', *Geographical* 73:1 (2001)

William Y.Y. Dessaint, A.Y. Dessaint, 'Opium and labor: social structure and economic change in the Lisu highlands', *Journal of Peasant Studies* 19:3/4, pp 147-77 (1992)

Gaudenz Domenig, 'Changing patterns of architecture and symbolism among the Sa'dan Toraja (Indonesia)' [review article on 'Banua Toraja: changing patterns ...' by J.I. Kis-Jovak and others (Amsterdam: Royal Trop Inst, 1988)], *Asian Folklore Studies* 49, pp 303-20 (1990)

E.P. Durrenberger, 'The economy of a Lisu village [Ban Lum, Thailand]', *American Ethnologist* 3:4, pp 633-44 (1976)

E.P. Durrenberger, 'Law and authority in a Lisu village', *Journal of Anthropological Research* 32:4, pp 301-25 (1976)

E.P. Durrenberger, 'Belief and the logic of Lisu spirits', *Bijdr Taal- Land- Volkenk* 136:1, pp 21-40 (1980)

A.P. Elkin, 'The aborigines in Australian society: a review article [on the series 'Aborigines in Australian society']' *Oceania* 42:1, pp 58-66 (1971)

Elliot Fratkin, 'Traditional medicine and concepts of healing among the Samburu pastoralists of Kenya', *Journal of Ethnobiology* 16:1, pp 63-97 (1996)

J.G. Galaty, 'Land and livestock among Kenyan Maasai', *Journal of Asian and African Studies* 16:1/2, pp 68-88 (1981)

Jan-Bart Gewald, 'The road of the man called love and the sack of Sero: the Herero–German war and the export of Herero labour to the south African rand', *Journal of African History* 40:1, pp 21-40 (1999)

Joan E. Gross, D.A. McMurray, 'Berber origins and the politics of ethnicity in colonial north African discourse', *Political and Legal Anthropology Review* 16:2, pp 39-57 (1993)

Rachel Hinton, 'NGO's as agents of change? The case of the Bhutanese refugee programme', *Cambridge Anthropology* 19:1, pp 24-56 (1996)

Krisadawan Hongladarom, 'Four rivers and six ranges', *Bangkok Post* (15 February 2001)

Hsain Ilahiane, 'The Berber Agdal institution: indigenous range management in the Atlas mountains', *Ethnology* 38:1, pp 21-45 (1999)

Margaret Jacobsohn, 'Preliminary notes on the symbolic role of space and material culture among semi-nomadic Himba and Herero herders in western Kaokoland, Namibia', *Cimbebasia* 10, pp 75-99 (1988)

Margaret Jacobsohn, *Himba: Die Nomaden Namibias,* Hannover: Landbuch Verlag (1990)

Frances Kennett, *World Dress*, London: Mitchell Beazley (1994)

Shinya Konaka, 'The Samburu livestock market in north central Kenya' [in special issue 'Social changes and self-reliant practices and agricultural peoples in Kenya'], *African Study Monographs* 18:3/4, pp 137-55 (1997)

Hans Peter P. Larsen, 'The music of the Lisu of northern Thailand', *Asian Folklore Studies* 43, pp 41-62 (1984)

L. Lesarge, 'The dances of the "ilmurran" and their girls', *Samburu Journal for the Anthropological Study of Human Movement* 7:2, pp 102-13, 135-8 (1992)

Roger Lewin, *The Origin of Modern Humans*, New York: Scientific American Library (1993)

M.A. Little, P.W. Leslie, K.L. Campbell, 'Energy reserves and parity of nomadic and settled Turkana women', *American Journal of Human Biology* 4:6, pp 729-38 (1992)

R.S. Mann, 'Social stratification and interaction in Ladakhi villages', *Bulletin of the Anthropological Survey of India* 21:3/4, pp 1-15 (1972)

R.S. Mann, 'Ladakhi polyandry reinterpreted', *Indian Anthropologist* 8:1, pp 17-30 (1978)

R.S. Mann, 'Role of monasteries in Ladakhi life and culture', *Indian Anthropologist* 15, pp 33-49 (1985)

Jean Michaud, 'A historical account of modern social change in Ladakh with special attention paid to tourism', *International Journal of Comparative Sociology* 37:3/4, pp 286-300. 0020-7152 (1996)

Edith T. Mirante, 'Hostages to tourism', *Cultural Survival Quarterly* 14, pp 35-8 (1990)

Diana K. Myers, 'Costume and ceremonial textiles of Bhutan', *The Textile Museum Journal* 26, pp 24-53 (1987)

Stephen Oppenheimer, 'The first exodus', *Geographical* 74:7 (2002)

Bess and Dave Price, 'Unheard voices', *Journal of Australian Indigenous Issues*, 1(2), pp15–23 (1988)

Republic of Kenya (ROK), *Samburu District Development Plan* (1979–1983), Nairobi: Ministry of Economic Planning and Development (1980)

T.O. Saitoti, C. Beckwith, 'Warriors of Maasailand: although a lion could run faster, we could run farther', *Nat. Hist. NY* 89:8, pp 42-55 (1980)

A. C. Sinha, 'The ethnic statement of Bhutan: who will upset the applecart?', *Himal* 9:5, pp 36-40 (1996)

V.L. Smith, 'Controlled vs. uncontrolled tourism: Bhutan and Nepal', *Royal Anthropological Institute News* 46, pp 4-6 (1981)

Louise Sperling, 'The adoption of camels by Samburu cattle herders', *Newsletter Commission on Nomadic Peoples* 23, pp 1-17 (1981)

W.E.H. Stanner, 'Aborigines in the affluent society: the widening gap', *Anthropological Forum* 3:3/4, pp 249-63 (1973/4)

W.E.H. Stanner, 'Aborigines and Australian society', *Mankind* 10:4, pp 201-12 (1976)

Survival, *Threatened pastures*, London (1988)

Survival, *Cattle people*, London (1998)

Survival, *People of the Dreaming*, London (1988)

Alan Turner, 'Early hominid dispersions', *Anthropologie Brno.* 37:1, pp 19-26 (1999)

Toby Alice A. Volkman, 'Great performances: Toraja cultural identity in the 1970s', *American Ethnologist* 11, pp 152-69 (1984)

Toby Alice A. Volkman, 'Visions and revisions: Toraja culture and the tourist gaze', *American Ethnologist* 17, pp 91-110 (1990)

Elspeth Young, 'Commerce in the bush: Aboriginal and Inuit experiences in the commercial world', *Australian Aboriginal Studies* pp 46-53 (1987)

Acknowledgements

The seeds for this project were planted seven years ago when I was approached by Chris Holt of British Airways to work on their corporate calendar. Little idea did I have that I would retain the commission for four years and travel over one million miles to some 35 countries. It proved a unique opportunity: Chris encouraged me to choose my own locations and indigenous groups throughout the world and made few editorial changes to the selected images.

I would like to extend my gratitude to Pete Duncan and Nova Jayne Heath of Constable & Robinson for their imaginative foresight and enthusiasm for this book, and to Carolyn Fry for her fascinating essays on the tribal groups.

Special thanks are due to the many manufacturers and travel companies who supported the projects, including Fuji Film (UK) Ltd, Canon (UK) Ltd, Hasselblad (UK) Ltd, Robert White Photographic Ltd, Abercrombie & Kent, Worldwide Journeys, KE Travel Ltd, Himalayan Kingdoms, Alivaktuk Outfitting, Nunavut Tourism, Etho Metho Tours and VAST.

I would also like to thank all who shared in my travels, including my father who accompanied me to Patagonia, Pakistan, Ladakh and Bhutan and Geraldine my wife, who encouraged me to fulfil what I am.

Posters and stock images can be sourced through the Earth Gallery (www.earthgallery.net).